150 GOLF COURSES

YOU NEED TO VISIT BEFORE YOU DIE

By Stefanie Waldek

Lannoo

Golf, more than any other sport, has an intimate relationship with place because it is inextricably tied to the landscape. Mother Nature herself could be considered a golfer's opponent; her rolling hills, sea breezes, and atmospheric pressure challenge all who face her. This is why golf courses are found in some of the world's most scenic locations.

Great masters such as Donald Ross, Pete and Alice Dye, and Tom Fazio have embraced the relationship between the natural site and the game, creating hazards that are not insurmountable, yet challenging enough to unnerve even veterans of the sport.

When it comes to ranking golf courses, it's entirely a subjective matter. For some it's all about the landscape or the conditions of the greens, while others may give greater importance to historical value. In *150 Golf Courses You Need to Visit Before You Die*, I have gathered an array of golf courses, from those in beautiful settings, often with an offbeat panache, to those traditionally considered "the best courses in the world."

I hope expert golfers, novice golfers, and even non-golfers will enjoy this collection of exceptional courses across the globe.

OVERVIEW

THE AMERICAS

ARGENTINA
001 CHAPELCO GOLF & RESORT — P.10
002 LLAO LLAO RESORT, GOLF, & SPA — P.14
003 USHUAIA GOLF CLUB — P.15

BRAZIL
004 GÁVEA GOLF AND COUNTRY CLUB — P.16
005 TERRAVISTA GOLF COURSE — P.17

CANADA
006 THE FAIRMONT BANFF SPRINGS GOLF COURSE: STANLEY THOMPSON — P.18
007 FURRY CREEK GOLF & COUNTRY CLUB — P.19
008 KANANASKIS COUNTRY GOLF COURSE: MOUNT KIDD — P.20

DOMINICAN REPUBLIC
009 PUNTA ESPADA GOLF CLUB — P.21

MEXICO
010 DIAMANTE CABO SAN LUCAS: DUNES — P.23
011 QUIVIRA GOLF CLUB — P.24

PERU
012 LIMA GOLF CLUB — P.28

USA
013 ARROWHEAD GOLF COURSE — P.29
014 BANDON DUNES GOLF RESORT: OLD MACDONALD — P.32
015 BLACK JACK'S CROSSING — P.33
016 THE BROADMOOR GOLF CLUB: EAST — P.34
017 COEUR D'ALENE RESORT — P.35
018 FAIRMONT GRAND DEL MAR: GRAND GOLF CLUB — P.36
019 FOUR SEASONS RESORT LANAI: MANELE — P.40
020 FOUR SEASONS RESORT HUALALAI — P.44
021 FURNACE CREEK GOLF COURSE AT DEATH VALLEY — P.45
022 GOLD MOUNTAIN: OLYMPIC — P.46
023 INDIAN WELLS GOLF RESORT: PLAYERS — P.50
024 KAPALUA PLANTATION COURSE — P.51
025 KIAWAH ISLAND: OCEAN COURSE — P.52
026 LOS ALAMOS COUNTY GOLF COURSE — P.53
027 MAUNA KEA GOLF COURSE — P.54
028 PGA WEST: STADIUM — P.56
029 PAYNE'S VALLEY GOLF COURSE — P.57
030 OJAI VALLEY INN — P.60
031 PEBBLE BEACH GOLF LINKS — P.62
032 PINEHURST NO. 2 — P.64
033 PRIMLAND RESORT: HIGHLAND COURSE — P.68
034 SEDONA GOLF RESORT — P.69
035 SILVIES VALLEY RANCH: HANKINS AND CRADDOCK — P.71
036 TORREY PINES: SOUTH — P.72

OVERVIEW

AFRICA

EGYPT
037 MARRIOTT MENA HOUSE GOLF COURSE — P.73

KENYA
038 WINDSOR GOLF HOTEL & COUNTRY CLUB — P.74

MAURITIUS
039 ÎLE AUX CERFS GOLF CLUB — P.75
040 TAMARINA GOLF CLUB — P.76

NAMIBIA
041 OMEYA GOLF CLUB — P.80

SEYCHELLES
042 CONSTANCE LEMURIA GOLF COURSE — P.81

SOUTH AFRICA
043 ARABELLA GOLF CLUB — P.82
044 GARY PLAYER COUNTRY CLUB — P.83
045 LEOPARD CREEK COUNTRY CLUB — P.85
046 PEZULA CHAMPIONSHIP COURSE — P.86
047 PEARL VALLEY: JACK NICKLAUS SIGNATURE GOLF COURSE — P.87
048 PINNACLE POINT GOLF CLUB: FYNBOS — P.90
049 SKUKUZA GOLF CLUB — P.94

TANZANIA
050 SEA CLIFF RESORT & SPA — P.96

UGANDA
051 LAKE VICTORIA SERENA GOLF RESORT & SPA — P.97

ZIMBABWE
052 ROYAL HARARE GOLF CLUB — P.98

ASIA

BHUTAN
053 ROYAL THIMPHU GOLF CLUB — P.102

CAMBODIA
054 PHOKEETHRA COUNTRY CLUB — P.103

CHINA
055 SHANQIN BAY GOLF CLUB — P.104
056 YALONG BAY GOLF CLUB — P.105

HONG KONG
057 THE CLEARWATER BAY GOLF & COUNTRY CLUB — P.106
058 JOCKEY CLUB KAU SAI CHAU: NORTH — P.107

INDIA
059 GULMARG GOLF CLUB — P.109
060 LALIT GOLF & SPA RESORT — P.110

INDONESIA
061 BALI NATIONAL GOLF CLUB — P.111
062 HANDARA GOLF & RESORT BALI — P.114
063 MERAPI GOLF YOGYAKARTA — P.115

MALAYSIA
064 THE ELS CLUB TELUK DATAI: RAINFOREST — P.118
065 MOUNT KINABALU GOLF CLUB — P.119
066 ROYAL SELANGOR GOLF CLUB — P.120
067 TEMPLER PARK COUNTRY CLUB — P.121
068 TPC KUALA LUMPUR: WEST — P.122

QATAR
069 EDUCATION CITY GOLF CLUB — P.123

SINGAPORE
070 MARINA BAY GOLF COURSE — P.124
071 SENTOSA GOLF CLUB: SERAPONG — P.125

SOUTH KOREA
072 JUNGMUN GOLF CLUB — P.126

OVERVIEW

	SRI LANKA	
073	**VICTORIA GOLF AND COUNTRY RESORT**	P.127
	THAILAND	
074	**AYODHYA LINKS**	P.128
075	**BLACK MOUNTAIN GOLF CLUB**	P.132
076	**SIAM COUNTRY CLUB: OLD HOUSE**	P.133
	UAE	
077	**DUBAI CREEK GOLF & YACHT CLUB: CHAMPIONSHIP**	P.134
078	**EMIRATES GOLF CLUB: MAJLIS**	P.136
	VIETNAM	
079	**BA NA HILLS GOLF CLUB**	P.137
080	**DAI LAI STAR GOLF & COUNTRY CLUB**	P.138
081	**KN GOLF LINKS CAM RANH: THE LINKS**	P.139
082	**LAGUNA GOLF LĂNG CÔ**	P.142
083	**VINPEARL GOLF NHA TRANG**	P.143

EUROPE

	AUSTRIA	
084	**GOLF CLUB WILDER KAISER**	P.144
	BELGIUM	
085	**ROYAL LIMBURG GOLF CLUB**	p145
	BULGARIA	
086	**THRACIAN CLIFFS GOLF & BEACH RESORT**	P.146
	FRANCE	
087	**CHAMONIX GOLF CLUB**	P.149
088	**GOLF BLUEGREEN PLÉNEUF-VAL-ANDRÉ**	P.150
089	**GOLF D'ÉTRETAT**	P.154
090	**LE GOLF NATIONAL: ALBATROS**	P.155
091	**GOLF DE SPÉRONE**	P.156

	GREECE	
092	**COSTA NAVARINO: THE DUNES**	P.160
	ICELAND	
093	**BORGARNES GOLF COURSE**	P.161
094	**KEILIR GOLF COURSE**	P.162
095	**WESTMAN ISLAND GOLF CLUB**	P.166
	IRELAND	
096	**BALLYBUNION GOLF CLUB: OLD**	P.167
097	**LAHINCH GOLF CLUB: OLD**	P.170
098	**OLD HEAD GOLF LINKS**	P.172
099	**PORTMARNOCK GOLF CLUB: CHAMPIONSHIP**	P.173
	ITALY	
100	**CERVINO GOLF CLUB**	P.174
101	**GOLF CLUB ALTA BADIA**	P.175
102	**GOLF CLUB CASTELFALFI: MOUNTAIN**	P.176
103	**GOLF CLUB COURMAYEUR ET GRANDES JORASSES**	P.177
104	**UNA POGGIO DEI MEDICI GOLF CLUB**	P.178
	THE NETHERLANDS	
105	**KONINKLIJKE HAAGSCHE GOLF AND COUNTRY CLUB: ROYAL HAGUE**	P.179
	NORWAY	
106	**LOFOTEN LINKS**	P.180
107	**TROMSØ GOLF CLUB**	P.181
	PORTUGAL	
108	**MONTEI REI GOLF & COUNTRY CLUB: NORTH**	P.182
109	**TROIA GOLF**	P.187
	RUSSIA	
110	**MOSCOW COUNTRY CLUB**	P.190
	SPAIN	
111	**ABAMA GOLF**	P.191
112	**ALCANADA GOLF CLUB**	P.192

OVERVIEW

113	FINCA CORTESIN	P.193
114	REAL CLUB VALDERRAMA	P.196
115	REAL GUADALHORCE CLUB DE GOLF	P.197
	SWEDEN	
116	BRO HOF SLOTT GOLF CLUB: STADIUM	P.198
	SWITZERLAND	
117	ANDERMATT SWISS ALPS GOLF COURSE	P.199
118	GOLF CLUB BAD RAGAZ: CHAMPIONSHIP	P.200
119	GOLFCLUB ENGELBERG-TITLIS	P.204
	TURKEY	
120	LYKIA LINKS	P.205
	UNITED KINGDOM	
121	ARDGLASS GOLF CLUB	P.206
122	GLENEAGLES: KING'S	P.207
123	ROYAL DORNOCH: CHAMPIONSHIP	P.208
124	MUIRFIELD	P.209
125	ROYAL LYTHAM & ST. ANNES GOLF CLUB	P.212
126	ST. ANDREWS LINKS: OLD COURSE	P.213
127	SUNNINGDALE: OLD	P.214
128	TRUMP INTERNATIONAL GOLF LINKS SCOTLAND	P.218
129	TRUMP TURNBERRY RESORT: AILSA	P.219
130	WHALSAY GOLF CLUB	P.220

OCEANIA

	AUSTRALIA	
131	BARNBOUGLE: DUNES	P.222
132	CAPE WICKHAM GOLF LINKS	P.223
133	CHRISTMAS ISLAND GOLF COURSE	P.224
134	COOBER PEDY OPAL FIELDS GOLF CLUB	p225
135	GRANGE GOLF CLUB: WEST	P.226
136	KINGSTON HEATH	P.227
137	LORD HOWE ISLAND GOLF CLUB	P.230
138	NEW SOUTH WALES GOLF CLUB	P.232
139	NULLARBOR LINKS	P.233
140	ROTTNEST ISLAND GOLF CLUB	p234
141	THE ROYAL ADELAIDE GOLF CLUB	P.235
142	13TH BEACH: BEACH	P.236
143	JOONDALUP RESORT COUNTRY CLUB	P.237
	NEW ZEALAND	
144	CAPE KIDNAPPERS	P.238
145	THE HILLS	P.242
146	JACK'S POINT	P.243
147	KAURI CLIFFS	P.244
148	MILLBROOK RESORT	P.248
149	PARAPARAUMU BEACH GOLF CLUB	P.249
	NORTHERN MARIANA ISLANDS	
150	LAO LAO BAY GOLF RESORT: EAST COURSE	P.252

The Americas · Argentina

01 CHAPELCO GOLF & RESORT

Ruta Nacional 40 Km 2226 CP 8370,
San Martín de los Andes, Neuquén, Argentina

TO VISIT BEFORE YOU DIE BECAUSE

This was Jack Nicklaus' first course in South America, which he designed with his son Jackie.

The Golden Bear couldn't have picked a more scenic place for his first course in South America. Chapelco Golf & Resort, designed by Jack Nicklaus and his son Jackie, is located in the Patagonian Andes, and the mountain backdrop is nothing short of breathtaking. But the landscape provides a lot of variety as you play through the 18 holes. In some areas you'll be surrounded by pampas grass plains, while in others you'll be in the pine forest. And between the two types of terrain, there are plenty of natural lakes and streams to keep things interesting. As with many Nicklaus designs, Chapelco strikes the right balance of being appropriately challenging without being overly frustrating.

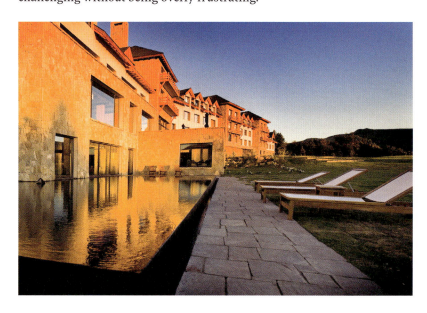

www.chapelcogolf.com +54 2972 42-1785

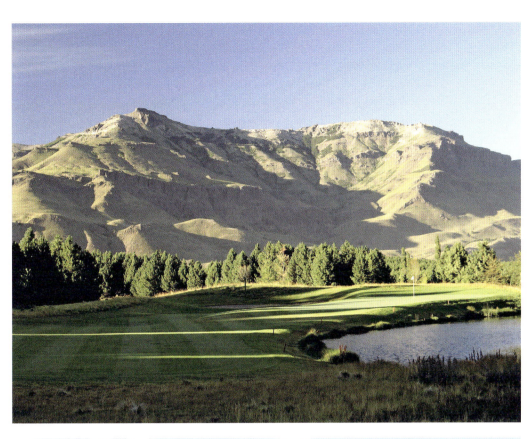
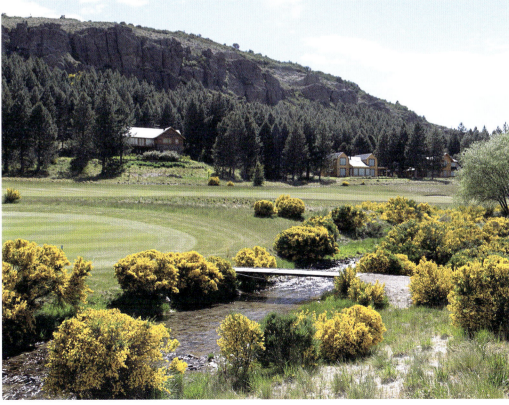

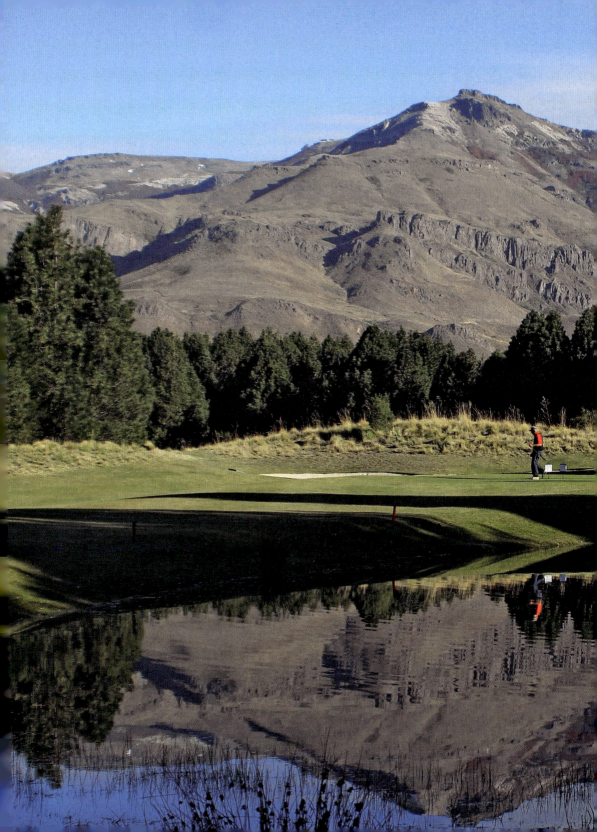

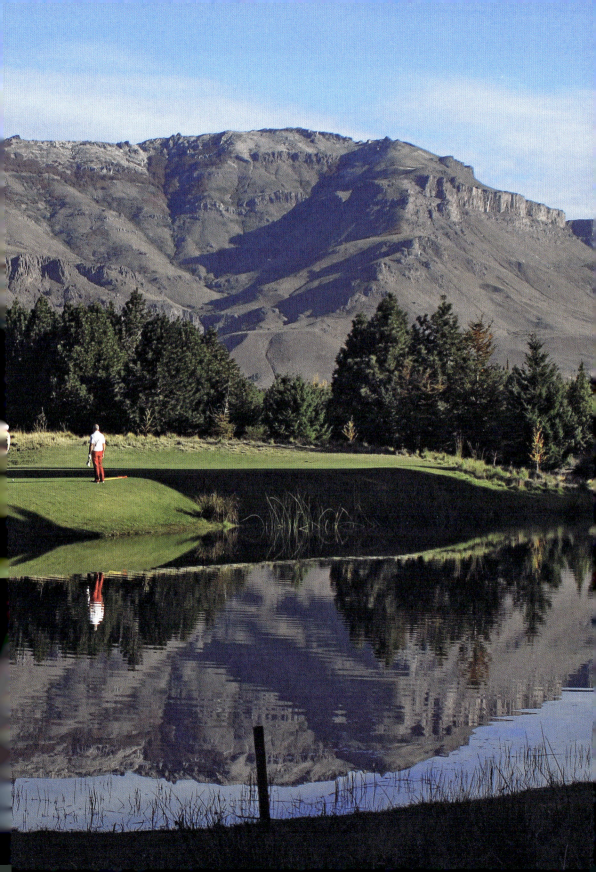

The Americas · Argentina

02 LLAO LLAO RESORT, GOLF, & SPA

Avenida Ezequiel Bustillo Km. 25 (R8401ALN), Bariloche, Río Negro, Argentina

TO VISIT BEFORE YOU DIE BECAUSE

You play in the middle of Nahuel Huapi National Park, an unbelievably scenic destination.

The setting for the Llao Llao Resort in Bariloche is reminiscent of a fantasy landscape in J.R.R. Tolkien's Middle-earth. But this is real life, and you're actually in the scenic Nahuel Huapi National Park, right on the shores of Nahuel Huapi Lake with the mountains of Patagonia behind you. It's one of the most breathtaking places to play golf, which is why it's worth the long trek to this remote destination. The original nine holes were designed by Luther Koontz, while the second nine were added in 1994 by Emilio Serra.

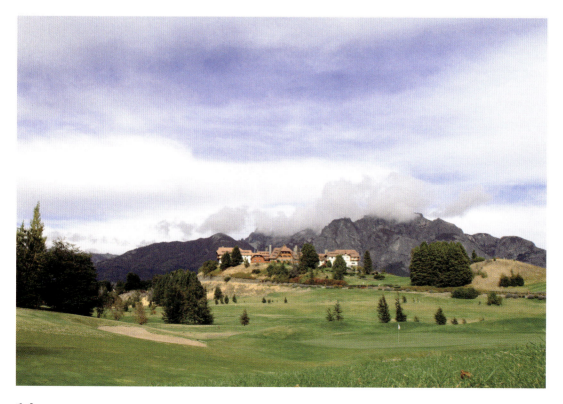

www.llaollao.com +54 294 444 5700 / 8530

The Americas — Argentina

03 USHUAIA GOLF CLUB

Ruta Nacional 3, Camino Al Parque Nacional Lapataia 9410, Ushuaia, Tierra del Fuego, Argentina

TO VISIT
BEFORE YOU DIE
BECAUSE

This is the most southerly golf course in the world.

If playing the world's most extreme courses is your goal, add Ushuaia Golf Club to your bucket list. Located on the edge of Tierra del Fuego National Park in Argentine Patagonia, it's the southernmost golf course in the world (excluding the makeshift courses in Antarctica run by research station staff). Its nine holes, five of which surround the powerful Pipo River, are open during the Southern Hemisphere's warmest seasons—roughly October through May—though players are often subject to pretty harsh weather conditions. It rains about half of the year here, and there are strong, freezing winds coming over the Drake Passage from Antarctica. Nevertheless, golfers persist, enjoying the chance to play on this atypical course.

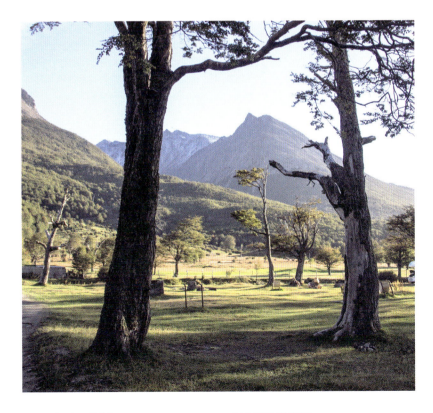

www.ushuaiagolfclub.com.ar +54 9 2901 61-6676

The Americas — Brazil

04 GÁVEA GOLF AND COUNTRY CLUB

Estrada da Gávea, 800, São Conrado,
Rio de Janeiro 22610-002, Brazil

TO VISIT
BEFORE YOU DIE
BECAUSE

Rio de Janeiro's first golf course still delights players a hundred years after it was built.

Rio de Janeiro might be famous for its beaches, but it also has a long golf history worth exploring if you're a fan of the sport. Founded in 1921 as the Rio de Janeiro Golf Club, Gávea, as it's known today, was the first golf course and club in the Brazilian city, and it remains the most prestigious. Throughout its history, Gávea has undergone a number renovations by Stanley Thompson, A. M. Davidson, Dan Blankenship, and Gil Hanse, all of whom have had their hand in updating the course. While the club is primarily for members only, guests of certain local hotels are able to score tee times.

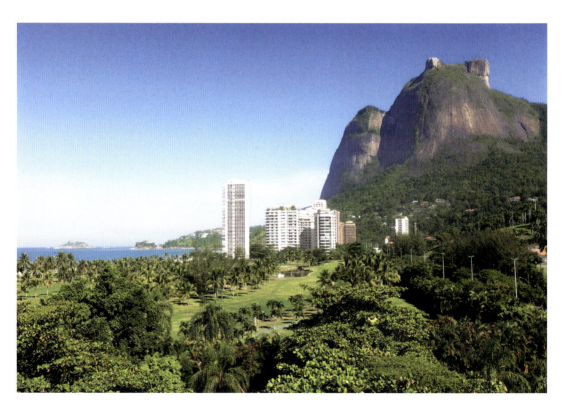

www.gaveagolfclub.com.br (21) 3323-6050

The Americas · Brazil

05 TERRAVISTA GOLF COURSE

Estrada Municipal de Trancoso, Km 18,
45810-000 Porto Seguro, Bahia, Brazil

TO VISIT BEFORE YOU DIE BECAUSE

Golfers play through the rain forest before emerging atop oceanfront cliffs.

One of Brazil's flagship golf courses, Terravista in jet-set chic Trancoso, allows golfers to enjoy two of the country's most scenic landscapes: The rain forest and the beach. The course was designed by American architect Dan Blankenship, with the first nine holes meandering through the dense forest, while the second half of the course moves toward the coast. Four holes abut 150-foot-tall cliffs overlooking the Atlantic; the particularly picturesque hole 14 is the standout as it's set on a section of the cliffs that juts out over the beaches below.

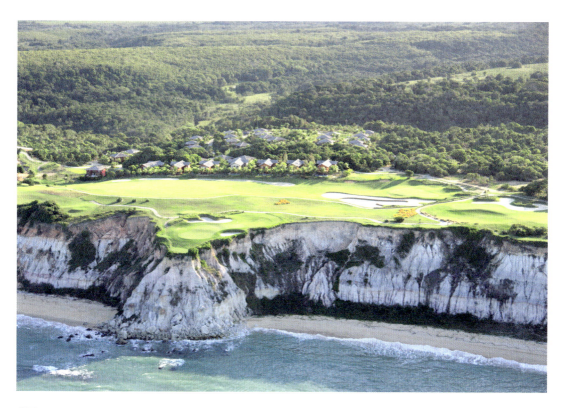

www.terravistagolf.com.br +55 73 3018 4072

The Americas — Canada

06 THE FAIRMONT BANFF SPRINGS GOLF COURSE: STANLEY THOMPSON

Golf Course Road, Banff, Alberta, T0L 0C0, Canada

TO VISIT BEFORE YOU DIE BECAUSE

The imposing Mount Rundle and Sulphur Mountain lend a sense of gravitas to this dramatic course.

The Fairmont Banff Springs is an iconic hotel in itself, but for golfers the property's adjacent Banff Springs Golf Course is the cherry on the top. Canadian designer Stanley Thompson designed an 18-hole course that follows the Bow River beneath Mount Rundle and Sulphur Mountain. At every hole, there's a postcard-perfect backdrop that could easily distract you from your swing. So, take your time and absorb the view before you tee off! There's also a nine-hole course here by Cornish and Robinson if you're short on time, or you can play on it too before or after the Stanley Thompson course to extend your day.

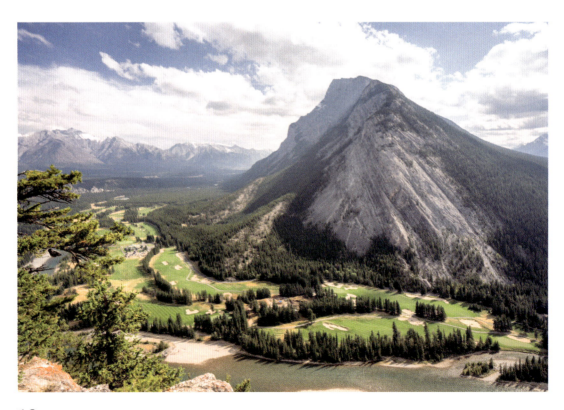

www.banffmountaingolf.com +1 403 762 6801

The Americas Canada

07 FURRY CREEK GOLF & COUNTRY CLUB

150 Country Club Road, Furry Creek, British Columbia V8B 1A3, Canada

TO VISIT BEFORE YOU DIE BECAUSE

This course is set in the quintessential British Columbian landscape—there are mountains, forests, and a sound.

Furry Creek might have a funny name (from the aptly named trapper Oliver Furry), but there's nothing funny about this golf course. Designed by Robert Muir Graves—it's the acclaimed American architect's only course in Canada—Furry Creek has one of the most dramatically beautiful settings of all courses in Canada. Furry Creek, known as "British Columbia's most scenic golf course," twists through the forested shoreline of Howe Sound Bay beneath snowcapped mountains in this stunning location. Hole 14, known as "tee to sea" is the signature green, descending right to the waterfront.

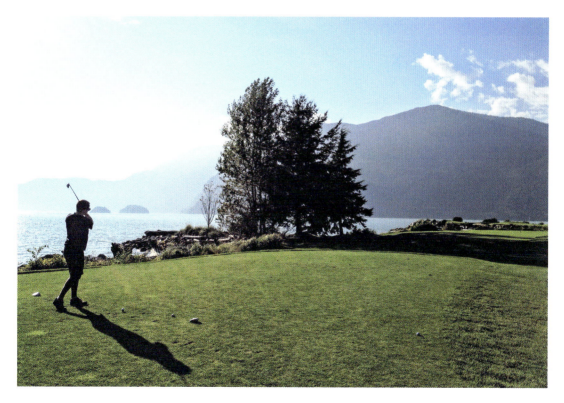

www.furrycreekgolf.com +1 604-896-2224

The Americas Canada

08 KANANASKIS COUNTRY GOLF COURSE: MOUNT KIDD

#1 Lorette Drive, Kananaskis, Alberta, T0L 2H0, Canada

TO VISIT BEFORE YOU DIE BECAUSE

The backdrop of the Canadian Rockies is truly special.

Albertans are lucky to have Kananaskis Country Golf Course as their home playing field. But tragedy struck in 2013, when floods wiped out much of the area, including Mount Kidd and its sister course, Mount Lorette. But the club brought in Gary Browning to restore the two courses, originally designed by Robert Trent Jones Sr. in 1983. Today, the courses continue to be the local golf community's hub. Mount Kidd Course is the superior course in terms of difficulty, though many golfers find it suitable for all levels.

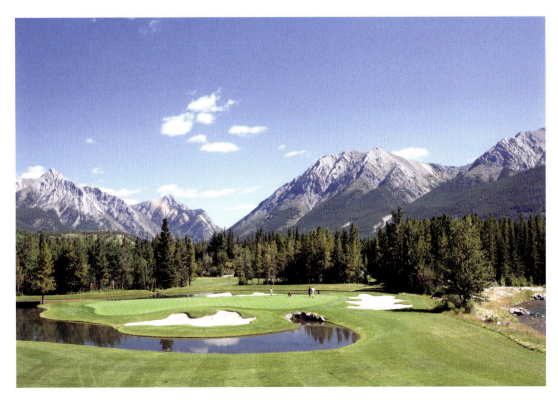

www.kananaskisgolf.com (403) 591-7070

The Americas — Dominican Republic

09 PUNTA ESPADA GOLF CLUB

Cap Cana, Punta Cana 23000, Dominican Republic

TO VISIT BEFORE YOU DIE BECAUSE

Many golfers regard this as one of the best Jack Nicklaus courses in the world.

The Dominican Republic's Punta Cana is already one of the most popular tourist destinations in the Caribbean, but it's the exclusive Cap Cana resort there that's turning golfers' heads. The Jack Nicklaus–designed Punta Espada was the first course to be built on the property, and among the prolific designer's many courses, it's considered one of his best. Of particular note are the coastal greens right up against the bright blue Caribbean Sea, though the inland holes (which still have ocean views) also have eye-catching features, from lakes to bluffs and lush landscaping. The signature hole is the 13th, which requires a shot over the ocean to a cliffside green.

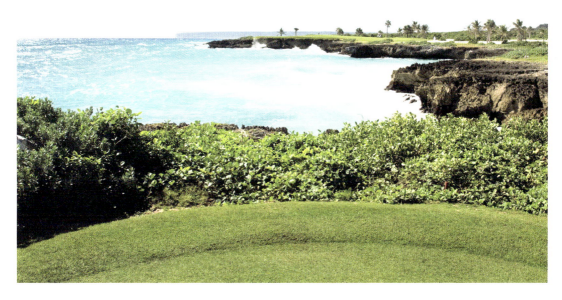

www.puntaespadagolf.com +1 809-469-7767

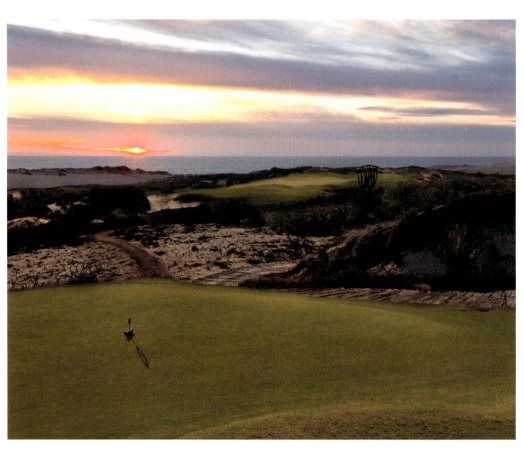
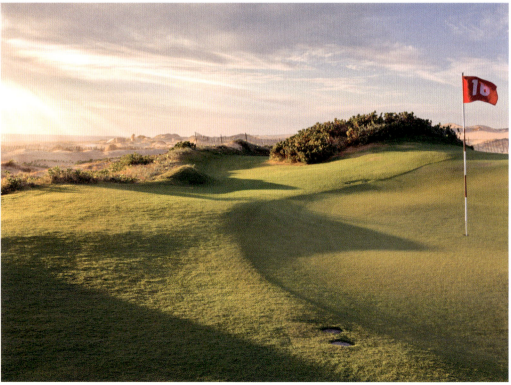

The Americas — Mexico

10 DIAMANTE CABO SAN LUCAS: DUNES

Diamante Boulevard, Cabo San Lucas,
Baja California Sur 23450, Mexico

TO VISIT BEFORE YOU DIE BECAUSE

The eponymous dunes create an otherworldly golf landscape.

The contrasts are stark at Diamante Cabo San Lucas' Dunes Course, one of the most highly ranked in Latin America. There's the bright green of the grass, the deep azure of the sea, the pale blue of the sky, and the stark beige of the sand dunes, which all together make for one beautiful golf course. "When you walk out here, you just all of a sudden think you're in Ireland or Scotland in true links land," the course's designer, Davis Love III, said in a video interview about the project. "The dramatic dunes and the windswept links of Ireland and Scotland are really the only things you can compare this piece of property to."

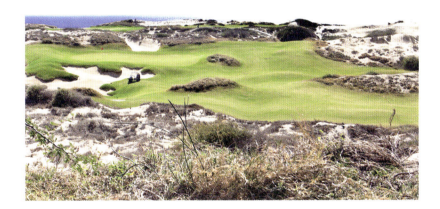

www.diamantecabosanlucas.com/golf/dunes-course

+52 (624) 144-2900

The Americas — Mexico

11 QUIVIRA GOLF CLUB

Prédio Paraíso Escondido S/N,
23450 Cabo San Lucas, B.C.S., Mexico

TO VISIT BEFORE YOU DIE BECAUSE

You work your way up and down the scenic desert cliffs at this beachside course.

For his sixth course in Los Cabos, Mexico, Jack Nicklaus went big on the views. According to some golfers, Quivira Golf Club, named for the mythical city of gold sought by Spanish conquistador Francisco Vásquez de Coronado, rivals California's acclaimed Pebble Beach in its scenic beauty. The course starts at a beachfront clubhouse before ascending the desert cliffs, running along their tops in what seems to be a gravity-defying manner (at least from the air), then descending back down to the beach. The resulting views are awe-inspiring, no matter how you think this course compares to Pebble Beach. Keep an eye out for whales as you play.

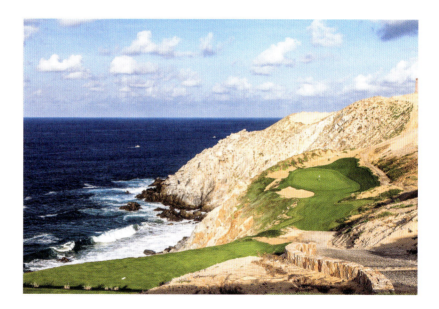

www.quiviraloscabos.com/golf 1-800-990-8250

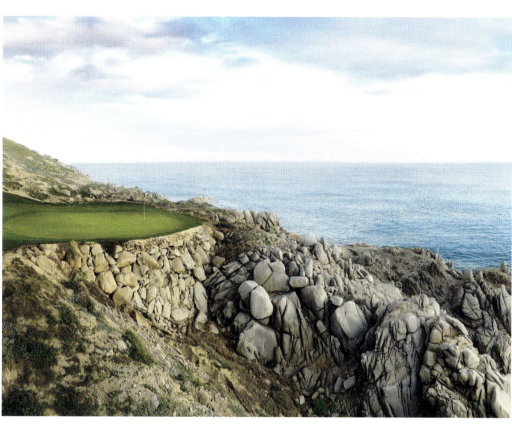
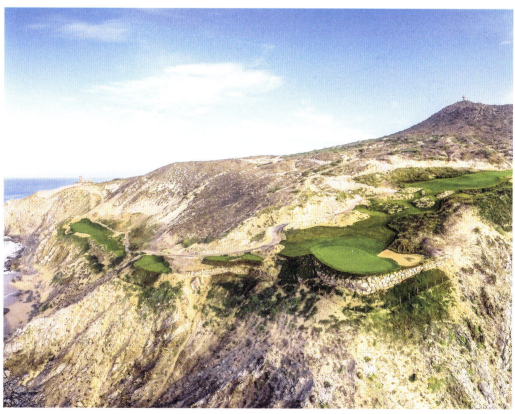

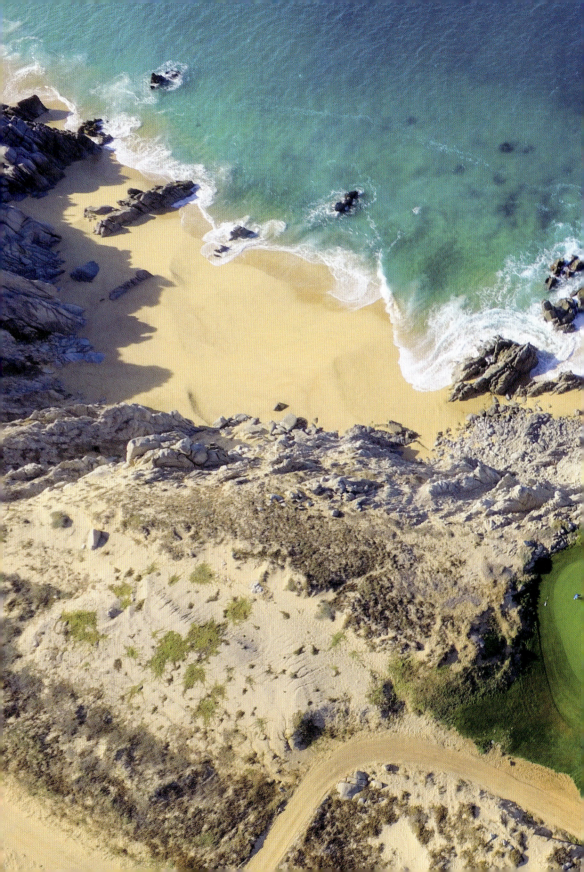

The Americas — Peru

12 LIMA GOLF CLUB

770 Avenida Camino Real, San Isidro 15073, Peru

TO VISIT BEFORE YOU DIE BECAUSE

It is a haven of tranquility and beauty in the heart of bustling Lima.

Lima is one of the most exclusive golf destinations, with many of its courses restricted to members only. However, there are a few loopholes for visitors. For instance, the historic Lima Golf Club, founded in 1924, is open to guests staying at the Country Club Lima Hotel, a heritage-protected establishment. The course is located bang in the middle of the residential San Isidro neighborhood—it grew around the course—and it's one of the largest green spaces in the city today. Because of its exclusivity, it's rarely crowded, which is a delight for those who play it.

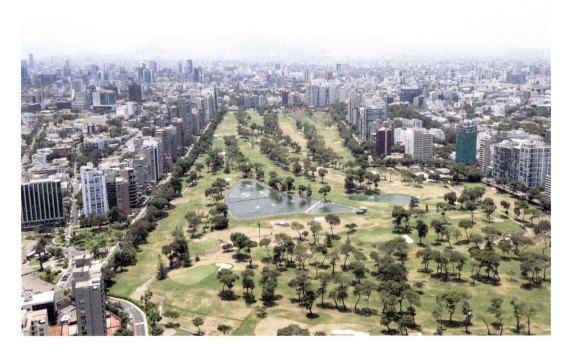

www.limagolfclub.org.pe +511 277 7090

The Americas — United States of America

13 ARROWHEAD GOLF COURSE

10850 Sundown Trail, Littleton, Colorado 80125, USA

TO VISIT BEFORE YOU DIE BECAUSE

The towering red sandstone rock formations provide a stunning atmosphere.

Geology is the name of the game at Arrowhead Golf Course in Colorado. The course, designed by Robert Trent Jones Jr., runs parallel to some of the most sublime rock formations in the United States. Sheets of red rocks called flatirons jut out of the Earth at a severe angle, contrasting the rolling fairways and greens—it's hard to fathom the strength of Mother Nature's cataclysmic forces that led to this landscape. If you wanted to put down your club and just marvel in the beauty here, no one would blame you.

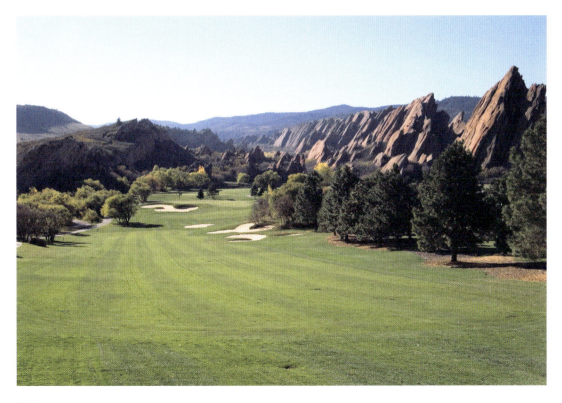

www.arrowheadcolorado.com — 303-973-9614

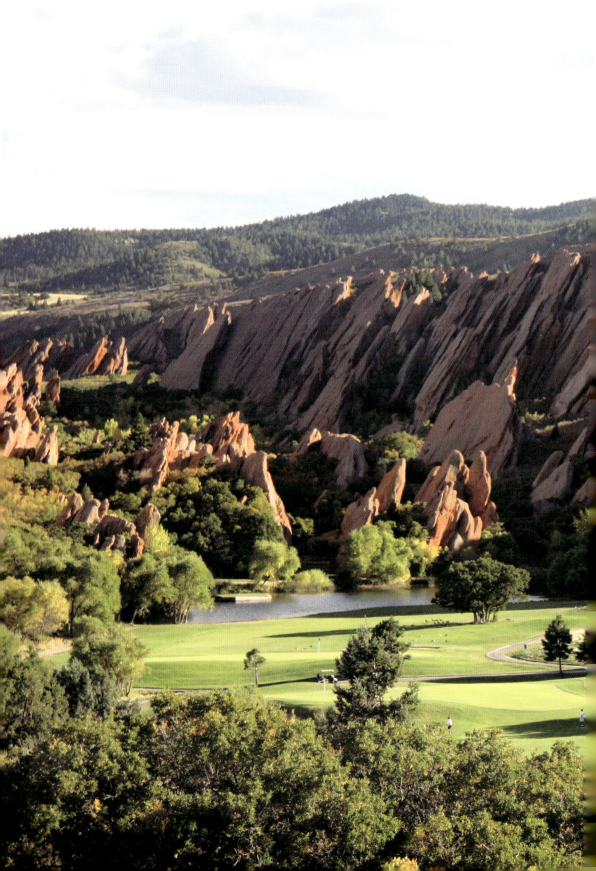

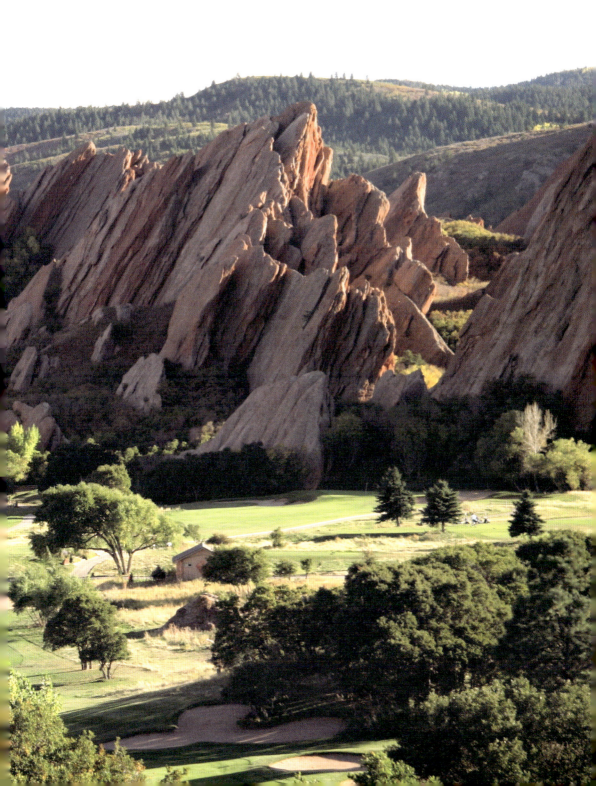

The Americas — United States of America

14 BANDON DUNES GOLF RESORT: OLD MACDONALD

57744 Round Lake Road, Bandon, Oregon 97411, USA

TO VISIT BEFORE YOU DIE BECAUSE

Designers Tom Doak and Jim Urbina channel the spirit of Charles Blair Macdonald at this course.

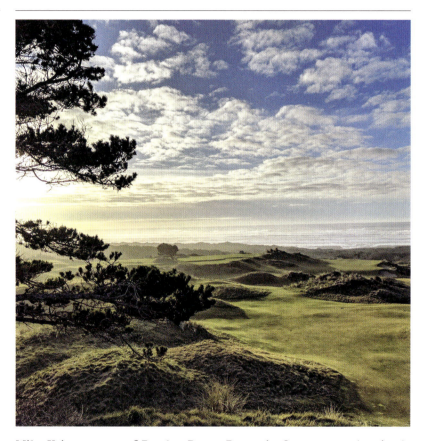

Mike Keiser, owner of Bandon Dunes Resort in Oregon, posed a simple question (perhaps figuratively, if not literally): "What if Charles Blair Macdonald built a course here?" Given that the great golf architect died in 1939, we will never actually know. But Tom Doak and Jim Urbina gave it their best guess, designing the Old Macdonald Course, the fourth at the resort, in Macdonald's iconic style. They ended up pulling together a true links course, with many holes here drawing inspiration from some of the most famous holes in the history of golf—the template hole method created by Macdonald himself.

www.bandondunesgolf.com/golf/golf-courses/old-macdonald

855-220-6710

The Americas — United States of America

15 BLACK JACK'S CROSSING

21701 FM 170 Lajitas, Texas 79852, USA

TO VISIT BEFORE YOU DIE BECAUSE

At this extremely remote course you're transported back to the days of the Wild West.

Unless you have a private jet, it's going to take some time to get to the farthest-flung golf course in Texas. Black Jack's Crossing at the Lajitas Golf Resort is located at the Mexican border in southwest Texas, a five-hour drive from El Paso and a seven-hour drive from San Antonio. But the payoff is worth the journey. Not only are you golfing amid the dramatic, Mars-like landscape of the Chihuahuan Desert, you're right next to Big Bend National Park. The resort itself is built around the former Lajitas Trading Post, a 19th-century structure that now houses the Pro Shop and the Yates Longhorn Museum. You can see bullet holes in its walls from the Wild West days—yeehaw indeed.

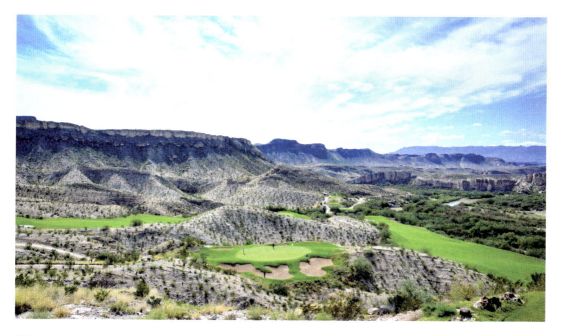

www.lajitasgolfresort.com (877) 525-4827

The Americas — United States of America

16 THE BROADMOOR GOLF CLUB: EAST

1 Lake Avenue, Colorado Springs, Colorado 80906, USA

TO VISIT BEFORE YOU DIE BECAUSE

The East Course features holes by both Donald Ross and Robert Trent Jones Sr.

In 1918, Donald Ross designed the first 18 holes at The Broadmoor in Colorado Springs. Some four to five decades later, Robert Trent Jones Sr. reconfigured Ross's original 18 holes to create two new 18-hole courses. As they currently stand, both the East and West Courses each have holes by both designers in a bit of a mashup. (There was also once a Mountain Course, but it was lost to a landslide.) Over its nearly century-long lifespan, the East Course has hosted a number of tournaments: Jack Nicklaus won his first of two U.S. Amateurs here in 1959.

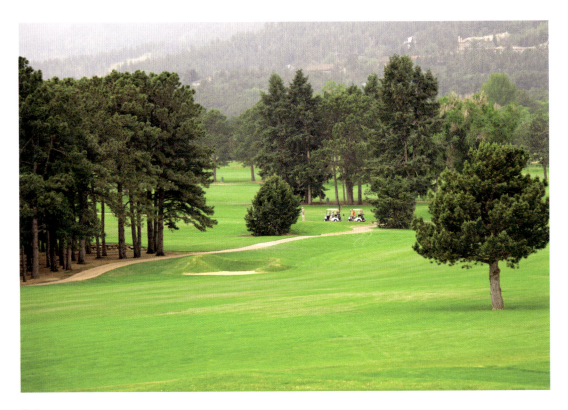

The Americas — United States of America

17 COEUR D'ALENE RESORT

115 South 2nd Street, Coeur d'Alene, Idaho 83814, USA

TO VISIT BEFORE YOU DIE BECAUSE

It's home to the world's only floating green.

To get to this lakefront golf course, players are ferried from the Coeur d'Alene Resort in luxurious shuttle boats. However, that's not the only time they'll need to get on the water: The course is famous for its 14th hole, which has the world's only floating green, located on its own little island, reachable only by an electric "Putter" boat. The resort's founder dreamed up the idea while walking his dog along the lake, and course designer Scott Miller realized that dream for him. But the island isn't just a fun little gimmick—it's actually a high-tech marvel, with an underwater cable system altering the distance from the tee to the green every single day. After you complete the hole, the Putter's captain rewards you with a certificate honoring your accomplishment.

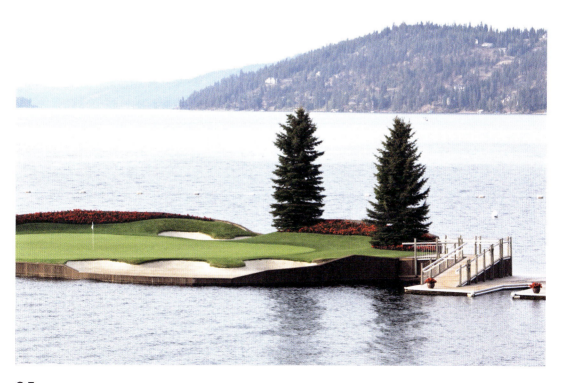

www.cdaresort.com — 1-855-703-4648

The Americas — United States of America

18 FAIRMONT GRAND DEL MAR: GRAND GOLF CLUB

5200 Grand Del Mar Way, San Diego, California 92130, USA

TO VISIT BEFORE YOU DIE BECAUSE

This is a fabulous inland resort course in California that's a delight to play.

While coastal courses like Pebble Beach are at the top of most golfers' bucket lists, when it comes to playing in California, the inland courses provide an entirely different experience. The Grand Golf Club at the Fairmont Grand Del Mar is set in the verdant hills of Los Peñasquitos Canyon, some 20 miles outside of San Diego. Blink, and for a second you might believe you're in Tuscany (thanks in part to the Mediterranean-style clubhouse). The Tom Lazio–designed course has the 18th hole as its signature, where a tumbling waterfall cascades behind the elevated green.

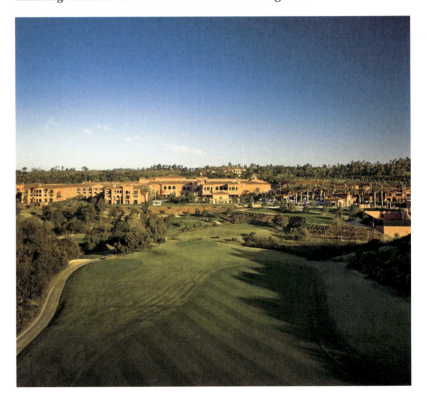

www.fairmont.com/san-diego/golf/the-grand-golf-club/

+1 858 314 1930

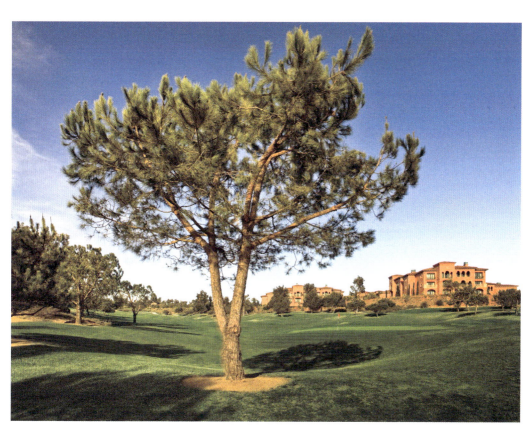
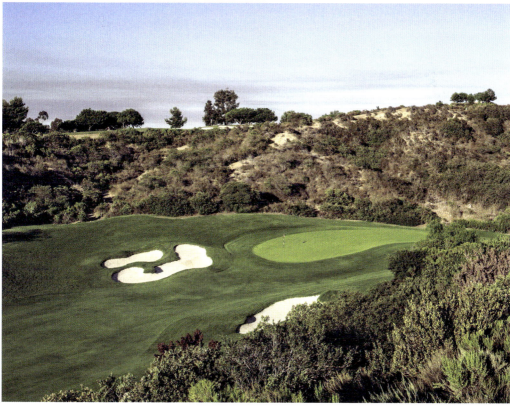

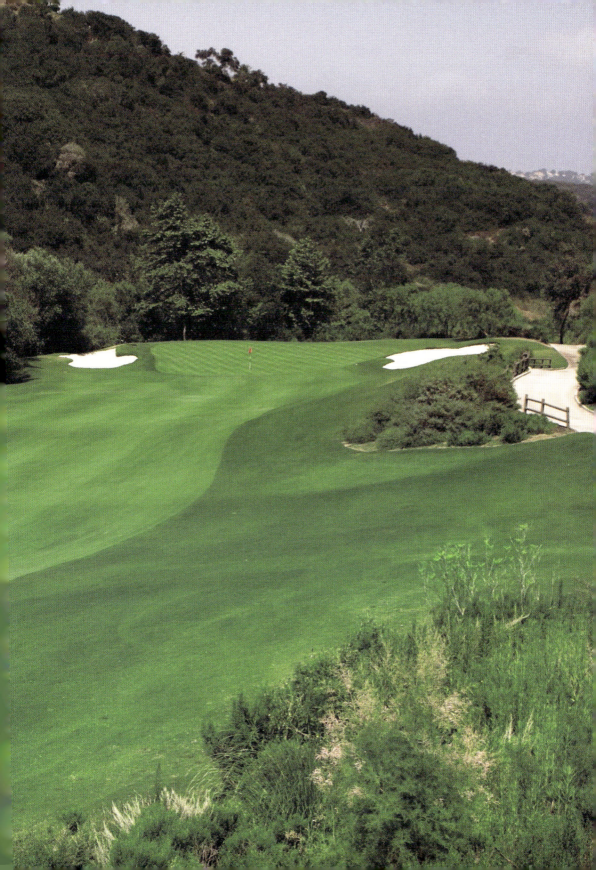

The Americas United States of America

19 FOUR SEASONS RESORT LANAI: MANELE

1 Manele Bay Road, Lanai City, Hawaii 96763, USA

TO VISIT BEFORE YOU DIE BECAUSE

The golf course winds its way along volcanic outcrops in a distinctly Hawaiian setting.

There's no shortage of beautiful golf courses in Hawaii, but the Manele Course at the Four Seasons Resort Lanai is by far one of the most scenic. The greens jut out onto black rocky outcrops—former lava flows—abutting the ocean, in a visually striking juxtaposition. As a well-balanced resort course, Manele isn't so challenging that golfers will feel frustrated during their round, but Jack Nicklaus ensured that the course is still championship-grade. Fun fact: Although they are now divorced, Bill Gates and Melinda French Gates said their marriage vows in front of the 12th hole's dramatic ocean-cove view. (The 12th is one of three ocean-cove holes on the course.)

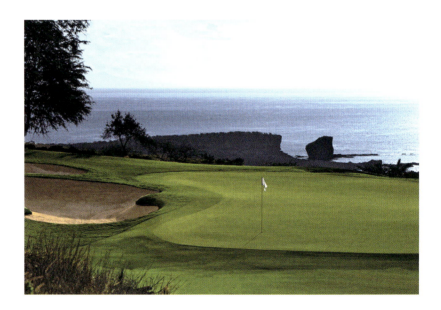

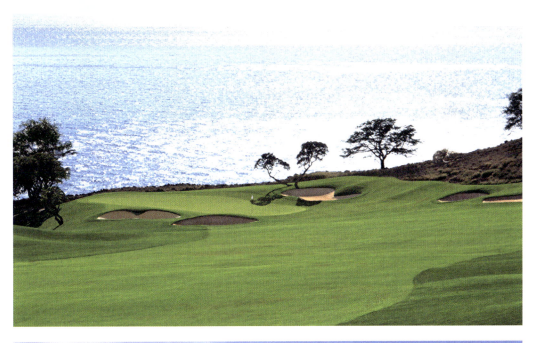
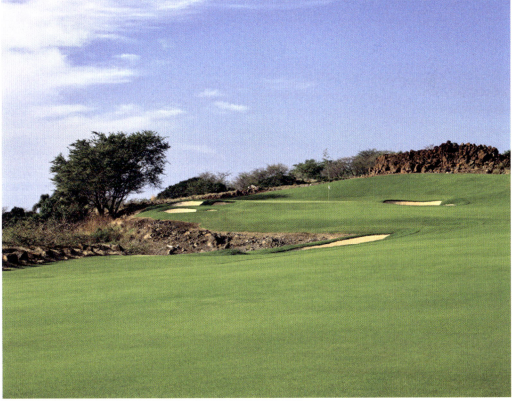

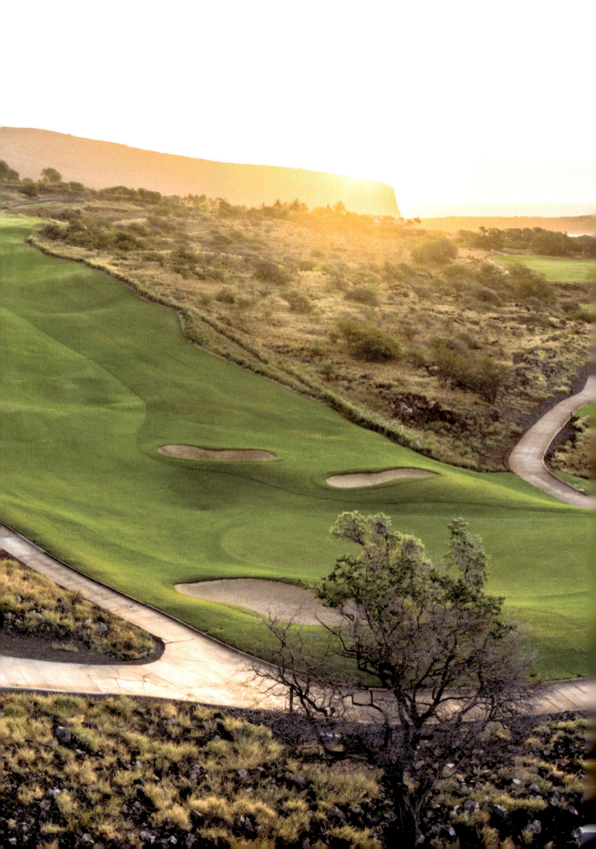

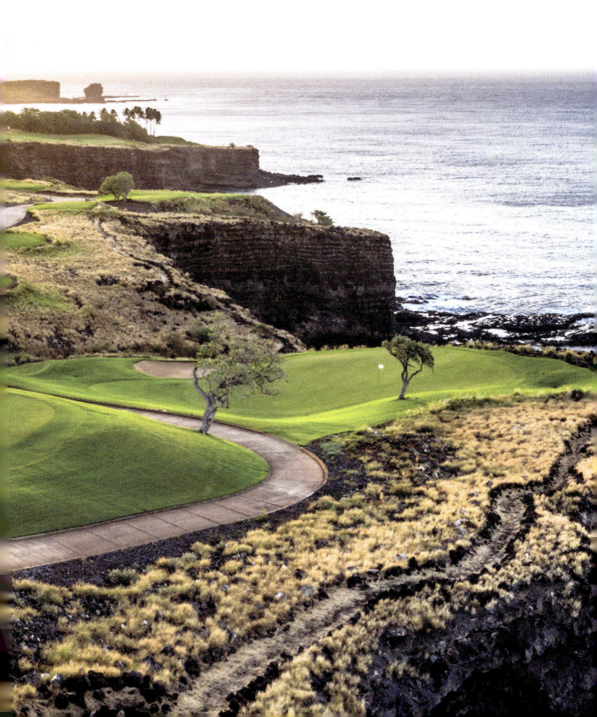

The Americas — United States of America

20 FOUR SEASONS RESORT HUALALAI

72-100 Ka'upulehu Drive, Kailua-Kona, Hawaii 96740, USA

TO VISIT BEFORE YOU DIE BECAUSE

This is a quintessential Hawaiian course with lush greenery, rocky lava fields, and sea views.

In terms of the scenery, the pacing is just right at the Four Seasons Hualalai Course, designed by Jack Nicklaus (it's a Signature Course). You begin in the green hills with looming mountains above you, then emerge into the black lava fields emblematic of the Big Island. Finally, you approach the sea—the 17th hole is the signature, played out toward the ocean with white-sand bunkers and craggy lava rocks throughout. In the winter, it's not uncommon to see whales swimming by as you play. The fact that the Champions Tour is hosted by the course each year is a testament to the great golf you'll play here.

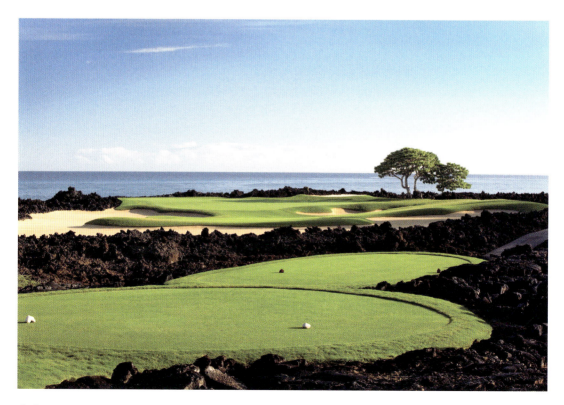

www.fourseasons.com/hualalai/golf/ (808) 325-8000

The Americas — United States of America

21 FURNACE CREEK GOLF COURSE AT DEATH VALLEY

Death Valley National Park,
Highway 190, Death Valley, California 92328, USA

TO VISIT BEFORE YOU DIE BECAUSE

Where else can you play 214 feet below sea level?

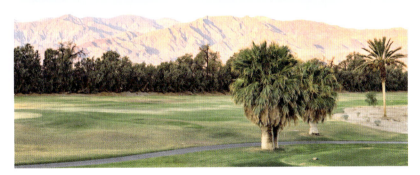

When golfers need to take elevation into consideration, it's usually because they're much higher than sea level. That's not the case at Furnace Creek, the world's lowest-elevation golf course at 214 feet below sea level. So, while the short, flat course might not be too difficult in itself, players need to deal with the extra barometric pressure, which translates to some wonky golf physics. On top of that, Death Valley has recorded the highest temperature in the world: 134°F. Needless to say, conditions are tough here, so golfers can certainly brag about making it through a full round.

www.oasisatdeathvalley.com/furnace-creek-golf-course/

760-786-2345

22 GOLD MOUNTAIN: OLYMPIC

7263 West Belfair Valley Road, Bremerton, Washington 98312, USA

TO VISIT BEFORE YOU DIE BECAUSE

The serene, almost spooky atmosphere is peak Pacific Northwest.

Driving up to Gold Mountain, you might feel like you are entering an episode of *The X-Files*; you drive up the mountain into a dark coniferous forest with looming pines all around. But there are no aliens or monsters here—just great golf. The Olympic Course, designed by John Harbottle, is the more challenging of the two at Gold Mountain, and it does an excellent job showing off the Pacific Northwest landscape all the while providing a thoroughly enjoyable game of golf. Gold Mountain's biggest claim to fame was the 2011 U.S. Junior Amateur, when Jordan Spieth became the second golfer to ever win the tournament more than once. (The first was none other than Tiger Woods.)

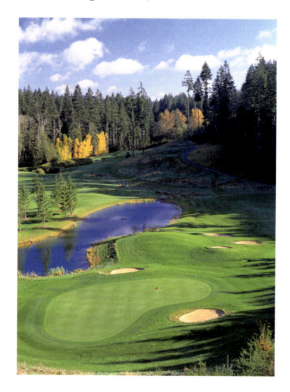

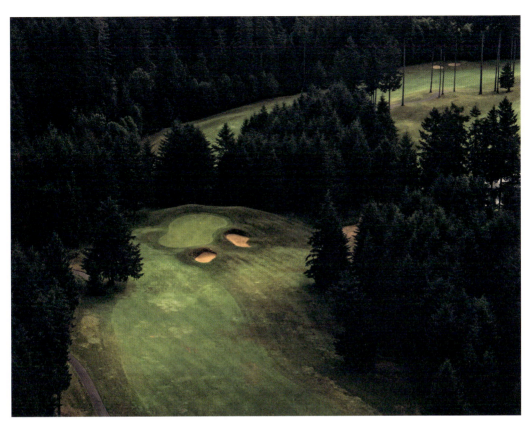
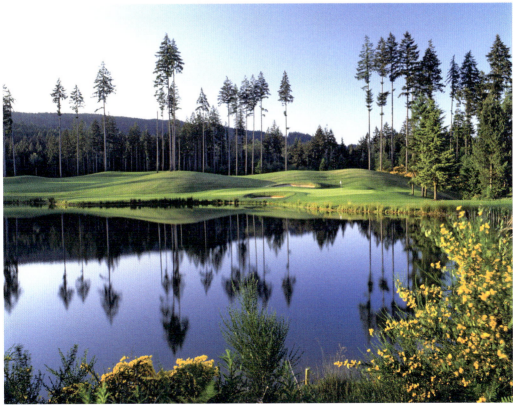

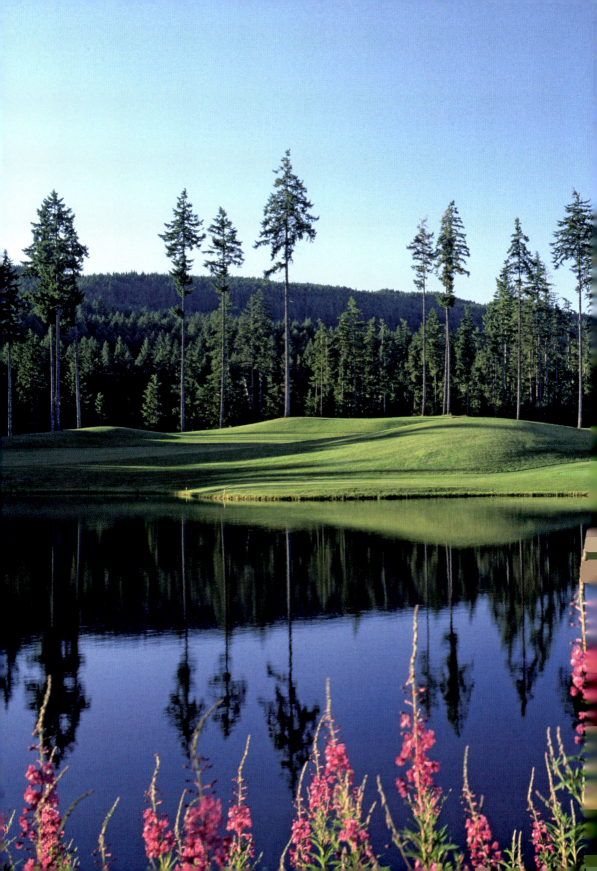

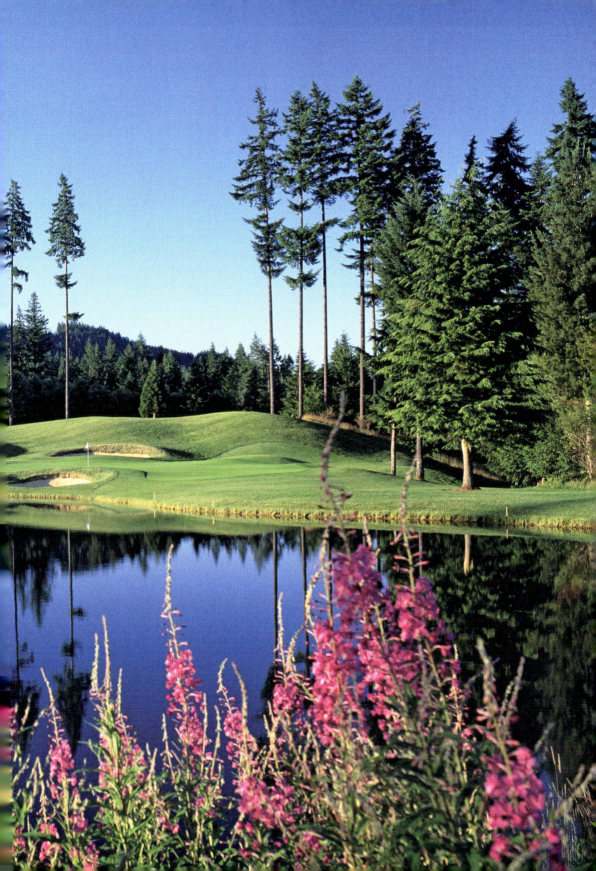

23 INDIAN WELLS GOLF RESORT: PLAYERS

44-500 Indian Wells Lane, Indian Wells, California 92210, USA

TO VISIT BEFORE YOU DIE BECAUSE

This is one of the best municipal courses in the country.

Among the Coachella Valley's 120-plus golf courses, few are open to the public. Indian Wells Golf Resort is one of them, and it's probably unlike the municipal courses you might be used to. Its two courses, renovated in 2007, are championship-caliber, though they don't often get the praise they deserve from the annual "best courses" lists. The John Fought–designed Players Course is highly regarded among golfers for the variety across its holes, including a number that demand high risk for high reward. It's a fun play and a fairly affordable one at that, given that it's city-owned.

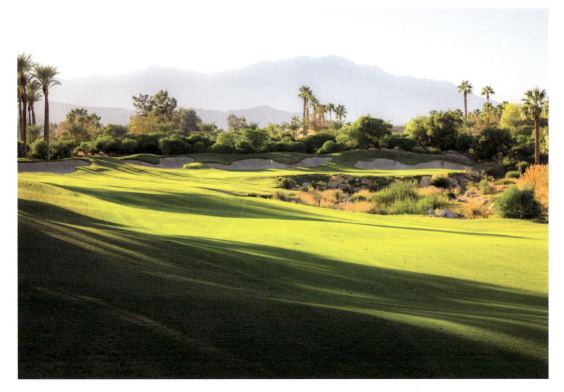

www.indianwellsgolfresort.com 760-346-4653

The Americas United States of America

24 KAPALUA PLANTATION COURSE

2000 Plantation Club Drive, Lahaina, Hawaii 96761, USA

TO VISIT BEFORE YOU DIE BECAUSE

This is the home of the Sentry Tournament of Champions, and it's one of the best courses in golf paradise Hawaii.

With so many golf courses in Hawaii, it's hard to be consistently ranked in the top three on virtually every list. Kapalua's Plantation Course does the trick, and it's not hard to see why. Designers Ben Crenshaw and Bill Moore integrated the course into the West Maui Mountains, and although water doesn't come into play on the course itself, you can see the sparkling blue sea throughout your round. One of the most memorable holes is number 18, a 663-yard downhill par five that's one of the longest on the PGA tour. The Plantation Course underwent a multimillion-dollar renovation in 2019, meaning it's bigger, better, and eco-friendlier than ever.

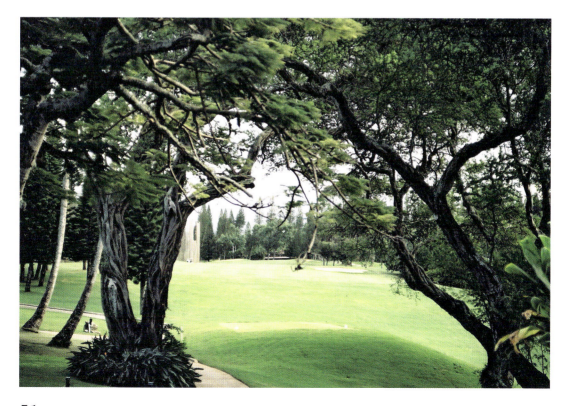

www.golfatkapalua.com/plantation-course 808-669-8044

The Americas — United States of America

25 KIAWAH ISLAND: OCEAN COURSE

1 Sanctuary Beach Drive, Kiawah Island,
South Carolina 29455, USA

TO VISIT BEFORE YOU DIE BECAUSE

The 1991 "War on the Shore" was fought at this difficult course, resulting in the American Ryder Cup victory.

When Kiawah Island's Ocean Course was constructed in 1991, it was one of the first golf courses to be purpose-built for an event; in this case, the Ryder Cup. That inaugural competition was quite the show. The drama captivated audiences across the United States and Europe—the Americans took the crown away from the Europeans in their first Ryder Cup win since 1983—and it created a massive demand to play Ocean Course in subsequent years. Designed by Pete and Alice Dye, the links-style course weaves through the dunes of Kiawah Island, providing beautiful ocean views, but also a challenge due to winds sweeping in from the sea. In fact, this is considered one of the most difficult courses in America.

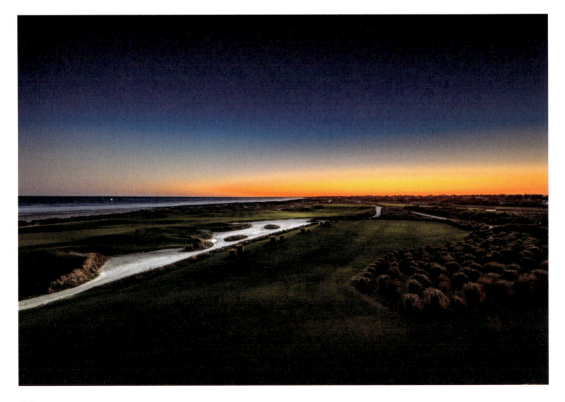

www.kiawahresort.com/golf/the-ocean-course 1-800-654-2924

The Americas United States of America

26 LOS ALAMOS COUNTY GOLF COURSE

4290 Diamond Drive, Los Alamos, New Mexico 87544, USA

TO VISIT BEFORE YOU DIE BECAUSE

This one's for the science history buffs.

In the 1940s, the town of Los Alamos in New Mexico was one of the most secretive places in the United States. The remote site was the home of the Manhattan Project's Project Y, the nuclear research laboratory that would ultimately develop the atomic bomb. Though the public knew little about Los Alamos, there were thousands of residents there—scientists, military personnel, support staff, and their families—and recreational activities abounded. The Atomic Energy Commission built an 18-hole golf course in Los Alamos in 1947, and as the secrecy around the town was lifted in the years following World War II, it opened to the public as a municipal course, which it remains to this day. Given the course's 7,400-foot elevation, the thin air challenges players.

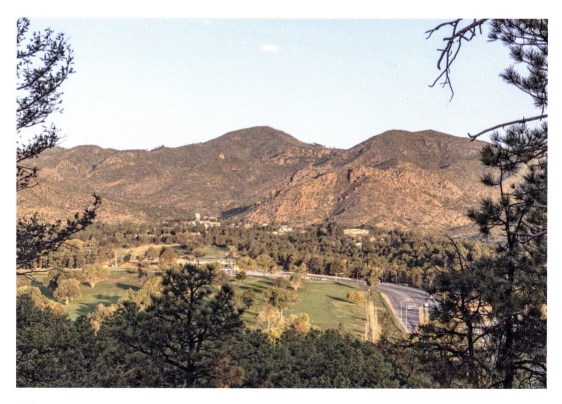

www.losalamosnm.us 505-662-8139

27 MAUNA KEA GOLF COURSE

62-100 Mauna Kea Beach Drive,
Kohala Coast, Hawaii 96743, USA

TO VISIT BEFORE YOU DIE BECAUSE

This was the first golf course to be built on the Big Island.

Before 1964, there were no golf courses on Hawaii's volcanically active Big Island. But developer Laurance S. Rockefeller, who built the island's first resort—the Mauna Kea Beach Hotel—asked architect Robert Trent Jones Sr. to change that. RTJ would go on to build his championship-caliber course atop a rough, black lava field, pioneering a new type of soil for the course made from crushed igneous rock, limestone, and coral. The first round was played by Arnold Palmer, Jack Nicklaus, and Gary Player in a televised special, with the signature third hole stunning not only the spectators, but also the golfers; from the back tee, they had to clear some 230 yards over the ocean and the lava rocks to reach the green. Only Palmer made it.

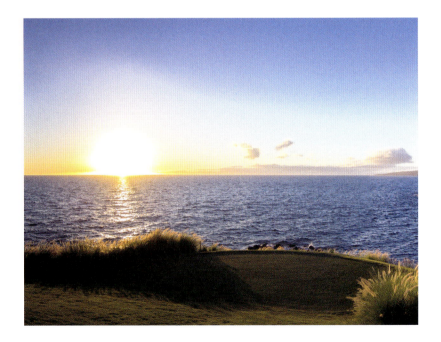

www.maunakearesort.com/golf/mauna-kea-golf-course

+1 808 882 5400

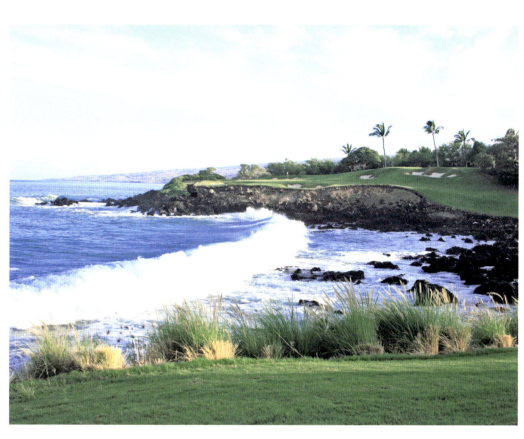
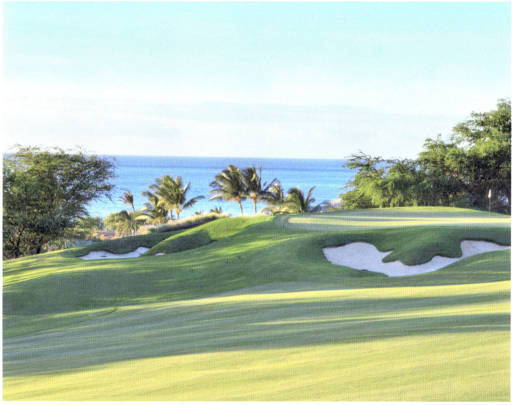

28 PGA WEST: STADIUM

56-150 Pga Boulevard, La Quinta, California 92253, USA

TO VISIT BEFORE YOU DIE BECAUSE

There's no course in California's Coachella Valley that's more devilish.

There's hardly a hotter spot in California to play golf than the Coachella Valley—there are more than 120 courses here. But none of them are as challenging as the Stadium course at PGA West, the monumental golf complex of the La Quinta Resort & Club. You can thank Pete Dye for that. The designer is known for his tough courses, but Stadium, the name of which comes from Dye's design choice to build seating for spectators into the terrain here, goes that extra mile in terms of difficulty. Nevertheless, many golfers are enthralled by the prospect of taking on such a daunting game—at least until the course shows them who's boss. However, there are some victors. In 1987, Lee Trevino hit a hole-in-one at the par-three 17th, better known as "Alcatraz," as it's on an island green completely surrounded by water.

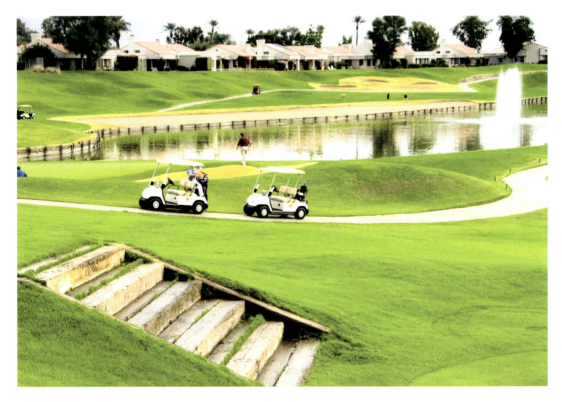

The Americas — United States of America

29 PAYNE'S VALLEY GOLF COURSE

1250 Golf Club Drive, Hollister, Missouri 65672, USA

TO VISIT BEFORE YOU DIE BECAUSE

Named after the late golfer Payne Stewart, this is Tiger Woods' first public golf course.

Like many of the world's best golfers, Tiger Woods turned to designing courses, not just playing on them. His firm, TGR Design, has realized a number of private courses, but Payne's Valley at Big Cedar Lodge in Missouri is its first public course, named in honor of the late Payne Stewart, who was born in the state. It's a fairly approachable course for golfers of all levels, perfect for a leisurely round or two with friends, so it's not for those seeking an extreme challenge. There's a particularly beautiful par-three 19th hole, complete with an island green at the base of the waterfall.

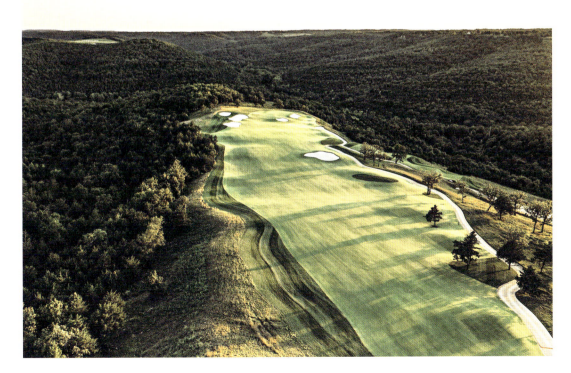

www.bigcedar.com/golf/paynes-valley-course 1-800-225-6343

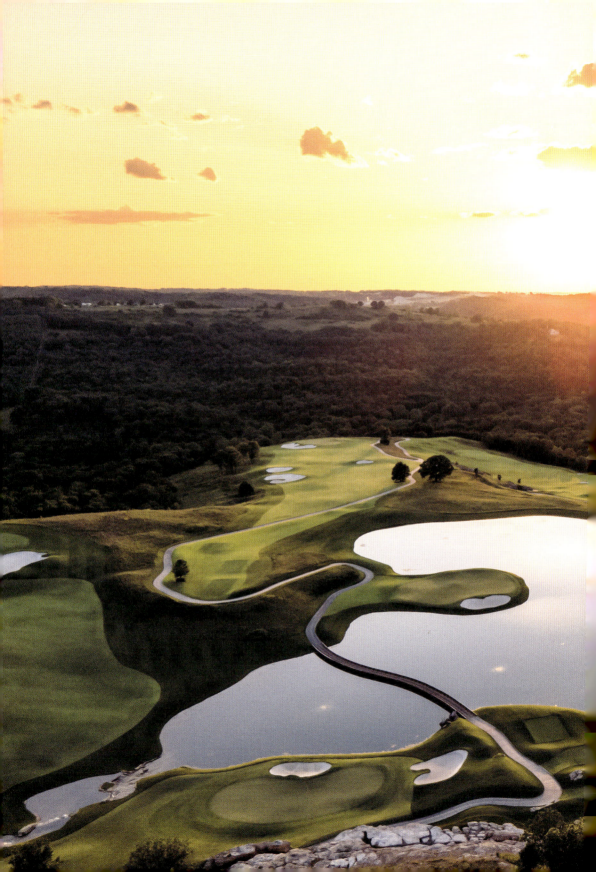

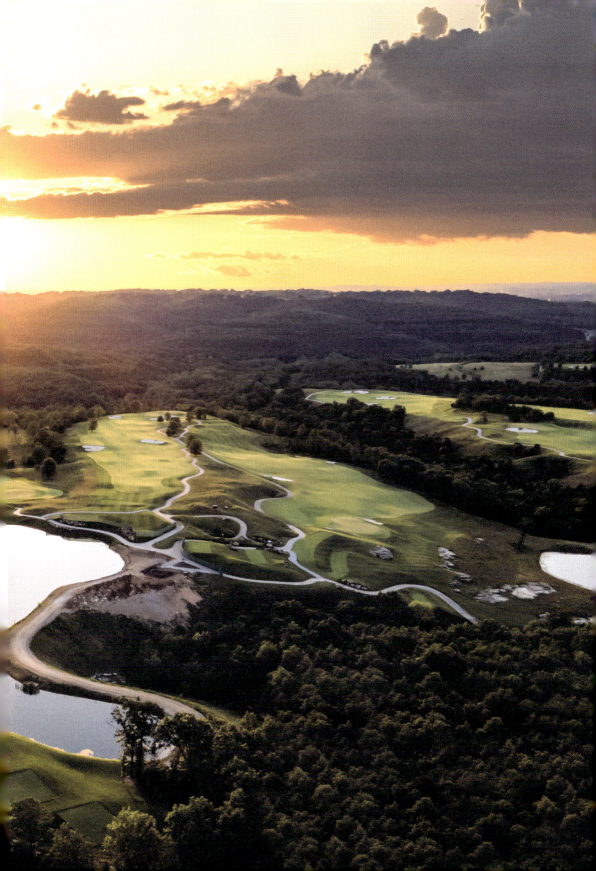

30 OJAI VALLEY INN

905 Country Club Road, Ojai, California 93023, USA

TO VISIT
BEFORE YOU DIE
BECAUSE

This is a controversial course—but golfers should play it before landing on either side of the argument about its design.

The Ojai Valley Inn is a historic hotel that's been a favorite of weekend-trippers from Los Angeles for the better part of a century, not least because of its golf course. Built in 1923, the course was revered by its designer, acclaimed golf architect George C. Thomas Jr., as "far and away above the best" of all his designs. But this is where the controversy begins: Between the Great Depression and World War II, Thomas' course was largely lost, and a series of renovations in the ensuing decades, perhaps most notably one in the late 1980s by Jay Morrish, all but obliterated the remnants of the course. Purists decry the Ojai Valley Inn for marketing the course as a Thomas design, while others put the renovation history aside and appreciate the course for its current layout—arguably a lovely design in any case. So, what side of the argument are you on? You will have to play to decide.

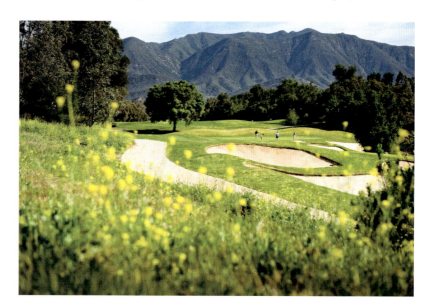

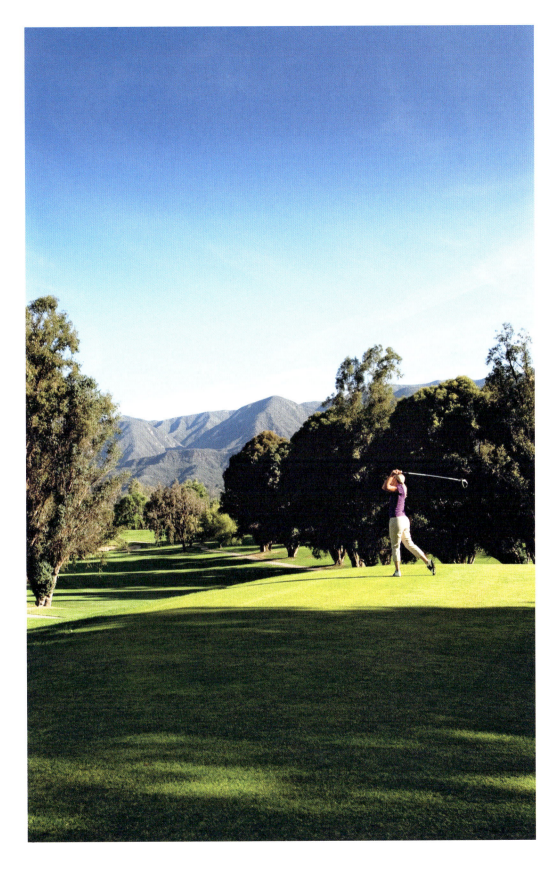

The Americas — United States of America

31 PEBBLE BEACH GOLF LINKS

1700 17-Mile Drive, Pebble Beach, California 93953, USA

TO VISIT BEFORE YOU DIE BECAUSE

Its views are the reason it's widely considered the best public golf course in America.

Pebble Beach is a California seaside resort town at its finest, known not only for its Concours d'Elegance car show, but also for being the best public golf course in the United States. Open to all—or at least all who are willing to pay the high fees—Pebble Beach has one of the best settings in golf history: the headlands extending into Carmel Bay. Technically speaking, it's not the most difficult course out there, featuring a simple out-and-back design by Jack Neville and Douglas Grant laid out in 1919, then updated by Henry Chandler Egan about a decade later. Yet golfers come here for views so majestic that *Golf Digest* hails the course the "greatest meeting of land and sea in American golf."

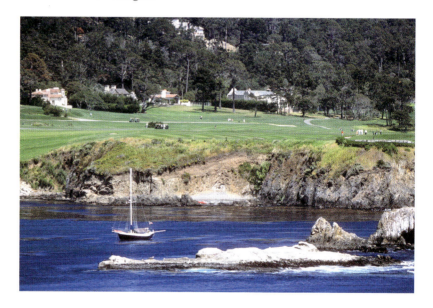

www.pebblebeach.com/golf/pebble-beach-golf-links/

1-800-877-0597

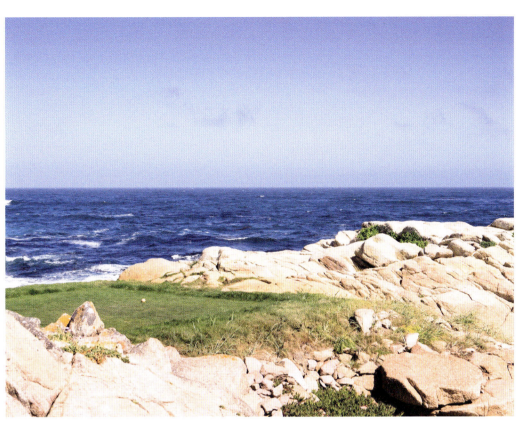
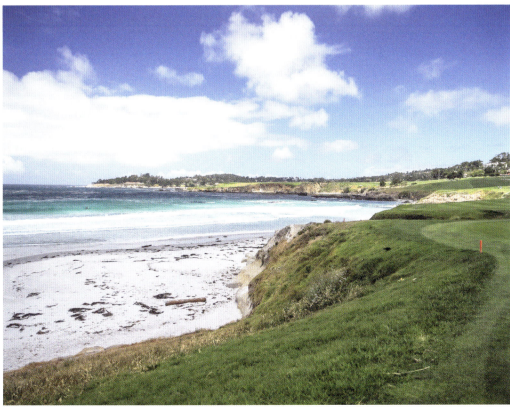

The Americas · United States of America

32 PINEHURST NO. 2

1 Carolina Vista Drive, Pinehurst, North Carolina 28374, USA

TO VISIT BEFORE YOU DIE BECAUSE

Not only is this course a challenge, it's also a big part of American golf history.

In 1999, Payne Stewart hit an incredible 15-foot putt that crowned him the winner of the U.S. Open after a fierce duel with Phil Mickelson. It's one of the most memorable shots in American golf history—and it happened at a historic American golf course. Pinehurst No. 2 in North Carolina was the crowning achievement of golf designer Donald Ross, who traveled to the United States from Scotland in 1899 to build the sport in the country. In 1907, he completed this challenging course, which quickly became one of the most beloved in the States, hosting many major tournaments. It underwent a major renovation by Coore and Crenshaw in 2010, which restored much of its historic charm.

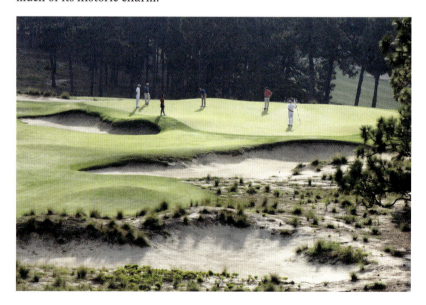

www.pinehurst.com/golf/courses/no-2/ · 1-877-545-2124

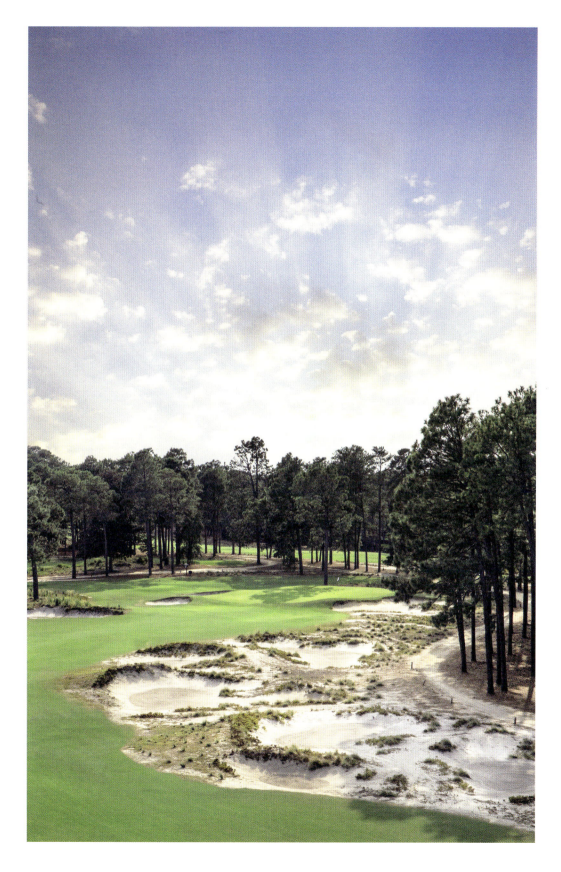

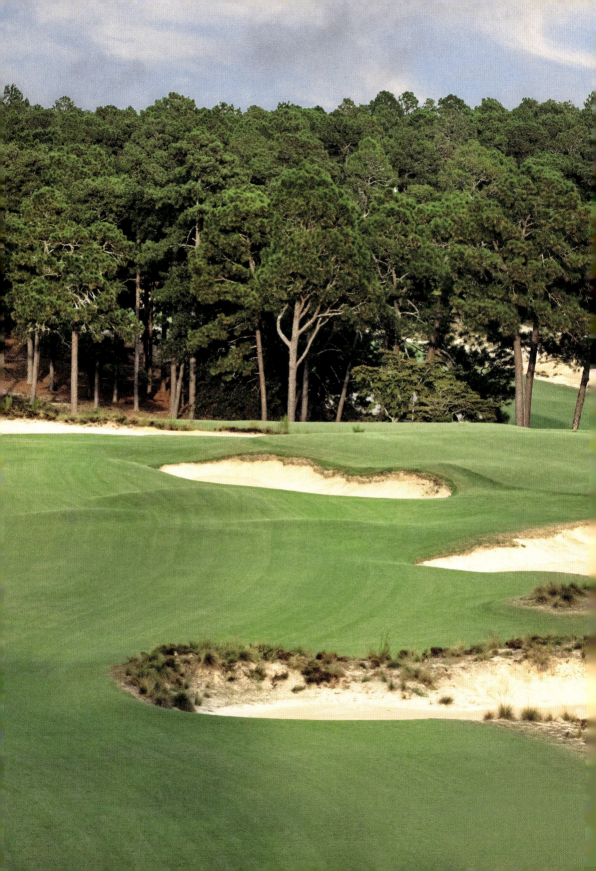

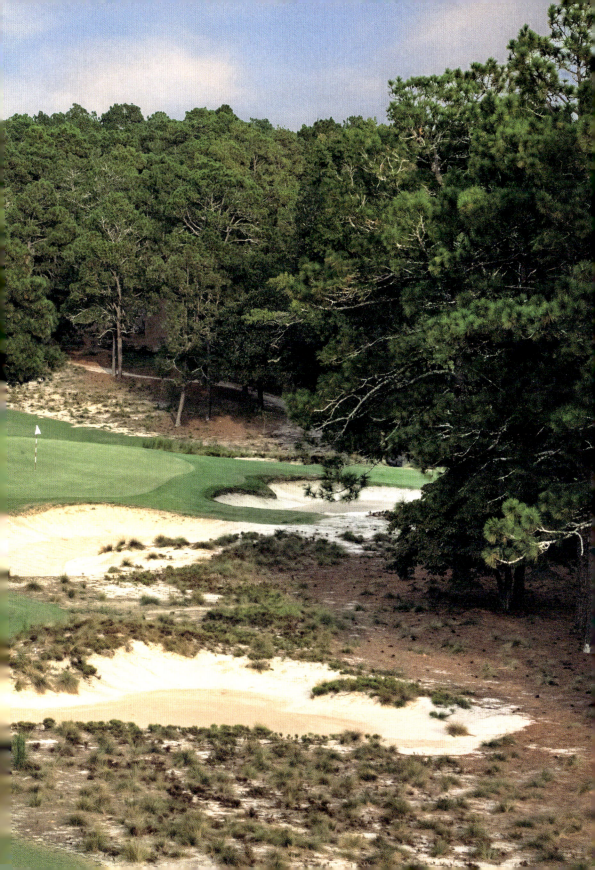

The Americas — United States of America

33 PRIMLAND RESORT: HIGHLAND COURSE

2000 Busted Rock Road, Meadows of Dan,
Virginia 24120, USA

TO VISIT BEFORE YOU DIE BECAUSE

You'll bear witness to the glory of the Blue Ridge Mountains as you play through this exquisitely maintained course.

Laid out by Donald Steel and his then-associates Martin Ebert and Tom MacKenzie, the Highland Course at the Primland Resort in Virginia is a lesson in design variation. The route through the Blue Ridge Mountains runs along dramatic ridges, settles deep into wooded valleys, and expands across plateaus, introducing all manner of challenges to golfers. And despite this difficult terrain, the Highland Course receives near-universal praise for its immaculate condition. The Primland Resort itself also knows something about variation: Its roster of activities ranges from shooting and RTV riding to stargazing at the onsite observatory, while its accommodation ranges from classic lodge-style hotel rooms to private houses. It's no wonder golfers from across the East Coast and the South regularly spend long weekends here.

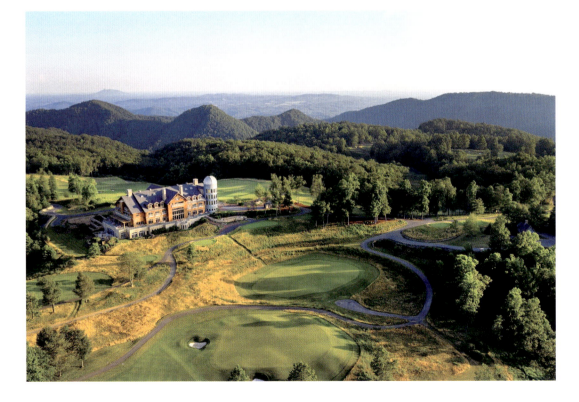

www.aubergeresorts.com/primland/experiences/golf

855-876-6593

The Americas — United States of America

34 SEDONA GOLF RESORT

35 Ridge Trail Dr, Sedona, Arizona 86351, USA

TO VISIT BEFORE YOU DIE BECAUSE

Nothing is more representative of the American Southwest than Sedona's Red Rocks, which form the backdrop to this course.

The 10th hole at Sedona Golf Resort is just one of those holes—you know, the ones you take a mental Polaroid of and hang somewhere in the recesses of your mind. That's because the backdrop is the spectacular Red Rocks (more specifically, Cathedral Rock) that make Sedona so photogenic. If you're more of a golfer than a hiker, this is a far more enjoyable way to see the site than trekking out into the desert. (Or you could always do both… the course is located at the base of Red Rock State Park.) Elsewhere, the Gary Panks–designed course runs through valleys filled with juniper.

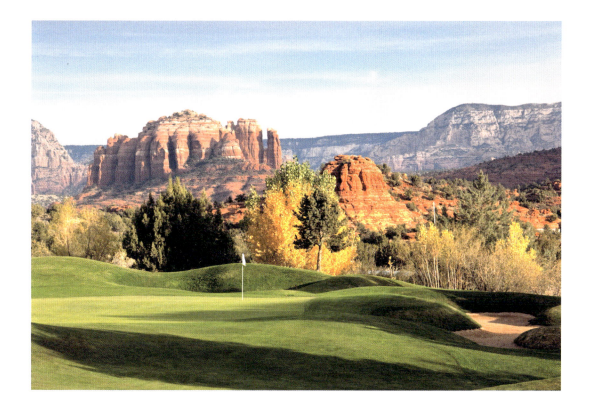

www.sedonagolfresort.com 928-284-9355

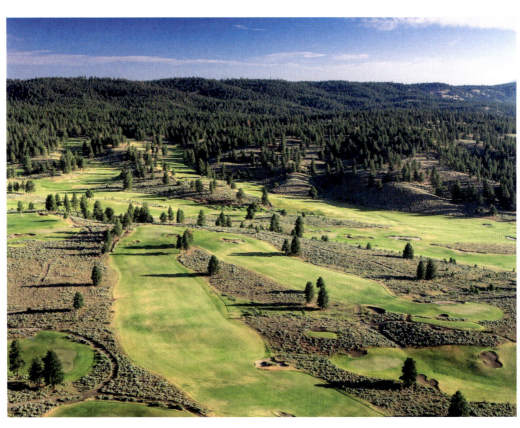
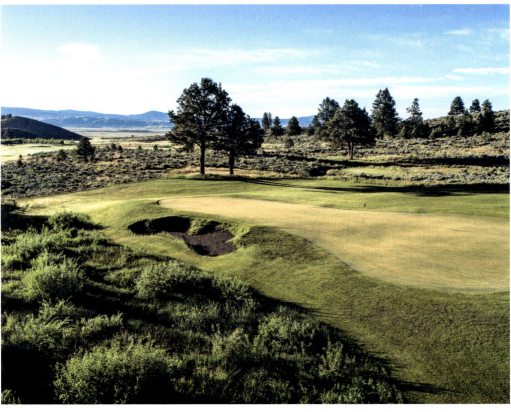

The Americas — United States of America

35 SILVIES VALLEY RANCH: HANKINS AND CRADDOCK

10000 Rendezvous Lane, Seneca, Oregon 97873, USA

TO VISIT BEFORE YOU DIE BECAUSE

These two courses are played on shared, reversible holes. Yes, you read that right.

Technically, the Hankins and Craddock courses at Silvies Valley Ranch—a remote resort between Portland, Oregon, and Boise, Idaho—are two separate courses… but not entirely. Confused? Okay, here's how it works: There are 36 holes across 27 greens, which means that some of the greens are shared by two different holes. Designed by Dan Hixon and resort co-owner Scott Campbell, the course is reversible, with the route being changed every single day. To make things even more complicated, the tee boxes and the pins themselves can move, providing additional variation during each round. Interestingly, reversibility is nothing new—the Old Course at St. Andrews was played both clockwise and counterclockwise for decades.

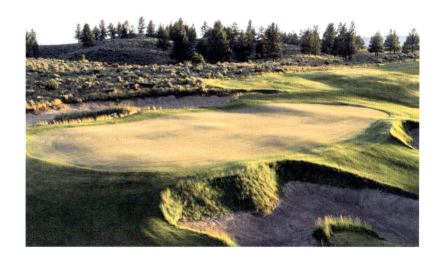

www.silvies.us/golf_courses.php 1-800-745-8437

The Americas · United States of America

36 TORREY PINES: SOUTH

11480 N Torrey Pines Road, La Jolla, California 92037, USA

TO VISIT
BEFORE YOU DIE
BECAUSE

Clifftop setting? Check. Host of two U.S. Opens? Check. Open to general public? Check.

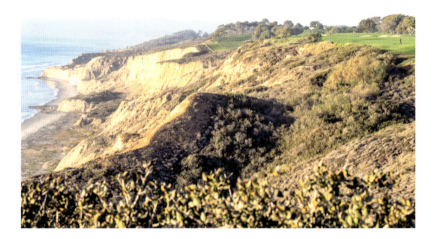

There are only a handful of public-access U.S. Open courses, and Clifftop Torrey Pines is among them. In 2008, it became only the second municipality to host the U.S. Open—and it received the honor of hosting the tournament again in 2021. Torrey Pines has two courses, but it's the South Course that receives the lion's share of praise, partly because it's more scenic and partly because it's more difficult. It's also imprinted into the minds of golf fans everywhere: The 18th hole of the South Course was the setting for a memorable finish as Tiger Woods claimed his 14th major title.

Africa Egypt

37 MARRIOTT MENA HOUSE GOLF COURSE

6 Pyramids Road, Giza, Giza Governorate 12556, Egypt

TO VISIT BEFORE YOU DIE BECAUSE

You'll be golfing next to the Great Pyramid of Giza.

The Great Pyramid of Giza, the only one of the Seven Wonders of the Ancient World that exists today, is a bucket-list item for many travelers. But there is more to do besides visit the towering structure; you can also play a round of golf right alongside it. The historic Marriott Mena House hotel that abuts the Giza pyramid complex is home to a nine-hole course that was originally built in 1899. While the course isn't the largest or most challenging in the world, it is certainly in one of the world's best locations, making it a worthwhile place to spend half a day. Given the age of the course, it's currently under a multi-year renovation, so you may need to bookmark it for a later date. When it reopens, it's a must-play for its ancient backdrop.

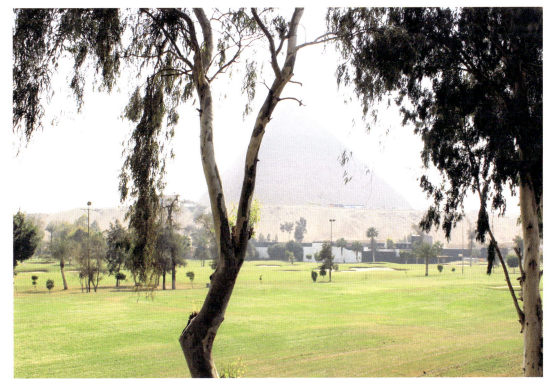

www.marriott.com/hotels/travel/caimn-marriott-mena-house-cairo/

+20 2 33773222

Africa Kenya

38 WINDSOR GOLF HOTEL & COUNTRY CLUB

Kigwa Road, Ridgeways Off Kiambu Road, Nairobi, Kenya

татьTO VISIT BEFORE YOU DIE BECAUSE

It's the ideal spot for a round of golf before heading out on safari.

Nairobi might be a busy metropolis, but just 15 minutes from the city center is a serene course that looks as if it could be way out in the bush. The fairways of the Victorian-themed Windsor Golf Hotel & Country Club in Nairobi, designed by Northern Irish architect Tom Macaulay, meander through lush gardens and dense groves of trees on the edge of a coffee plantation. It's the perfect place to ease yourself into a safari trip—after your international flight, spend a day or two here getting in a little golf before starting your wildlife adventure. Keep in mind that the Windsor is situated at an altitude of more than a mile above sea level—this could certainly factor into your game.

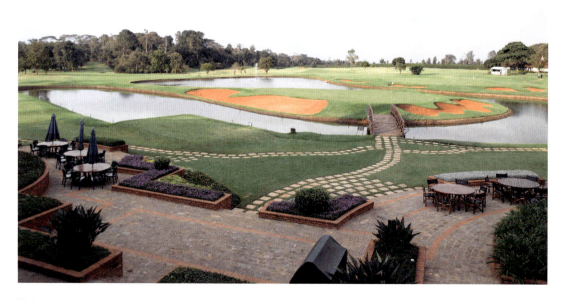

www.windsorgolfresort.com +254 208 647000

Africa — Mauritius

39 ÎLE AUX CERFS GOLF CLUB

Ile aux Cerfs, Trou d'Eau Douce, Mauritius

TO VISIT BEFORE YOU DIE BECAUSE

The course covers an entire island.

After you've flown all the way to remote Mauritius in the Indian Ocean, there's still another journey you'll have to make if you want to play the best golf course in the country. Thankfully, it'll be a lot shorter than your flight—just a few minutes on a little ferry boat. Île Aux Cerfs is set just off the mainland on its own island, a former sugar plantation, and the Bernhard Langer–designed course makes excellent use of the topography, meandering through the beaches, tidal pools, mangrove swamps, and volcanic outcrops. For all its beauty, Île aux Cerfs is perhaps more difficult than it looks. The greens are notoriously small, and you're likely to lose a few golf balls to the landscape during your round.

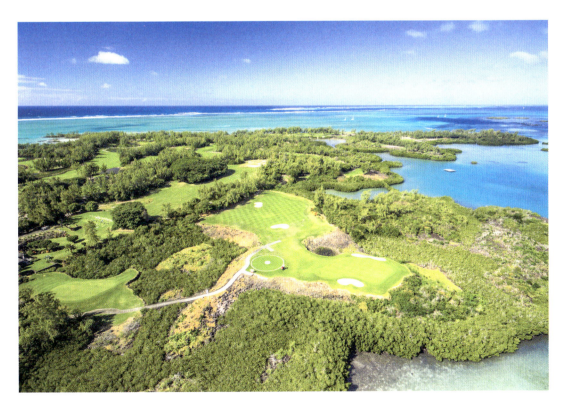

www.ileauxcerfsgolfclub.com +230 402 7720

Africa — Mauritius

40 TAMARINA GOLF CLUB

Tamarin Bay, Tamarin 90922, Mauritius

TO VISIT BEFORE YOU DIE BECAUSE

The spectacular setting is a tropical forest surrounding a river beneath craggy mountains.

Even though Mauritius is an island nation, the ocean doesn't play a major role at Tamarina. Instead, the views are all about the mountains, including the imposing Mount Rempart and the triple peaks of the Trois Mamelles. And the immediate landscape surrounding the course—designed by Rodney Wright—is primarily lush tropical forest or open savannah. But there is water here by means of the Rampart River, whose gorge and estuaries serve as hazards on a few holes. The signature hole here is number 13, a par-three with an 82-foot drop from tee to green. This is by no means the most challenging course on the golf-heavy island, but it's certainly fun to take in the scenery during a round.

www.tamarinagolfclub.com +230 401 3006

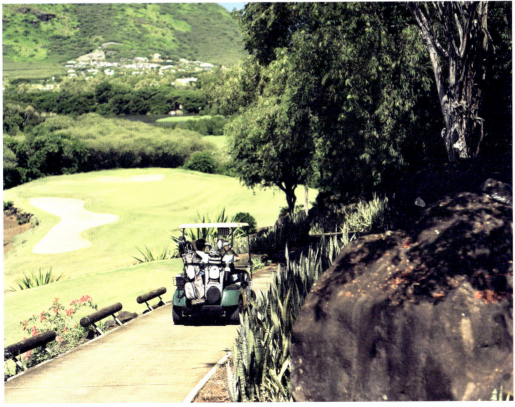

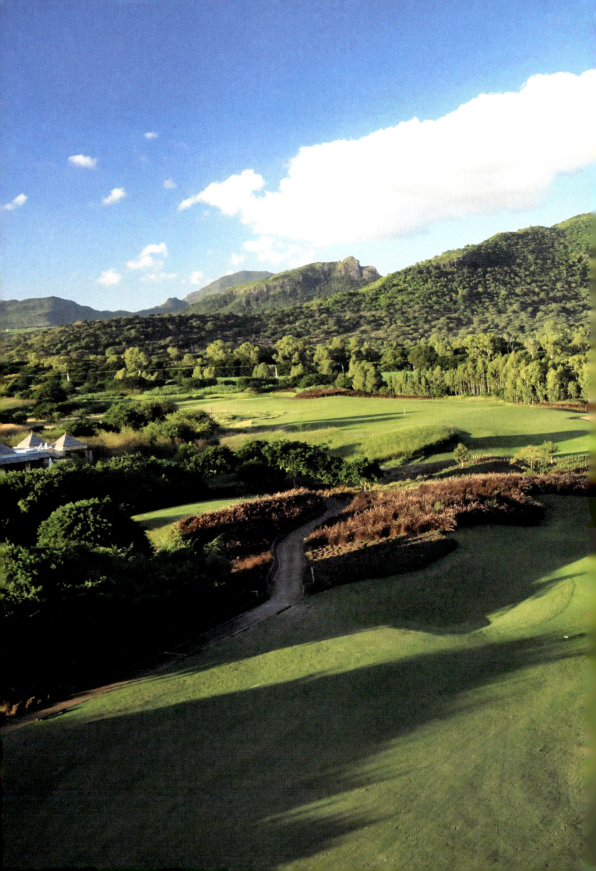

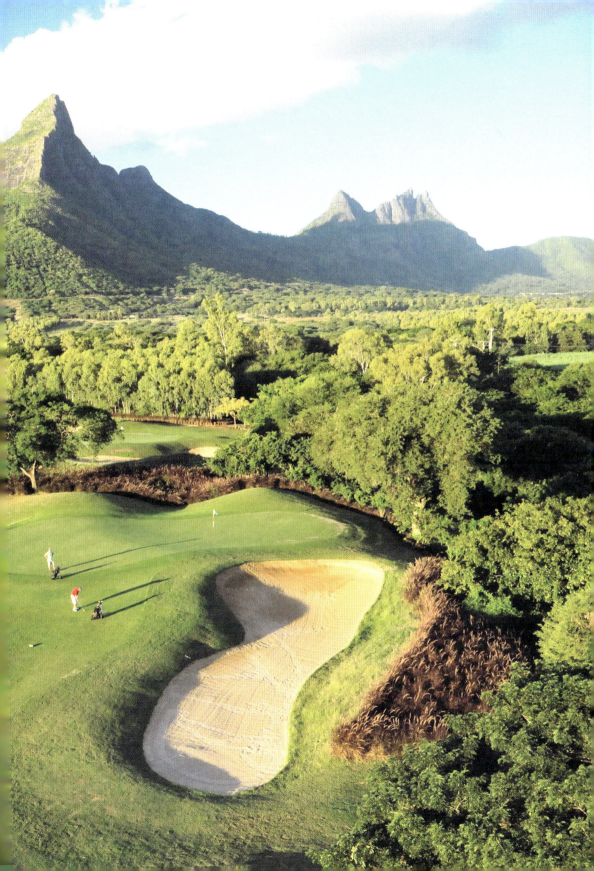

Africa Namibia

41 OMEYA GOLF CLUB

44V7+646, Perahomp, Namibia

TO VISIT BEFORE YOU DIE BECAUSE

This "emerald jewel of Namibia" is an oasis in the rugged bushveld.

If you've never been to Namibia, you might imagine it as filled with towering red sand dunes—and it is. However, the terrain of the Namib Desert is more varied than you might think and includes a bright green golf course. Omeya Golf Club, located a 30-minute drive south of the capital, Windhoek, was designed by Peter Matkovich to blend seamlessly into the surrounding Namibian bushveld, or acacia savannah. In fact, during construction, only a handful of camel thorn trees were felled to make way for the course, which twists and turns through the natural landscape. With such arid surroundings, it's no wonder that the lush course is called "the emerald jewel of Namibia".

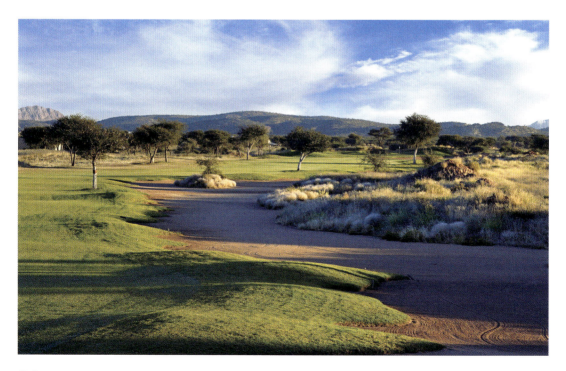

www.omeyagolfclub.com +264 81 144 9000

Africa — Seychelles

42 CONSTANCE LEMURIA GOLF COURSE

Anse Kerlan Praslin Seychelles, Seychelles

TO VISIT BEFORE YOU DIE BECAUSE

This is the only 18-hole golf course in the Seychelles and a delightfully laid-back place to play.

There are more than a hundred islands in the Seychelles, an Indian Ocean nation famed for its tropical resorts. But only one of them has an 18-hole golf course, namely Praslin Island, which is home to the Constance Lemuria Seychelles resort and its associated golf course by Rodney Wright and Marc-Antoine Farry. Although the property is without a doubt a luxurious one, playing golf here is a far more leisurely affair than the more formal courses elsewhere in the world. But leisurely doesn't necessarily mean easy. Keep an eye out for quagmires and ball-stealing crabs throughout the course, plus a tricky uphill battle at the par-five 16th hole. It comes right after the course's signature, the par-three 15th hole, where the tee sits some 250 feet above the green, overlooking the pristine Anse Georgette beach.

www.constancehotels.com/en/true-experiences/golf/lemuria/

(248) 4281 281

Africa / South Africa

43 ARABELLA GOLF CLUB

R44, Kleinmond, 7195, Western Cape, South Africa

TO VISIT BEFORE YOU DIE BECAUSE

This Peter Matkovich–designed course is one of the highlights on the Garden Route.

If you're playing South Africa's golf hotspot Garden Route, be sure to fit time into your schedule for a round at Arabella Golf Club, located on the Arabella Country Estate. The course opened in 1998 and has racked up accolades for its integration with the natural landscape—a crucial detail given its location in the Kogelberg Biosphere Reserve. Of special note are the views over the Bot River Lagoon with the Palmiet mountain range in the background, particularly from the exhilarating par-five eighth hole, which plays downhill toward the water. The ninth, 17th, and 18th are played parallel to the lagoon, while the rest of the holes wander through hilly parkland.

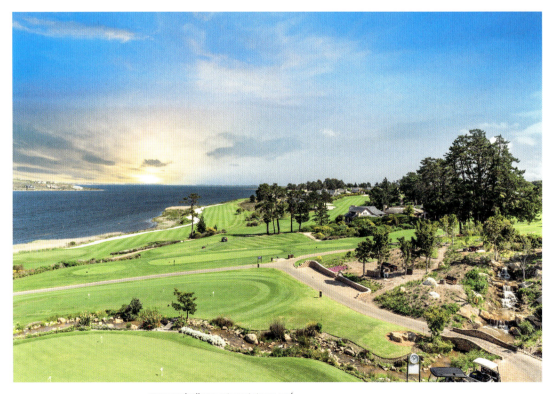

www.arabellacountryestate.co.za/arabella-golf-course/

+27 28 284 0105

Africa South Africa

44 GARY PLAYER COUNTRY CLUB

Sun City Resort, Sun City, 0316, South Africa

TO VISIT BEFORE YOU DIE BECAUSE

It hosts the annual Nedbank Golf Challenge, formerly known as the Million Dollar Golf Challenge.

Since 1981, players have been vying for a one-million-dollar prize at the annual Nedbank Golf Challenge, formerly known as—wait for it—the Million Dollar Golf Challenge at Gary Player Country Club in South Africa. A million dollars might not seem like a big prize today (in the golf world, anyway), but considering the entire purse for the 1981 Masters Tournament was just $362,587, with winner Tom Watson taking home just $60,000, the Challenge sent waves through the golf world. As you might infer from its name, this course at the Vegas-style Sun City Resort was designed by Gary Player, and it's regularly ranked among the best courses in South Africa.

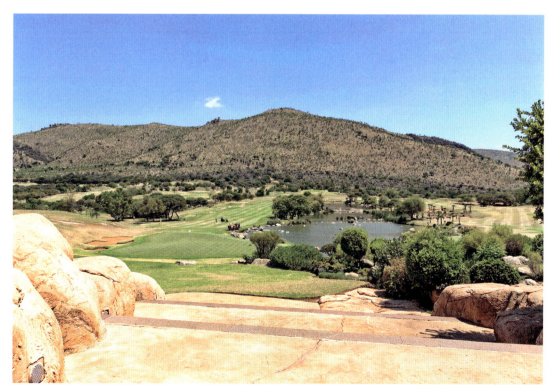

www.suninternational.com/sun-city/activities/golf/gary-player-golf-course +27 14 557 1246

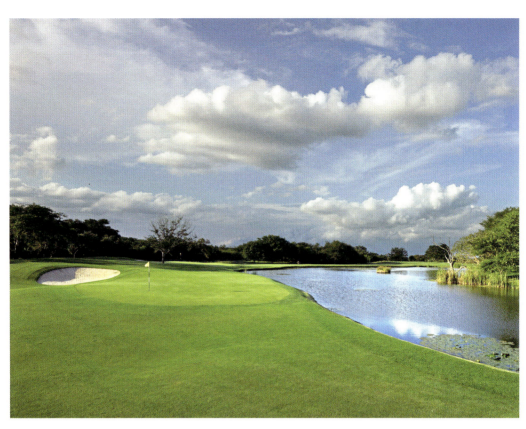
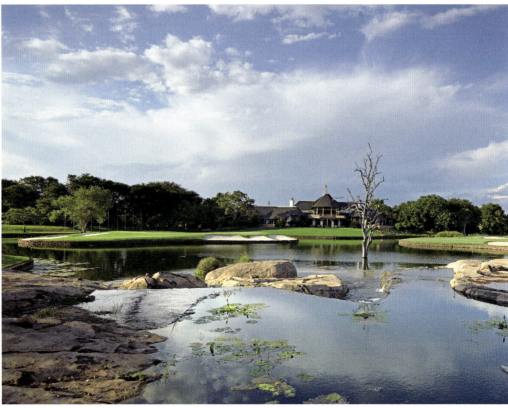

Africa — South Africa

45 LEOPARD CREEK COUNTRY CLUB

Leopard Creek Estate, R570, Malalane Gate—Kruger National Park, Malalane, Mpumalanga 1320, South Africa

TO VISIT BEFORE YOU DIE BECAUSE

You may see crocodiles or hippos as you play.

Don't let Leopard Creek's name fool you—you're golfing alongside the Crocodile River that borders Kruger National Park, and you're far more likely to see the aquatic giants than the elusive cats. Hippos, too, are a fan of the river here, especially near the green at hole 13. But don't worry, the Gary Player–designed course has some hidden features to keep you safe as you play. The wildlife element here isn't the only highlight: This is a tournament-caliber course that's hosted the Alfred Dunhill Championship since 2000, so you can expect a stimulating game. While Leopard Creek is an exclusive members-only club, guests staying at some of the nearby luxury lodges can arrange bookings through their hotels for certain days of the week.

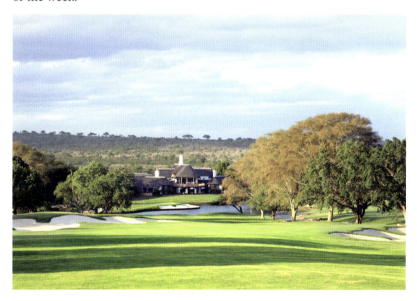

www.leopardcreek.co.za/ +27 (0)13 791 2000

Africa South Africa

46 PEZULA CHAMPIONSHIP COURSE

1 Laggon View Drive, Sparrebosch, Knysna 6571, South Africa

TO VISIT BEFORE YOU DIE BECAUSE

Among South Africa's many world-class golf courses, this is widely considered to have one of the best views.

The Shona word *pezula* means "'up high with the gods," which is a pretty apt name for this clifftop course. Pezula is built atop the East Head of Knysna along South Africa's Garden Route, and it provides panoramic views of the Indian Ocean as well as of the cliffs that line the shore. It was designed by American Ronald Fream, who convinced the developers to allow him to set the 14th hole right against the edge of the cliff. It has since become the signature, and it's one of the most photographed parts of the course. Pro tip: Allow yourself plenty of time to play, as Pezula reports the average round takes just shy of five hours.

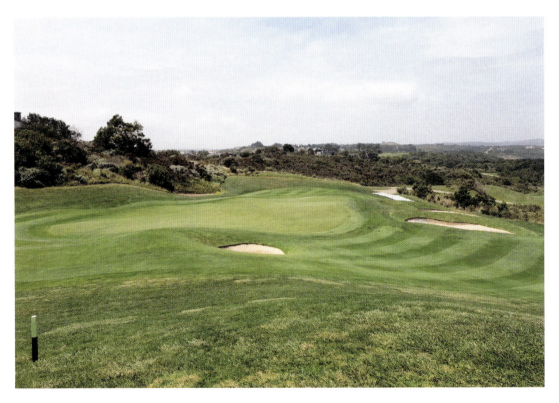

www.pezulagolf.com +27 (0)44 302 5310/11

Africa — South Africa

47 PEARL VALLEY: JACK NICKLAUS SIGNATURE GOLF COURSE

R301, Wemmershoek Road, Paarl 7646, South Africa

TO VISIT BEFORE YOU DIE BECAUSE

Jack Nicklaus and Gary Player were the first two to play this course, a Nicklaus Signature, when it opened in 2003.

Val de Vie is one of the premier luxury residential estates in South Africa, with an impressive array of amenities, from an equestrian center and polo field to a wine cellar. But the standout among the A-list activities is the Pearl Valley golf course, the second Jack Nicklaus Signature Course in the country. It's located in a valley amid the Drakenstein Mountains, which provide some excellent scenery while you play. Though the course is pretty flat, Nicklaus has infused it with enough features to keep things interesting during a round. The fourth and 13th holes are the signatures, each offering picture-perfect views of the landscape.

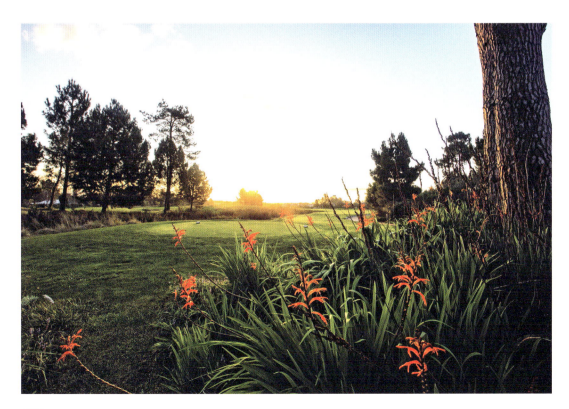

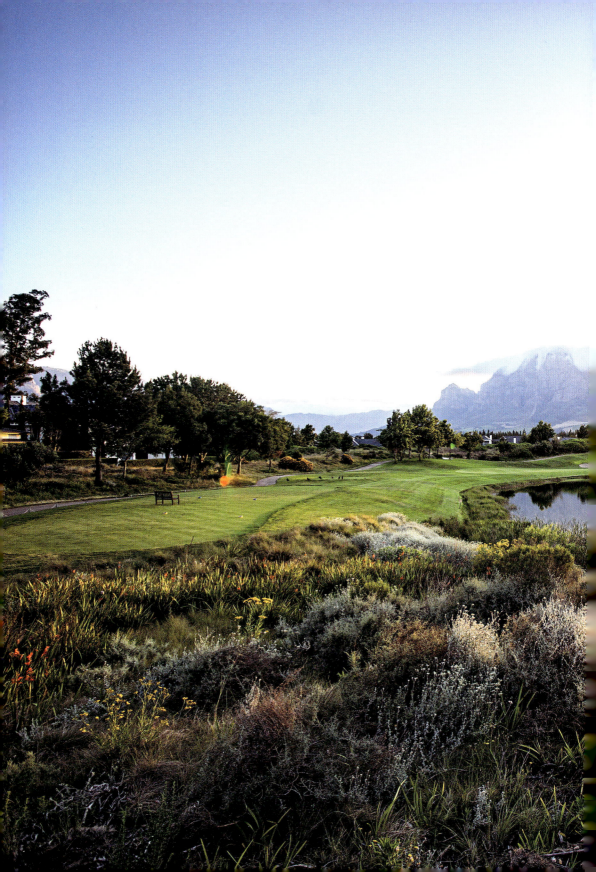

48 PINNACLE POINT GOLF CLUB: FYNBOS

1 Pinnacle Point Road, Mossel Bay 6506, South Africa

TO VISIT BEFORE YOU DIE BECAUSE

The clifftop views over the Indian Ocean are simply magnificent.

Golfers with a fear of heights might want to stay away from Pinnacle Point Golf Club's Clifftop Fynbos Golf Course, but if you can stomach sheer drops off the oceanfront cliffs, you're rewarded with not only one of the best views in golf, but also an extremely challenging game. Seven of the 18 holes dance right along the edge of the cliffs, and four of them even challenge golfers to play over the drop-offs and the roiling Indian Ocean below. Upon completing the course in 2006, designer Peter Matkovich said, "Pinnacle Point Estate is without a doubt the most spectacular golf course I have ever had the opportunity to design." No doubt designers are apt to say such things, but in this case it's probably true.

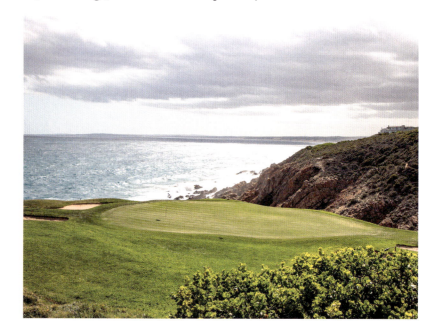

www.pinnaclepointestate.co.za/golf-club/ +27 (0) 44 606 5329

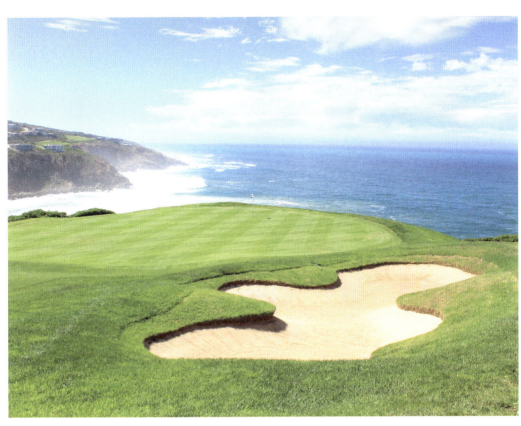
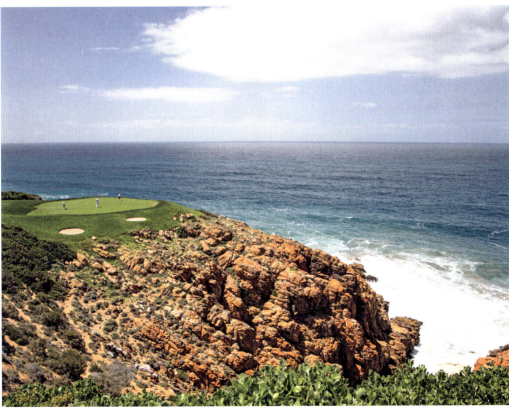

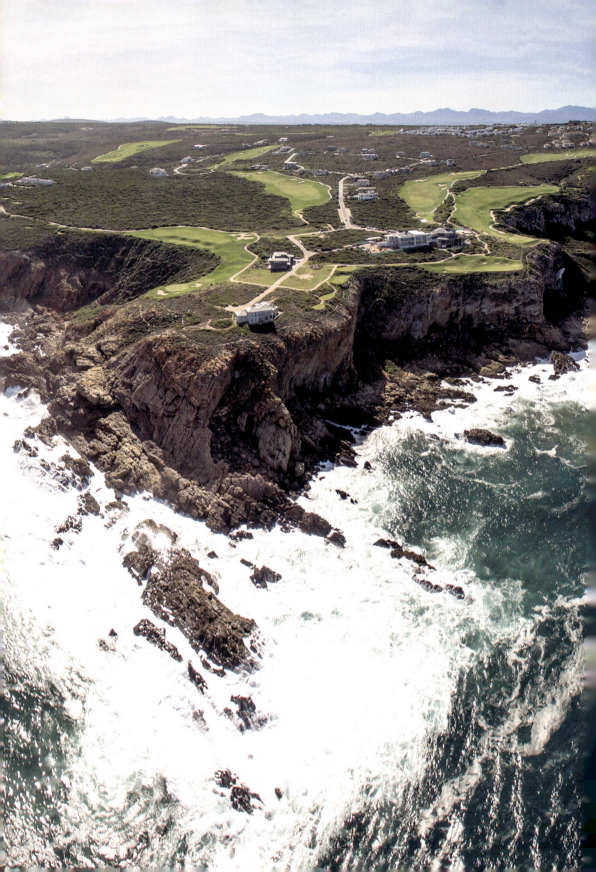

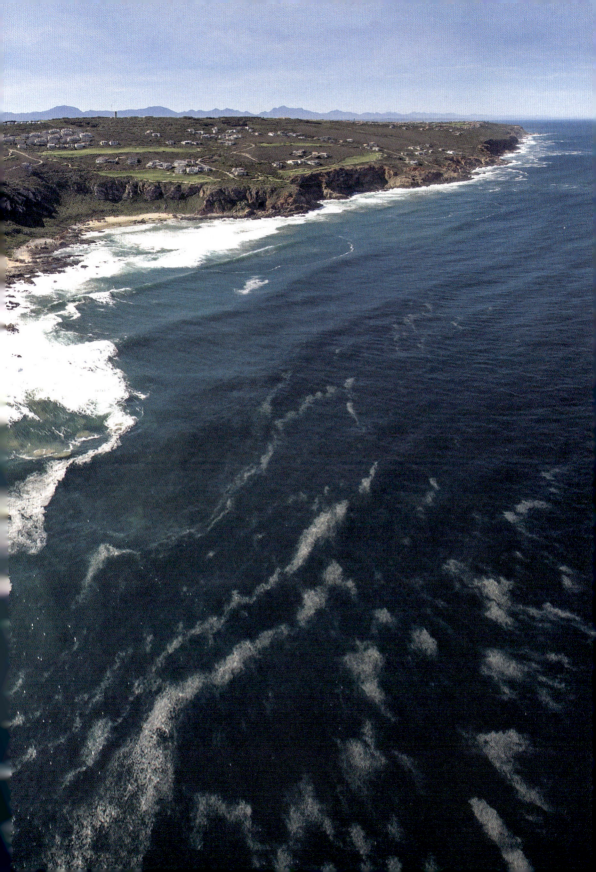

Africa | South Africa

49 SKUKUZA GOLF CLUB

Skukuza Camp, Kruger National Park, South Africa

TO VISIT BEFORE YOU DIE BECAUSE

This is a golf safari—keep your eyes peeled for the Big Five as you tee off.

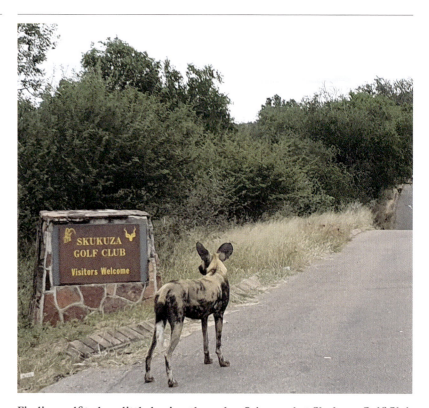

Finding golf to be a little boring these days? A round at Skukuza Golf Club will certainly spice up your routine. Located inside Kruger National Park—South Africa's safari hotspot—the course was originally built for staff but has since opened to visitors, too. Since the nine-hole course isn't fenced in, it's quite common to spot all manner of wildlife on the course, from the Big Five to hippos and warthogs. (In one report, a lion made a kill on the first green, while a different video shows a herd of elephants crossing right in the middle of a golfer's game.) Even though park staff always keep an eye out for dangerous wildlife situations, players nevertheless do have to sign an indemnity form before teeing off, just in case.

www.skukuzagolf.co.za +27 13 110 4660

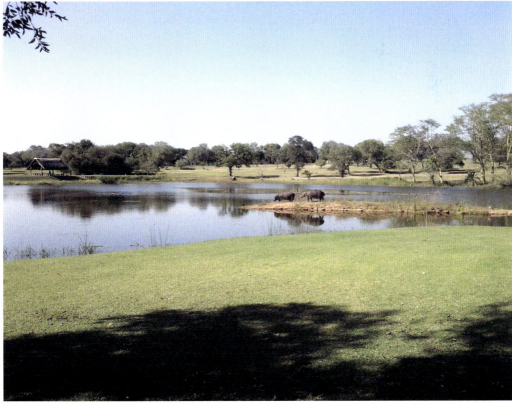

Africa — Tanzania

50 SEA CLIFF RESORT & SPA

X693+JC2, Fujoni, Tanzania

TO VISIT BEFORE YOU DIE BECAUSE

The clubhouse at Zanzibar's only golf course has a private beach.

For beach lovers, Zanzibar Island (formally named Unguja) off the coast of Tanzania is a dream. But, until 2015, it lacked something crucial as a leisure destination: a golf course. That changed with the establishment of Sea Cliff Resort & Spa's nine holes, designed by Peter Matkovich to be played from different tees in two rounds for a full 18-hole game. The flat course leads to two oceanfront holes, the 7th/16th and the 9th/18th, as well as a clubhouse on a private white-sand beach. Zanzibar is a worthy stop for any traveler, but this off-the-beaten-path course is even more reason to visit.

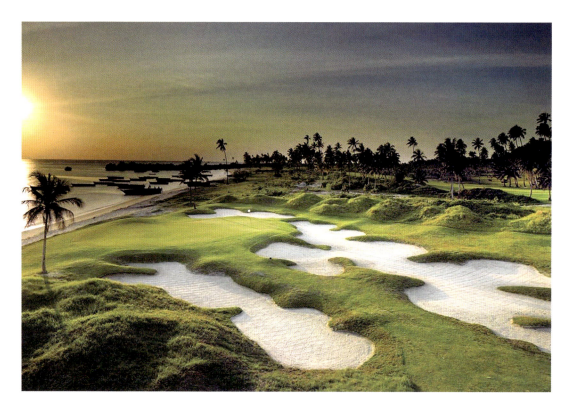

www.seacliffgolf.com +255 (0) 76 770 2241 - 9 Extension 2003

Africa Uganda

51 LAKE VICTORIA SERENA GOLF RESORT & SPA

Lweza-Kigo Road off Entebbe Road, Kampala, Uganda

TO VISIT BEFORE YOU DIE BECAUSE

This is one of Uganda's finest courses, set on the shores of Lake Victoria.

Set roughly halfway between Kampala and Entebbe, Lake Victoria Serena Golf Resort & Spa, which opened in 2018 for the inaugural Serena-Johnnie Walker Golf Open Championship, is not only a perfect leisure destination for Ugandans, but also for tourists traveling through the cities to and from their gorilla treks or jungle safaris. Designed by Kevin Ramsey of the U.S.-based firm Golfplan, the 18-hole course is built right into the shoreline of Lake Victoria, the largest tropical lake in the world, with the final hole playing to an island green. Golf has a long history in Uganda, whose first course opened in 1901, and Lake Victoria Serena continues the country's development in the sport.

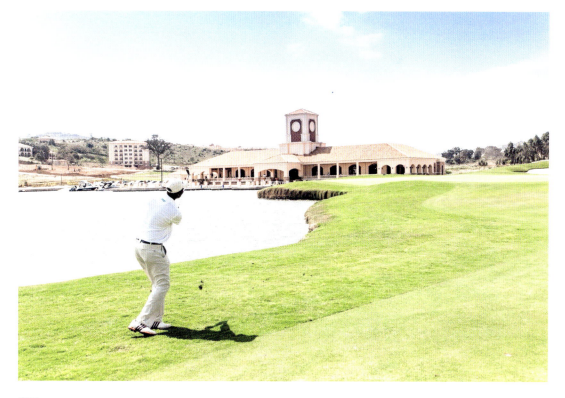

www.serenahotels.com/lake-victoria +256 313 221000

Africa — Zimbabwe

52 ROYAL HARARE GOLF CLUB

5th Street Extension, Harare, Zimbabwe

TO VISIT BEFORE YOU DIE BECAUSE

Founded in 1898, this is one of the oldest golf courses in Africa and it has Royal Patronage.

When golfers first swung at Royal Harare, formerly known as Salisbury Golf Club, the grounds looked ever so slightly different than they do today. The year was 1898 and the game was played on sand greens. Over the years, the course has been renovated by such names as Fred W. Hawtree, Nick Price, and Steve Smyers, which resulted in the beautiful parkland fairways with the kikuyu grass that exist today (thanks to the development of irrigation technology that was crucial in bringing verdant hues to the arid region). Royal Harare was granted Royal Patronage in 1929 by King George V of England.

www.royalharare.co.zw +263 242 702 927

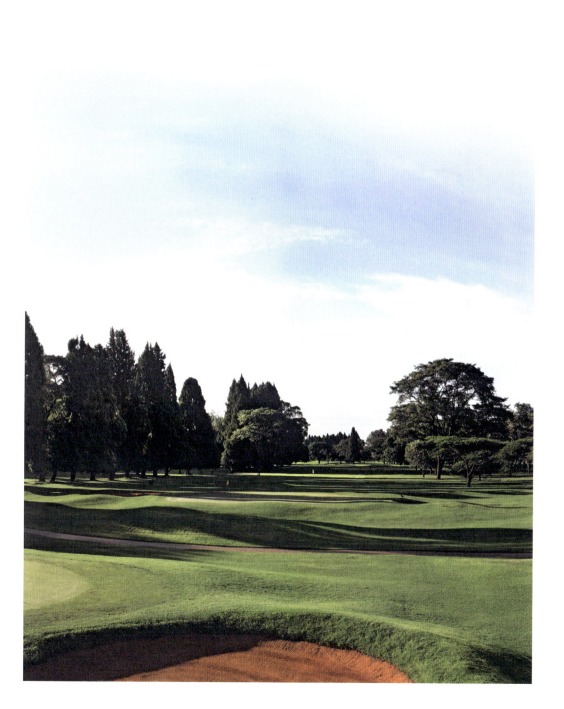

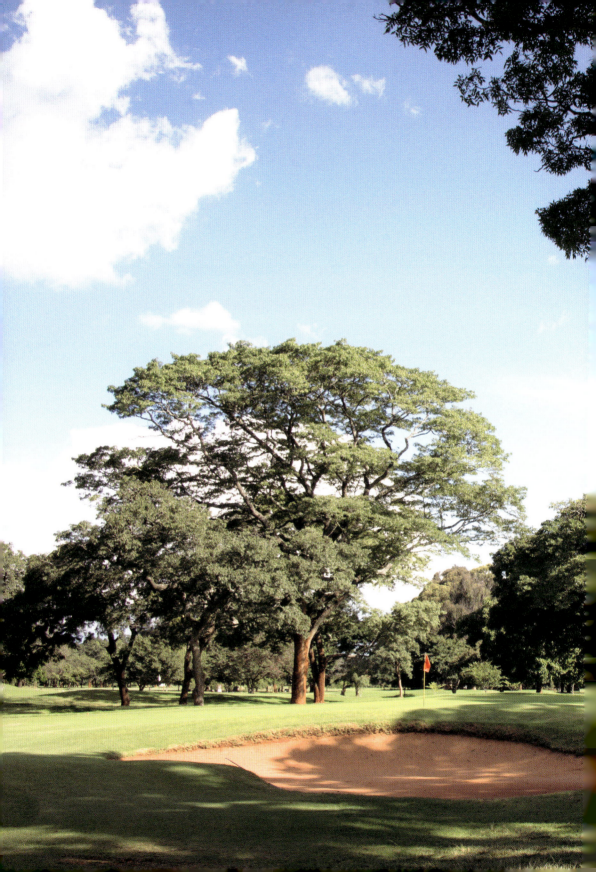

Asia Bhutan

53 ROYAL THIMPHU GOLF CLUB

Kurdey Lam 5, Thimphu, Bhutan

TO VISIT
BEFORE YOU DIE
BECAUSE

Where else can you play on the same course as a king?

For world travelers, Bhutan is a bucket-list destination, known for being difficult to access as a tourist, but incredibly worth the effort for the landscape and the culture. It stands to reason that, for golfers, the kingdom's only public golf course should be a bucket-list item, too. Designed by Ronald Fream, the nine-hole course (there are two sets of tees for a full round of 18) is located right next to the Tashichho Dzong, a 17th-century fortress and monastery that houses the king's offices; the king himself sometimes plays at Royal Thimphu. During your round, take in the mountainous scenery—you're in the middle of the Himalayas at an elevation of around 7,500 feet.

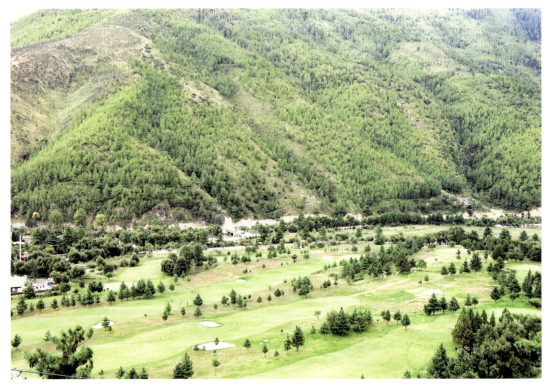

www.top100golfcourses.com/golf-course/royal-thimphu

+975 2 325429

Asia Cambodia

54 PHOKEETHRA COUNTRY CLUB

Dontro Village, Lavea Commune, Puok District, Siem Reap Province, Cambodia

TO VISIT BEFORE YOU DIE BECAUSE

Cambodia's first international-class golf course is just down the road from Angkor Wat.

This might surprise you, but the UNESCO-designated ancient temple complex of Angkor Wat, near the modern city of Siem Reap, doesn't actually have its own golf course. Fortunately, there are a few nearby! The Phokeethra Country Club, just a 30-minute drive outside of town, is Cambodia's first international-class championship golf course, opened in 2007. That same year, it hosted the Cambodian Open, drawing the attention of the Asian Tour's professionals, and the course continues to delight both local and international players. As you play, keep an eye out for the Roluh Bridge, an 11th-century stone structure that reminds golfers exactly where they are: that is, on ancient Khmer lands.

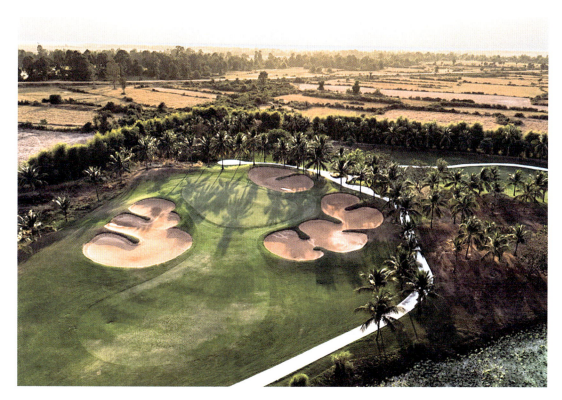

103 www.phokeethraangkor.com +855 63 964 600

Asia China

55 SHANQIN BAY GOLF CLUB

Longgun Town, Wanning City, Hainan Province, China

TO VISIT BEFORE YOU DIE BECAUSE

Several golf architects have reportedly said that a course could never be built here, yet Shanqin Bay exists nonetheless.

The city of Sanya on the southern tip of China's Hainan Island is a well-known tourist destination. But just two hours north, there are large swaths of undeveloped land with mountainous terrain that is complicated to build upon. But that didn't stop Chairman Wang Jun dreaming to build his highly exclusive golf course here. Due to the extreme topography along the cliff-lined coast, several golf architects reportedly turned down the Shanqin Bay commission, claiming the job couldn't be done. But Bill Coore and Ben Crenshaw were up for the challenge, and in 2004 Coore spent a week inspecting the raw landscape before determining a plausible route. The resulting course is one of the most highly sought after in China, though it's only open to members (who must be invited to join) and their guests. Many who have been lucky enough to play here have cited Shanqin Bay as one of their favorite golf experiences.

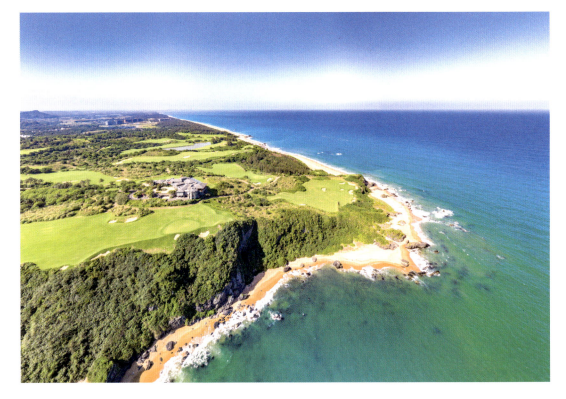

Asia China

56 YALONG BAY GOLF CLUB

Yalong Bay National Resort District,
Sanya, Hainan Province 572000, China

TO VISIT
BEFORE YOU DIE
BECAUSE

This course is the grande dame of Sanya.

Where you'll find beach resorts, you'll also find golf courses. This is true of China's premier beach destination Sanya on the island of Hainan, where luxury resorts line the tropical shores. Opened in 2000, the Yalong Bay Golf Club could be considered "historical" by Sanya standards, as many of the courses there are much younger. It was designed by Robert Trent Jones Jr. to mimic classic links with soft dunes, even though the course is set just slightly inland from the sea. Keep an eye out for the 98 bunkers and the winding river that cuts through the course.

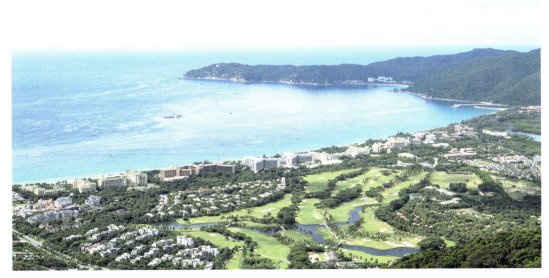

www.ritzcarlton.com/en/hotels/china/sanya/area-activities/activities/golf

+86 (0) 898 8898 8888

Asia — Hong Kong

57 THE CLEARWATER BAY GOLF & COUNTRY CLUB

139 Tai Au Mun Road, Clear Water Bay, New Territories, Hong Kong

TO VISIT BEFORE YOU DIE BECAUSE

The course's clifftop location has drawn comparisons to California's Pebble Beach and New Zealand's Cape Kidnappers.

At Clearwater Bay in Hong Kong, you don't play the front nine and back nine; you play the Ocean nine and the Highland nine. The course starts by winding its way down a cliff-lined, hook-shaped peninsula that recalls elements of California's Pebble Beach and New Zealand's Cape Kidnappers, then heads back inland to forested hills with mountain backdrops. When it opened in 1982, the layout was actually reversed, but a 2006 renovation by Peter Thomson and Ross Perrett flipped the holes to create what's largely praised as a vast improvement. Take a moment at hole three to enjoy the ocean view; this is considered one of the best golf holes in the world.

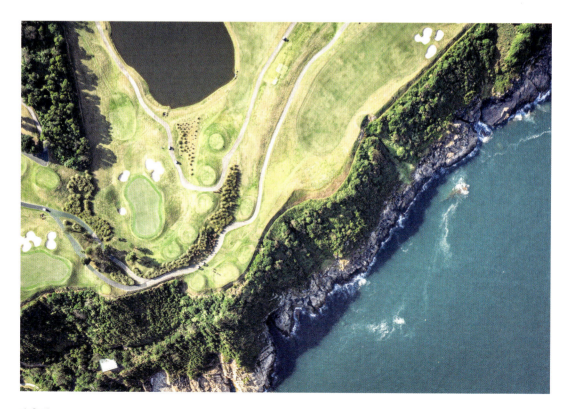

www.cwbgolf.org/ (852) 2335 3700

Asia Hong Kong

58 JOCKEY CLUB KAU SAI CHAU: NORTH

P.O. Box 88, Sai Kung Post Office, New Territories, Hong Kong

TO VISIT BEFORE YOU DIE BECAUSE

There's a reason this is one of the busiest—if not the busiest—golf courses in Hong Kong.

Opened in 1995, the Jockey Club Kar Sai Chau offers three public golf courses, but it's notoriously difficult to score a tee time. Why? Well, as the only public courses in Hong Kong, they are in high demand. Public playability aside, the three courses are actually pretty spectacular, set on the coastal hills of the island of Kau Sai Chau. The Gary Player–designed North Course is the favorite here in terms of actual play, as it's the longest and most difficult of the three. But the East Course does put on a spectacular show in terms of setting, as every hole boasts an ocean view.

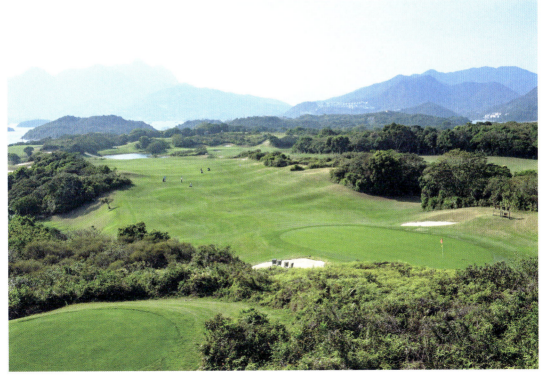

www.kscgolf.org.hk/golf/golf-courses/north-course/ 2791-3388

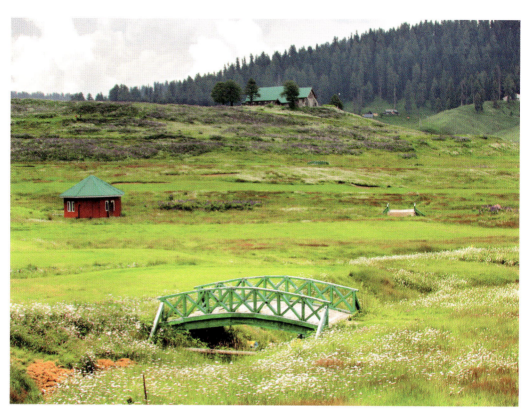
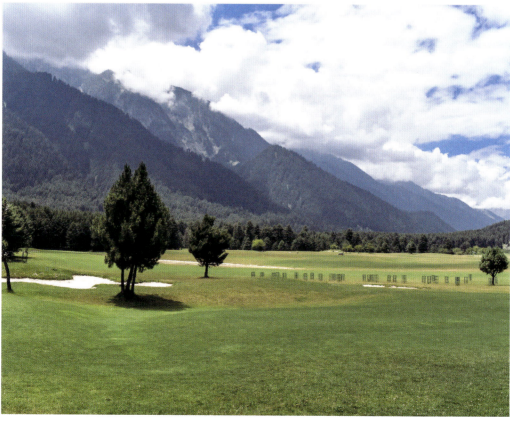

Asia — India

59 GULMARG GOLF CLUB

Gulmarg, Jammu and Kashmir 193403, India

TO VISIT BEFORE YOU DIE BECAUSE

This off-the-beaten-track golf course is one of the highest in the world.

In the northernmost reaches of India is the historic Gulmarg Golf Club, whose elevation of almost 8,700 feet in the Himalayas makes it one of the highest courses in the world. Though the club was officially inaugurated in 1911, golf has been played here since the late 19th century, when British colonel Neville Chamberlain established a small six-hole course in what was then a summer retreat for British officers. Kashmir is not one of the most popular golf destinations, but for intrepid travelers looking to play in atypical locales, a stop at Gulmarg is well worth it.

www.kashmirdmc.com/gulmarg-golf-club

Asia India

60 LALIT GOLF & SPA RESORT GOA

Raj Baga, Canacona, Goa 403702, India

TO VISIT BEFORE YOU DIE BECAUSE

There's no better place in resort-laden Goa to play golf.

Though Goa might be a popular resort destination in India, golf hasn't yet quite caught on there, but there are courses here where golfers visiting the area can get in a round or two. For a full 18-hole experience the Lalit Golf & Spa Resort is the place to play. It's currently the only international-standard course in the state, offering nine double-teed holes designed by Col. K. D. Bagga, a student of Alister MacKenzie. The palm-tree-lined course runs between the Portuguese Baroque resort buildings out toward the dunes along the beach.

www.thelalit.com/the-lalit-goa/ +91 (0832) 266 7777

Asia Indonesia

61 BALI NATIONAL GOLF CLUB

The MAJ Nusa Dua, Kawasan Wisata Lot S-5, Nusa Dua, Bali 80363, Indonesia

TO VISIT BEFORE YOU DIE BECAUSE

The landscaping here is designed to evoke Bali's signature rice terraces.

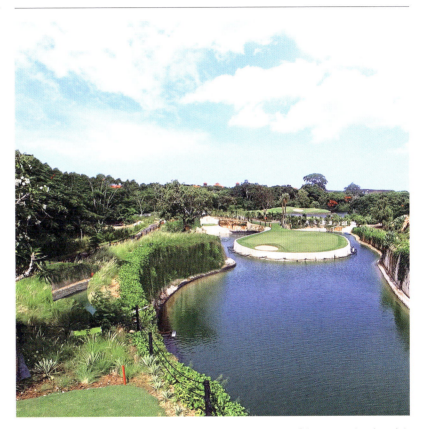

When you embark on a round at the Bali National Golf Club, you begin with nine holes in the jungle, weaving through hills with hand-built stone walls that are terraced like rice paddies. Then for the back nine, you're on flatter terrain surrounded by palm trees and artificial lakes. Here you'll find the tricky 17th hole, where you're hitting to an island green. The course was designed by Robin Nelson and Rodney Wright, opening in 1991 as the Bali Golf & Country Club. The architects also spearheaded an overhaul 20 years later when it was renamed the Bali National Golf Club.

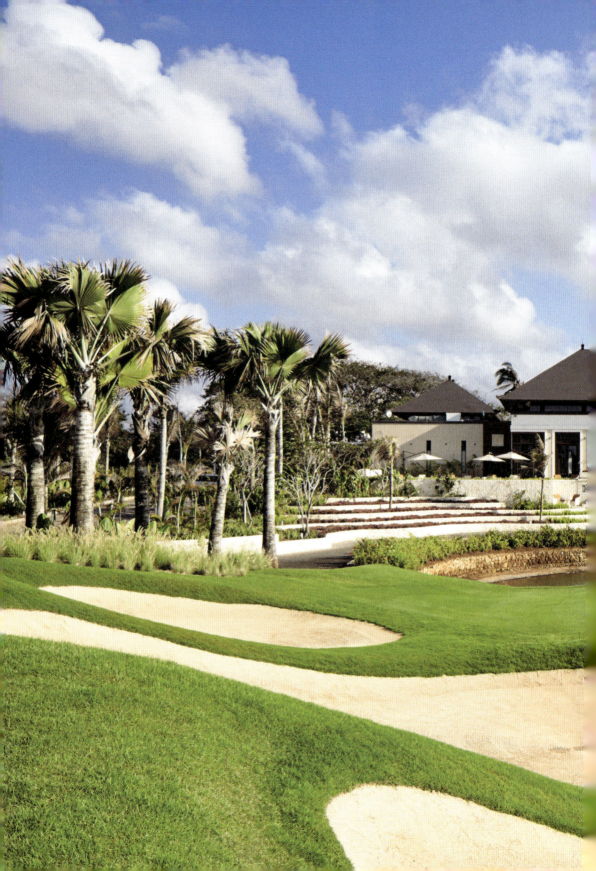

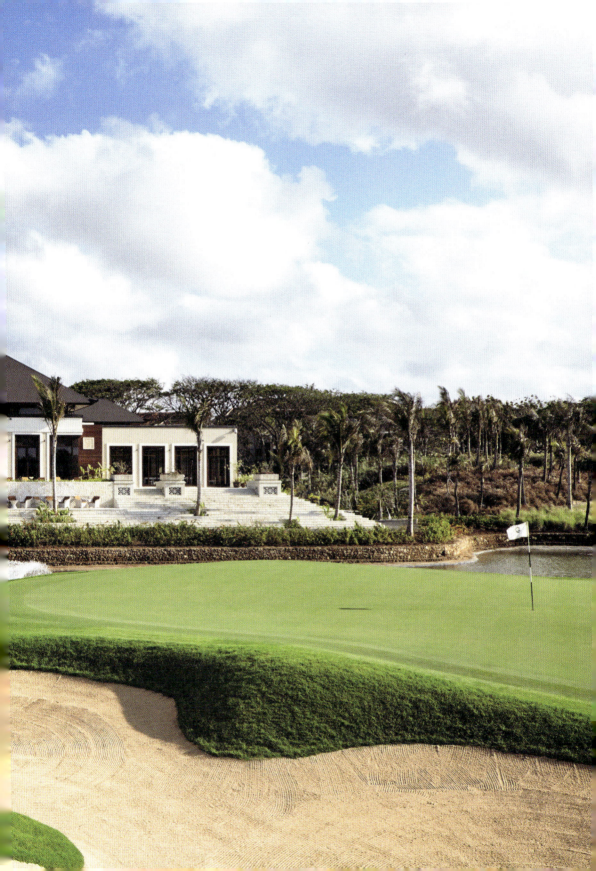

Asia Indonesia

62 HANDARA GOLF & RESORT BALI

Desa Pancasari-Singaraja, Bali, Indonesia

TO VISIT BEFORE YOU DIE BECAUSE

It lies in the crater of an extinct volcano.

Designed by Peter Thomson, Michael Wolveridge, and Ronald Fream, the course opened in 1974. There aren't that many golf courses set inside the crater of an extinct volcano, so when you get the opportunity to play in one, you should grab it. Handara Golf & Resort Bali has one such course, at an elevation of about 3,750 feet, making it the highest golf course on the tropical island, with the mountainous scenery to match. Because of its elevation, the course has cool temperatures for playing—a welcome respite in Bali!

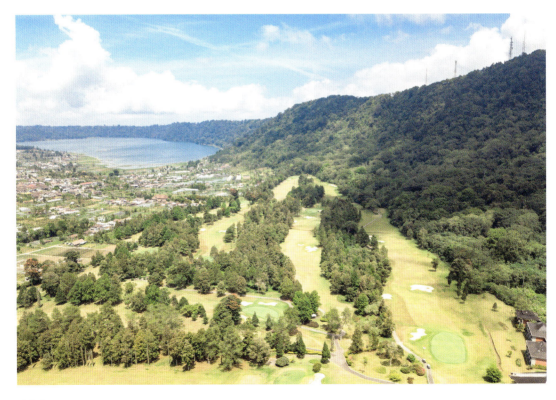

114 www.handaragolfresort.com +62-362 3422 646

Asia Indonesia

63 MERAPI GOLF YOGYAKARTA

Jl. Golf No 1 Kepuharjo, Cangkringan,
Kab. Sleman - Yogyakarta 55281, Indonesia

TO VISIT
BEFORE YOU DIE
BECAUSE

The fairways are set out on ancient lava flows.

Located on the island of Java, Mount Merapi is Indonesia's most active volcano, erupting every few years since 2006, not to mention dozens of times in the 19th and 20th centuries. That hasn't stopped the construction of a golf course just five miles away. Merapi Golf, designed by firm Thomson, Wolveridge & Perrett, sits between the city of Yogyakarta and the volcano, providing players absolutely magnificent views of the cone—a view made even more awe-inspiring when Merapi emits gentle clouds of smoke and ash. Of course, larger eruptions pose a safety threat, so the golf course does close as necessary.

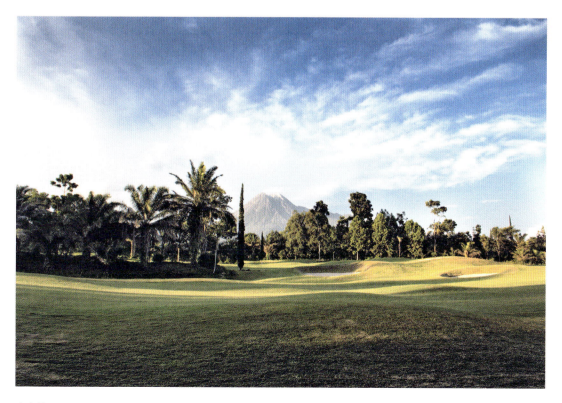

www.merapigolf.co.id/ (62 274) 896176 896177 896178

Asia — Malaysia

64 THE ELS CLUB TELUK DATAI: RAINFOREST

Jalan Teluk Datai, 07000 Pulau Langkawi, Kedah Darul Aman, Malaysia

TO VISIT BEFORE YOU DIE BECAUSE

The rain forest setting between the beach and the mountains has an almost mystical quality to it.

Global golf brand Els Club, founded by golfer Ernie Els, has outposts in Dubai and Copperleaf, but its remote courses in Malaysia are the ones you need to see. In particular, the Rainforest Course at Els Club Teluk Datai on the island of Langkawi provides one of the best tropical golf settings. The 18 holes sit between the Mat Cincang Mountains and the turquoise Andaman Sea in lush ancient rain forest, with babbling streams running along some of the fairways and with five of the holes reaching the edge of the ocean. Interestingly, there are no bunkers here—the tropical rainstorms would wash them away. Instead, hazards involve the trees and grassy swales.

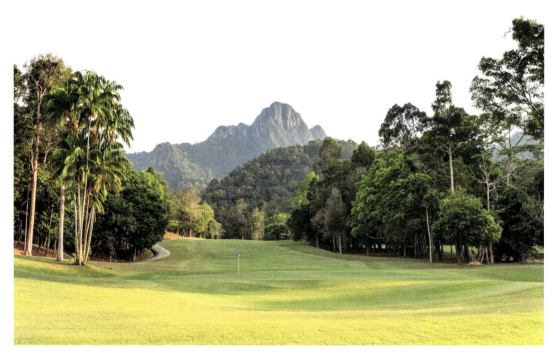

www.elsclubmalaysia.com/rainforest_course/ +60 (4) 959 2700

Asia Malaysia

65 MOUNT KINABALU GOLF CLUB

Jalan Cinta Mata Mesilou, 89308 Kundasang, Sabah, Malaysia

TO VISIT
BEFORE YOU DIE
BECAUSE

If it's a foggy day, you'll feel like you're playing in the clouds.

At 13,435 feet, Mount Kinabalu, a UNESCO World Heritage Site, is the tallest mountain in Malaysia, located on the island of Borneo. Amid all the biodiversity found on its flanks, there's actually a golf club up there. Designed by Robert Muir Graves, the club's most famous hole is the 14th, where golfers must make a shot over a deep ravine to the cliffside green. In the early morning, the course tends to be shrouded in mist, creating the sensation that you're playing in the clouds. In fact, at an elevation of 5,000 feet, you are!

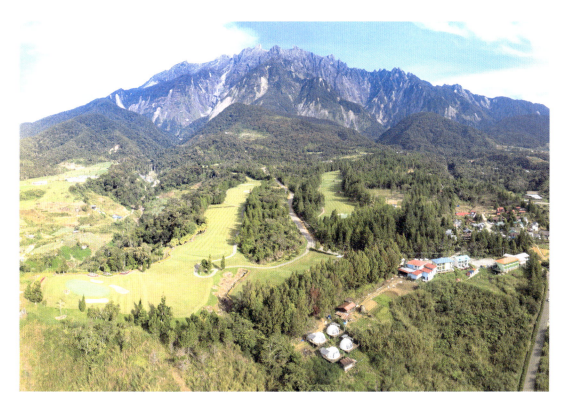

www.mount-kinabalu-golf-club-mkgc.business.site/ 088-889 445

Asia · Malaysia

66 ROYAL SELANGOR GOLF CLUB: OLD

Jalan Kelab Golf, Off Jalan Tun Razak
55000 Kuala Lumpur, Malaysia

TO VISIT BEFORE YOU DIE BECAUSE

One of the oldest clubs in Asia, Royal Selangor is located right in the city center of Kuala Lumpur with the Petronas Towers as the backdrop.

More often than not, golf courses are located out in nature, surrounded by breathtaking landscapes. After all, you need a lot of land to build a course. But Royal Selangor Golf Club is smack in the middle of the city, and that's because the modern city actually grew around it. The club was founded in 1893, making it one of the oldest in Asia, though its current grounds are not in the original location. When the city of Kuala Lumpur decided it wanted Royal Selangor's land to be converted into a park, the club negotiated a lucrative deal that established its new home in 1921. The Old Course is the more prestigious of the two 18-hole courses here, having hosted the inaugural Malaysian Open, among many other tournaments. The club is open only to members and their guests, though certain hotels can book tee times for their guests.

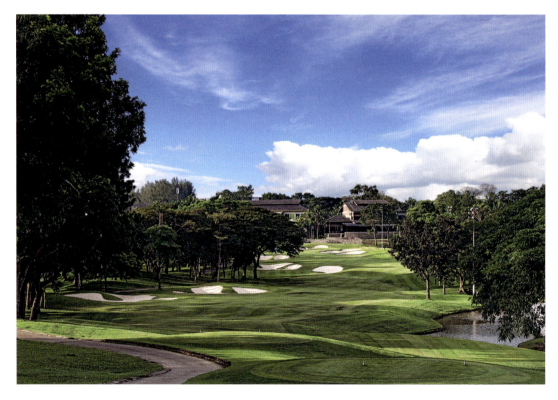

https://rsgc.com.my/ · +603-9206 3333

Asia — Malaysia

67 TEMPLER PARK COUNTRY CLUB

KM21 Jalan Rawang 48000 Rawang,
Selangor Darul Ehsan, Malaysia

TO VISIT BEFORE YOU DIE BECAUSE

The limestone cliffs are a sight to behold.

Drive just 45 minutes out of Kuala Lumpur to reach the Templer Park Country Club, a phenomenal golf course located adjacent to the Templer Park Forest Reserve. Its focal point is the distinctive Bukit Takun limestone "hill," a million-year-old rocky monolith that's a favorite of rock climbers. The course was designed by two Japanese golf legends, player Masashi "Jumbo" Ozaki and architect Kentaro Sato, who devised a challenging layout that's hosted the Malaysian Open three times since the club was established in 1990. The club also has traditional Japanese onsen (hot spring baths), enticing golfers to soak in warm, soothing waters from the limestone hills.

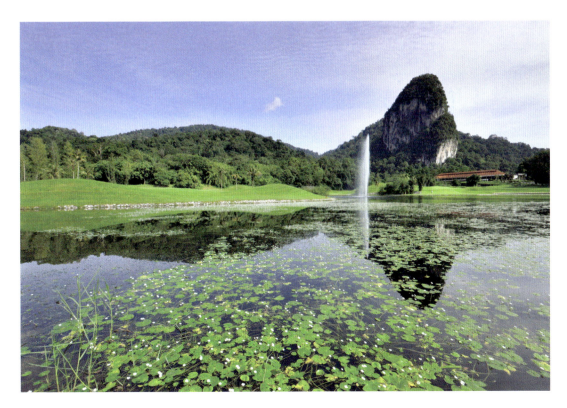

www.tpcc.com.my +60 3 6091 9630

68 TPC KUALA LUMPUR: WEST

10, Jalan 1/70 D, Bukit Kiara, 60000 Kuala Lumpur, Federal Territory of Kuala Lumpur, Malaysia

TO VISIT BEFORE YOU DIE BECAUSE

This is a popular spot for national and international tournaments in Malaysia.

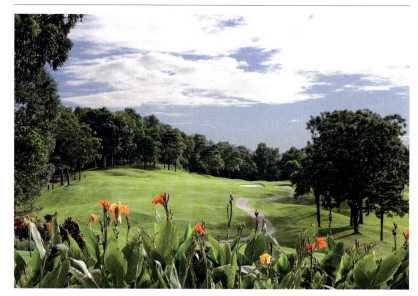

Formerly known as the Kuala Lumpur Golf & Country Club, TPC Kuala Lumpur is one of the top courses in Malaysia, located just outside the city in the Bukit Kiara Hills. The West Course, which is slightly more difficult than its companion, the East Course, was originally designed by Nelson & Haworth, then completely overhauled by Parslow and Associates in 2008. Since the Malaysian Open became the first co-sponsored tournament between the European and Asian Tours in 1999, the event has been held at TPC Kuala Lumpur no fewer than seven times. The course also hosted five CIMB Classics, the first co-sponsored tournament between the PGA and Asian Tours.

www.klgcc.com +60 3-2011 9188

Asia Qatar

69 EDUCATION CITY GOLF CLUB

Education City - Al Rayyan Road PO Box 12182 - Doha, Qatar

TO VISIT BEFORE YOU DIE BECAUSE

It's always fun to play golf in a desert setting and this Qatari course is no exception.

Qatar's Education City is a wonderland of learning in the broadest sense. Yes, it's home to 20 schools and universities, but there are also research centers, a public library, and an art museum. And you can also hone your swing here at the Education City Golf Club, a full-fledged golf center designed for both novices and pros. If you don't feel the need to take a lesson, you can simply play the 18-hole championship course, designed by golfer José María Olazábal, which is illuminated by floodlights for night rounds. (It gets a little hot in Doha, so it helps to play at night.) In 2020, the club became the host of the Qatar Masters.

Asia　　　　　　　　　　　Singapore

70　MARINA BAY GOLF COURSE

80 Rhu Cross, Singapore 437437

TO VISIT BEFORE YOU DIE BECAUSE

This is Singapore's only public 18-hole golf course.

Covering about 275 square miles, Singapore is a very small island. And although roughly 50 percent of that is green space, golf courses don't rank too highly in the green space hierarchy. Designed by Phil Jacobs and opened in 2006, Marina Bay Golf Course is the country's only public 18-hole golf course. In fact, it's technically two courses. In 2019, the course was reconfigured so that golfers can play two different courses on the same holes: Course A and Course B. It's also home to Singapore's only par-six hole, which is an impressive 712 yards from the back tee.

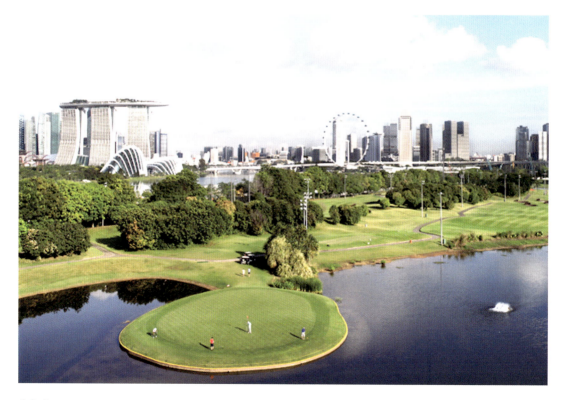

www.mbgc.com.sg/　　　　　+65 6345 7788

Asia — Singapore

71 SENTOSA GOLF CLUB: SERAPONG

27 Bukit Manis Road, Singapore 099892

TO VISIT BEFORE YOU DIE BECAUSE

The third hole provides sweeping views of Singapore's harbor and skyline.

Once a military base, Sentosa Island in Singapore is now a major resort island, complete with two golf courses at the Sentosa Golf Club. The Serapong Course, which opened in 1982, is the heavyweight here, designed by American architect Ronald Fream, who transformed a former mangrove swamp into the lush fairways you see today. It was later renovated in 2006 by the Bates Golf Design Group in 2006, then again in 2021 under general manager Andrew Johnston, both contributing to the course's high ranking on many of the world's best lists. Serapong is best known as the home of the Singapore Open (since 2005) and for its astounding views of the Singapore skyline, especially from the third hole.

Asia — South Korea

72 JUNGMUN GOLF CLUB

Saekdal-dong, Seogwipo, South Korea

TO VISIT BEFORE YOU DIE BECAUSE

The clifftop views from the front nine are spectacular.

Until the 1980s, there were no public golf courses in South Korea. But the country has developed a voracious appetite for the sport, and new, more accessible courses are being built across the country. One of the earliest is Jungmun Golf Club on Jeju Island, a popular vacation destination known for its volcanic geology. The outward holes at Jungmun are played onto a cliff formed by lava quite some time ago (Jeju Island's volcano, Mt. Halla, hasn't erupted in over a thousand years), providing golfers with impressive views. Moving back inward you play amongst pine and palm trees.

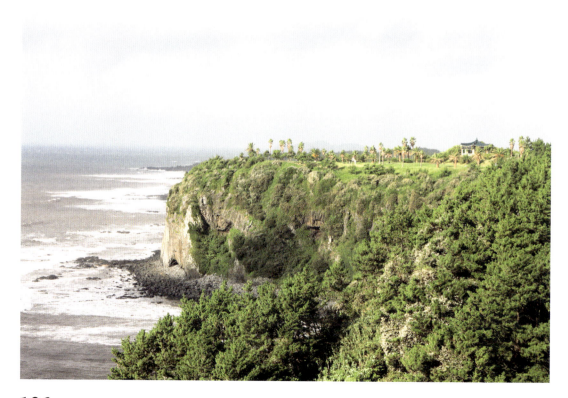

www.visitjeju.net/en (+82) 064-735-7241

Asia — Sri Lanka

73 VICTORIA GOLF & COUNTRY RESORT

Digana 20180, Digana, Sri Lanka

TO VISIT BEFORE YOU DIE BECAUSE

This handbuilt golf course is one of the most impressive in Sri Lanka.

The British brought golf to Sri Lanka in the late 19th century, but the game really only took off there in the past few decades. Victoria Golf and Country Resort opened the nation's third-ever course in 1998, and it's still lauded as one of the best in the country. Perhaps most impressive, the course is largely natural, with most of the alterations made by hand rather than machine, something almost unheard of in modern-day golf construction. As you play a round, enjoy the gorgeous surroundings, including massive trees along the fairways and the Kandyan mountains in the distance. The view from the signature sixth hole is particularly impressive; it overlooks the Victoria Dam.

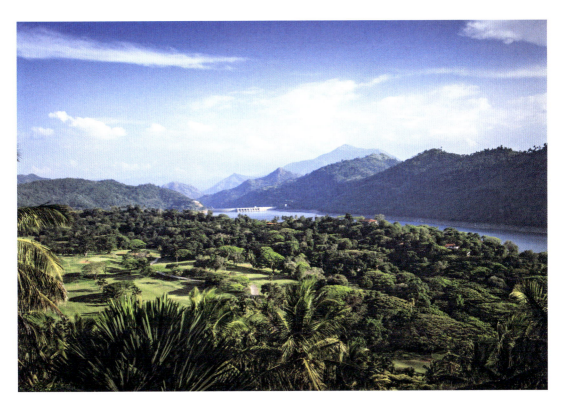

www.golfsrilanka.com +94 717 376 376

Asia Thailand

74 AYODHYA LINKS

199 Moo 10, Boh Talo,
Wangnoi, Ayutthaya 13170, Thailand

TO VISIT BEFORE YOU DIE BECAUSE

Its extreme exclusivity makes this course a must-play—you need to know the right people to gain access.

There are many golf courses that are members-only, but there are relatively few where membership itself is invitation-only. Ayodhya Links, outside of Bangkok, is one of the few. The ultra-exclusive club was founded in 2007 and its course was designed by Peter Thomson, Ross Perrett, and Tim Lobb, with finishing touches by Ayodhya Links' founder and chairman, Pitak Intrawityanunt, who redesigned the holes after a major flood in 2011. Though few outsiders have played the course—membership is limited and only guests of current members can play—its design has been greatly praised by those lucky enough to score a round. So, if you want to add the Ayodhya Links badge to your sash, you might want to start making some new friends.

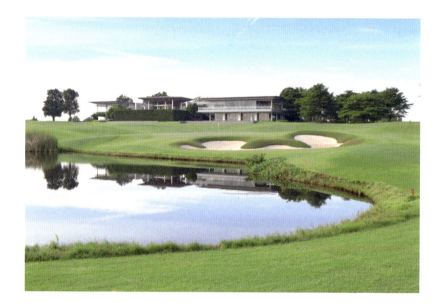

www.ayodhyalinks.com +66 35 257 999

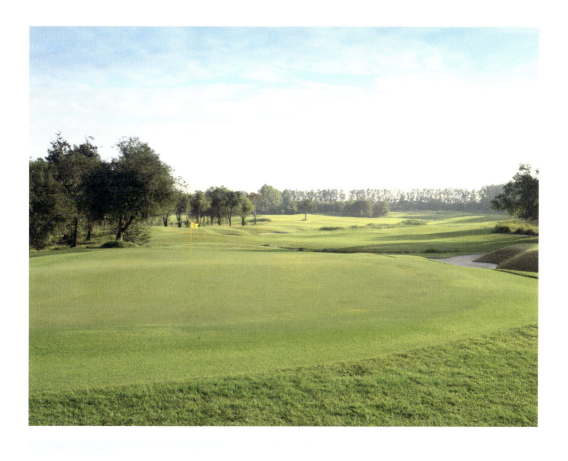
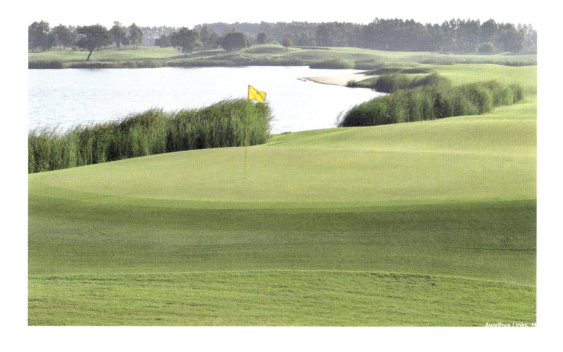

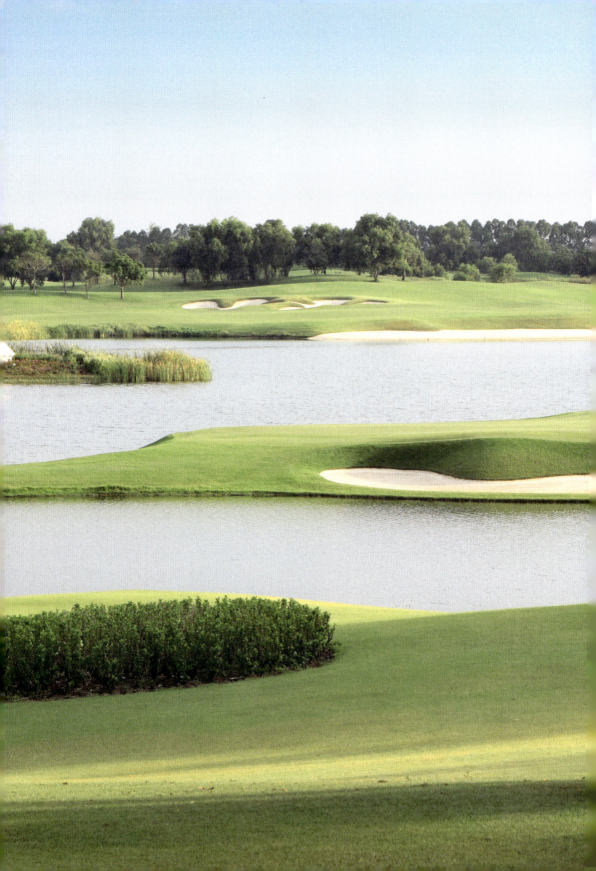

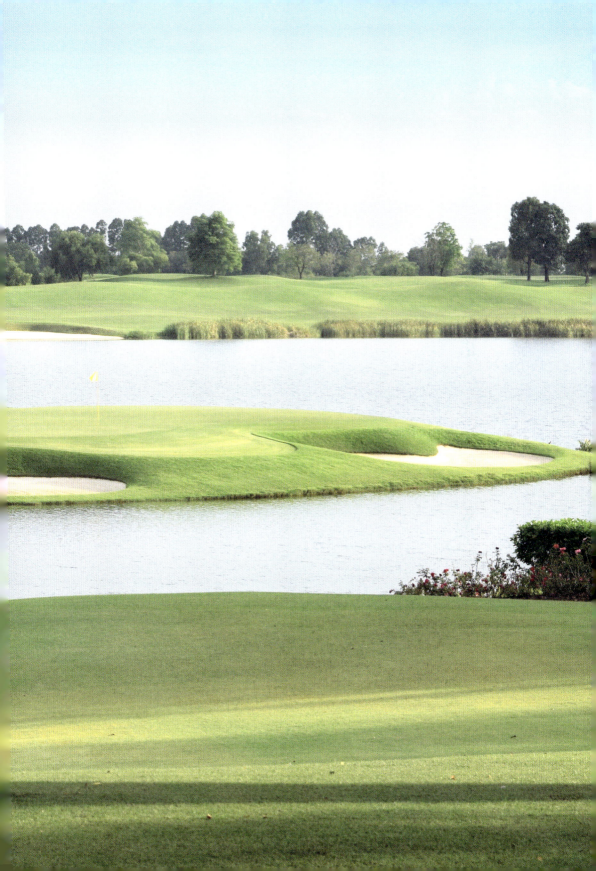

Asia Thailand

75 BLACK MOUNTAIN GOLF CLUB

565 Moo7, Nong Hieng Road, Hin LekFai, Hua Hin, Prachaubkirikhan 77110, Thailand

TO VISIT BEFORE YOU DIE BECAUSE

With three nine-hole courses, you can DIY your own 18-hole round.

When Black Mountain Golf Club—located in former pineapple fields—opened in 2007, it had a classic 18-hole course designed by Australian Phil Ryan. But in 2016, a further nine holes were added by the club's founder Stig Notlov and golfer Johan Edfors. Now, players can choose between the original front nine (East), the original back nine (North), and the new holes (West) to create their own layout for a full round. No matter which combination you choose, you're all but guaranteed to enjoy the lush scenery surrounding the courses—not to mention the championship-caliber golfing.

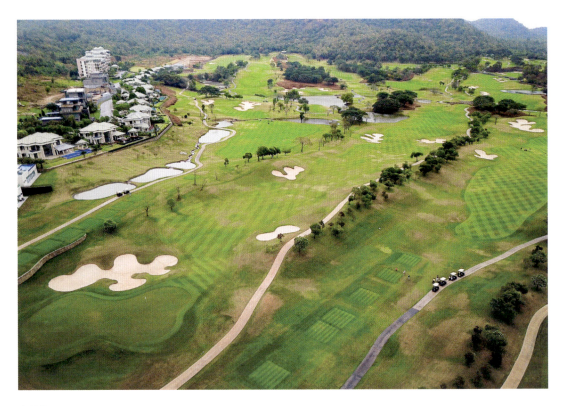

www.blackmountainhuahin.com/golf/ +66 (0)32 618 666

Asia — Thailand

76 SIAM COUNTRY CLUB: OLD COURSE

50/6 Moo 9, T. Pong, A. Banglamung,
Chonburi 20150, Thailand

TO VISIT BEFORE YOU DIE BECAUSE

It's home to Thailand's own "Amen Corner."

Although golf has been played in Thailand for more than a century, the sport has grown in popularity among both local and international golfers over the past 50 years. Built in 1971 just outside the city of Pattaya, Siam Country Club's Old Course—which isn't altogether that old in the scheme of the sport—was one of the first courses of Thailand's modern golf era, designed by Japanese architect Ichisuke Izumi. The course underwent a major renovation by Lee Schmidt and Brian Curley in 2007, and since 2010 it has been home to the LPGA Honda Classic tournament. Its four final holes are considered Thailand's "Amen Corner," nodding to the three-hole stretch of the same name at Augusta National Golf Club in the United States.

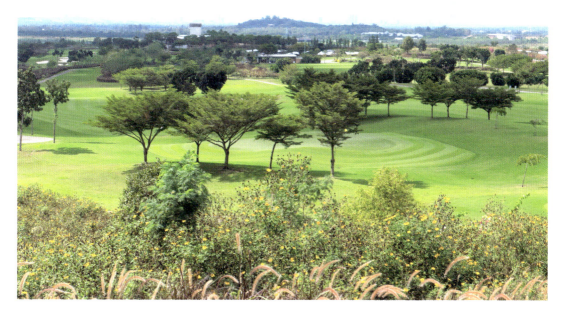

www.siamcountryclub.com +66 38 909 700

Asia — United Arab Emirates

77 DUBAI CREEK GOLF & YACHT CLUB: CHAMPIONSHIP

Baniyas Road, Port Saeed, Dubai, UAE

TO VISIT BEFORE YOU DIE BECAUSE

There's a "floating" tee at hole six.

For a desert golf course, it's unusual that water plays so prominently in the design. But that's exactly what happens at Dubai Creek Golf & Yacht Club's Championship Course, opened in 1993. The eponymous creek affects four holes—including the sixth, where golfers must tee off from a platform on the water, while artificial lakes add to the difficulty of other holes, thanks to designer and golfer Karl Litten, the original architect of the project who oversaw a 2004 renovation. The views from the course are pretty spectacular no matter where you stand, as you look out at the water, the city's skyscrapers, and the sail-shaped clubhouse, which acknowledges the connection to the creek.

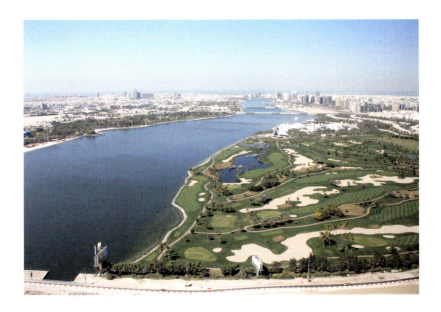

www.dubaigolf.com/dubai-creek-golf-and-yacht-club/

+971 4 295 6000

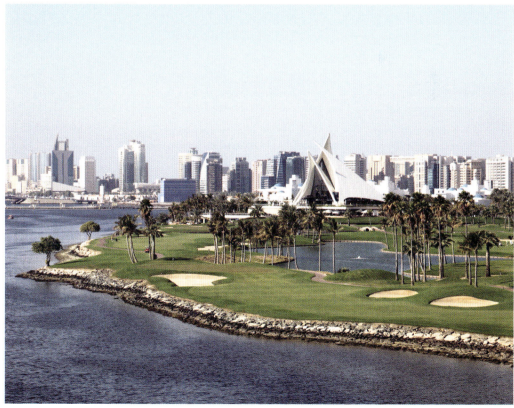

Asia — United Arab Emirates

78 EMIRATES GOLF CLUB: MAJLIS

17/2, Al Naseem Street Emirates Golf Club, Al Thanyah 3, Hadaeq Mohammed Bin Rashid, Dubai, UAE

TO VISIT BEFORE YOU DIE BECAUSE

Before Emirates opened in 1988, there were no 18-hole grass golf courses in the Middle East.

Before 1988, the site of the Emirates Golf Club was just desert dunes. Today, greenery abounds—in the form of fairways and greens, that is. The club's Majlis Course was the first grassy championship course in the entire Middle East, designed by Karl Litten with support from His Highness General Sheikh Mohammed bin Rashid Al Maktoum. But grass isn't the only thing growing on the course: At the sheikh's request it also features various indigenous plants. The Majlis Course debuted a renovation in 2021 that expanded the greens and incorporated new sustainable features to meet the standards of the United States Golf Association (USGA).

www.dubaigolf.com/emirates-golf-club.aspx +971 4 417 9999

Asia Vietnam

79 BA NA HILLS GOLF CLUB

An Son, Hoa Ninh Ward, Hoa Vang District, Da Nang City, Vietnam Da Nang 550000, Vietnam

TO VISIT
BEFORE YOU DIE
BECAUSE

It perfectly showcases the splendor of Vietnam's inland courses.

Many of Vietnam's golf courses are located along the sea, which, considering there are more than 2,000 miles of coastline along the mainland, makes plenty of sense. But courses are also being developed inland, including the spectacular Ba Na Hills Golf Club. Opened in 2016, the course—Luke Donald's first in Asia—is located an hour's drive from the seaside city of Da Nang, where the terrain begins to rise into the Annamese Mountains. You won't feel the cool sea breezes here, but thanks to the floodlights on the course you can play at night when it's cooler. You also won't get to enjoy the dramatic views of the mountains and valleys, so maybe playing at dusk is the happy medium.

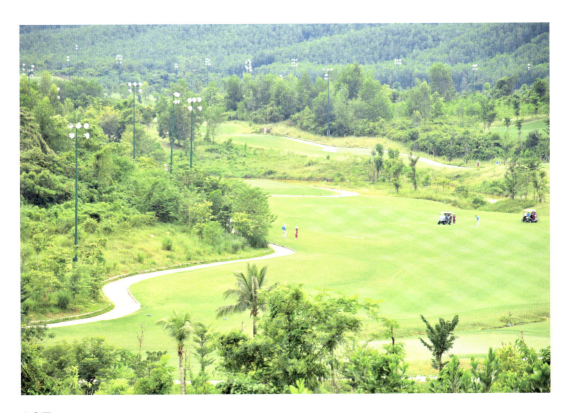

www.banahillsgolf.com +84 236 3924 888

Asia — Vietnam

80 DAI LAI STAR GOLF & COUNTRY CLUB

Ngoc Thanh, Phúc Yên, Vinh Phuc Province, Vietnam

TO VISIT BEFORE YOU DIE BECAUSE

Only an hour outside Hanoi, this is a prime lakefront golf course.

Playing a round of golf at Dai Lai Star Golf & Country Club, you'd never know you were just an hour outside of Hanoi. The course is set on the shores of Dai Lai Lake in the shadow of Ngoc Thanh Mountain—a somewhat unusual location for a Vietnamese golf course, as most are oceanfront. On the front nine you're playing in the forest, while on the back nine the lake is the dominant feature, though it's not really an ominous obstacle. Instead, the main challenge comes from the bunkers and the fairly large greens.

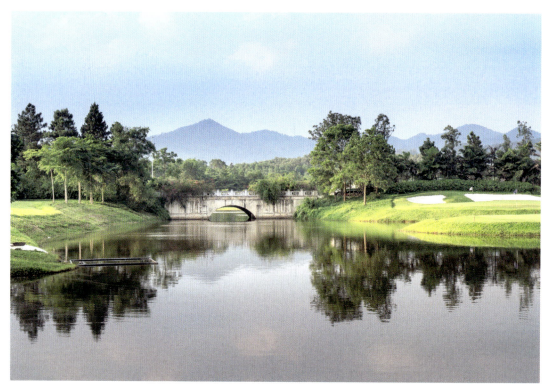

www.1golf.eu/en/club/dai-lai-star-golf-country-club/

+84 2116 29 2222

Asia Vietnam

81 KN GOLF LINKS CAM RANH: THE LINKS

Long Beach, Cam Ranh Peninsula,
Khanh Hoa Province, Vietnam

TO VISIT
BEFORE YOU DIE
BECAUSE

Players experience some 160 feet of elevation change in the rolling dunes on this course.

For an ever-so-brief moment, a quick look around the Links Course at KN Golf Links might trick you into thinking you're on the other side of the planet—in Scotland. Greg Norman designed this links-style course to work perfectly with the barren dunes of the natural coastal landscape, drawing golfers up and down a 160-foot elevation change between the highest and lowest points. Highlights are the 10th and 15th holes, both of which are run downhill toward the azure South China Sea. Opened in 2018, this is one of Vietnam's newer courses.

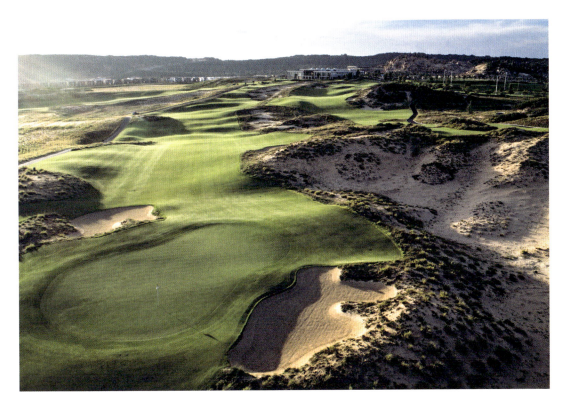

www.kngolflinks.com (+84) 2583 999 666

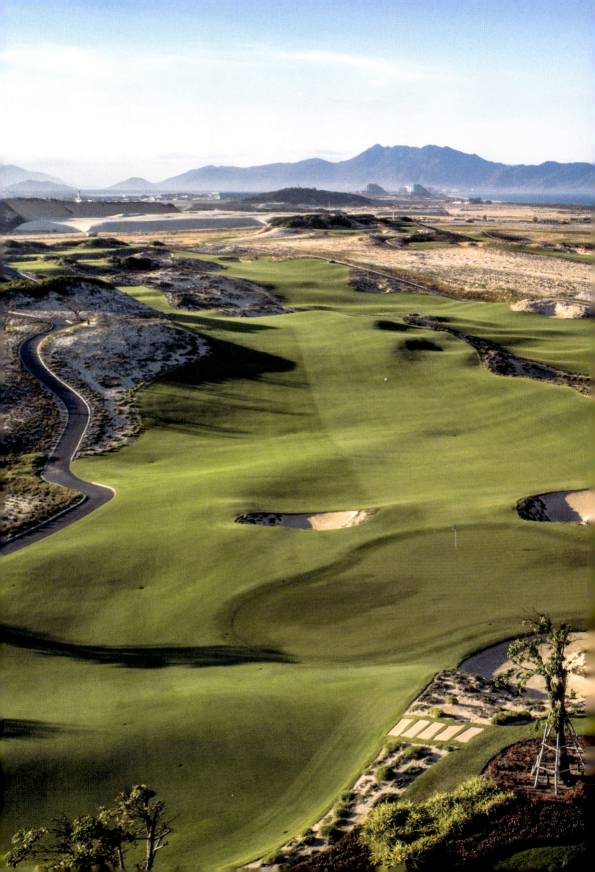

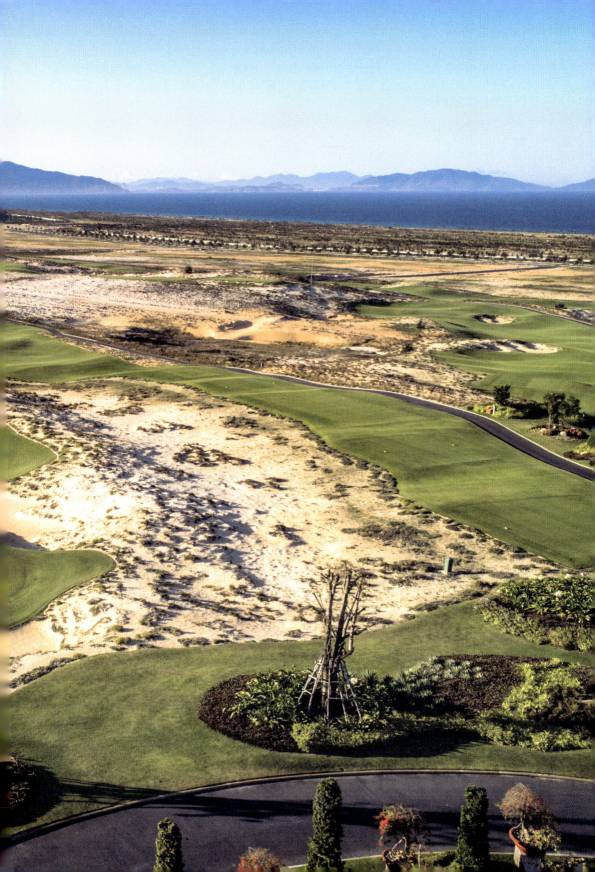

Asia — Vietnam

82 LAGUNA GOLF LĂNG CÔ

Cu Du Village, Lôc Vĩnh Commune,
Phú Lôc District, Thua Thien Hue Province, Vietnam

TO VISIT BEFORE YOU DIE BECAUSE

You'll find jungle, rice paddies, and beaches at this eco-friendly golf course.

In 2013, golfer Sir Nick Faldo opened the championship-caliber course Laguna Golf Lăng Cô not only as its owner but also as its designer. Located in the jungle and the sand dunes between the sea and the mountains, it has a magnificent setting, with challenging holes to boot. Overall, the course is relatively links-like, with an out-and-back layout and a strong focus on the land—including rice paddies whose harvests are primarily donated to local families. However, one of the most impressive aspects of Laguna Golf Lăng Cô is its commitment to sustainability. Single-use plastics are banned, while water buffalo are used as greenskeepers. The course earned EarthCheck Gold certification in 2019.

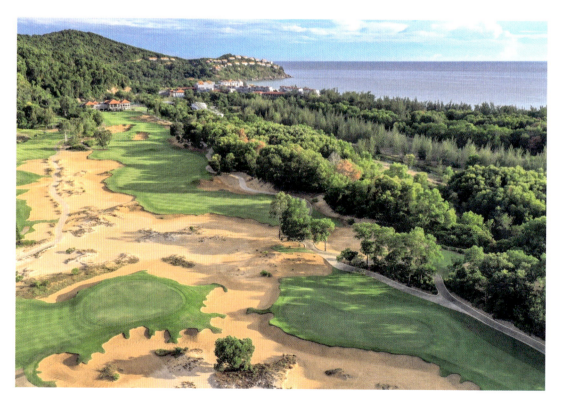

www.lagunalangco.com/en/golf/ — +84 (0) 234 3695 880

Asia Vietnam

83 VINPEARL GOLF NHA TRANG

Hon Tre Island, Vinh Nguyen Ward,
Nha Trang City, Khanh Hoa Province, Vietnam

TO VISIT BEFORE YOU DIE BECAUSE

The views at this island golf course are the reason Vietnam's coastal courses are so popular.

Popular vacation destination Nha Trang in Vietnam has a number of golf courses, but one of the most spectacular is the Vinpearl Nha Trang. The IMG-designed course is located on Hon Tre Island, which means that to get there you either need to take the scenic cable car (that's hoisted over the bay by structures that look like the Eiffel Tower) or a boat ride, which, many golfers report, is all part of the fun. The course itself is one of the best resort layouts in the area, challenging golfers to play through a number of lakes set against the backdrop of the bay and mountains beyond.

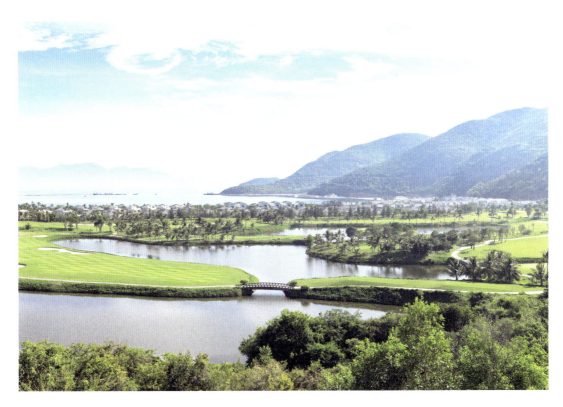

Europe Austria

84 GOLF CLUB WILDER KAISER

Auerbichl 2, 6352 Ellmau, Austria

TO VISIT BEFORE YOU DIE BECAUSE

You can mix-and-match two of the three nine-hole courses here for a full round.

Set in Austria's Kaiser Mountains, the Golf Club Wilder Kaiser is unsurprisingly a mountain course with scenic views. However, what makes this course stand out among its Alpine neighbors is the fact that it comprises three nine-hole courses across nearly 220 acres, allowing players to mix-and-match to play a full round. The variety keeps golfers coming back again and again (and the mountain views don't hurt, either!). Like other nearby courses, Wilder Kaiser is set in a valley, meaning the topography of the course is relatively flat, allowing for a leisurely game.

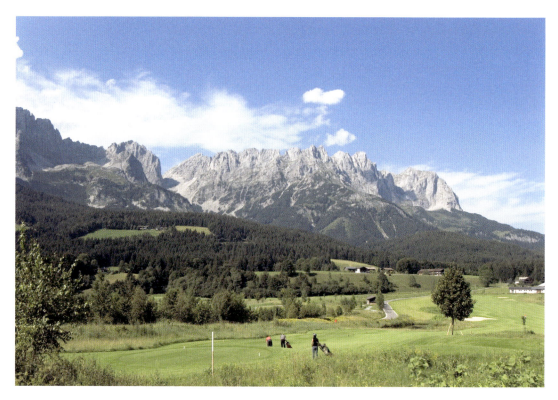

www.wilder-kaiser.com/en/ +43 5358 4282

Europe · Belgium

85 ROYAL LIMBURG GOLF CLUB

Golfstraat 1, 3530 Houthalen-Helchteren, Belgium

TO VISIT BEFORE YOU DIE BECAUSE

During the late summer and early fall, purple heathers bloom across the course.

Green is the de facto color of golf, but at the Royal Limburg Golf Club in Houthalen, purple takes over—at least for several months a year! The course is primarily heathland, set partially in the Tenhaagdoornheide nature reserve and partially in a pine and birch forest. The standout feature of the landscape is, of course, the heather fields, which bloom between late July and early September, washing the course in a lovely violet hue. Royal Limburg was founded by the golf-loving residents of the town of Limburg in 1966, who commissioned British architect Fred Hawtree to design the course. The full 18 holes were completed in 1972.

www.klgc.be/ · +32 (0)89 843 204

Europe Bulgaria

86 THRACIAN CLIFFS GOLF & BEACH RESORT

9656 Bozhurets Village, Kavarna, Bulgaria

TO VISIT BEFORE YOU DIE BECAUSE

The refreshing white-chalk cliffs are a sight to be seen.

Bulgaria's Cape Kaliakra on the Black Sea coast might not be familiar to casual golfers from outside Europe, but the destination has been steadily growing in popularity among the larger golf crowd. The signature course in this resort region is Thracian Cliffs, thanks to the eponymous white cliffs that line the shore, providing a stunning backdrop to the golf course, designed by South African golfer Gary Player. The most photogenic hole is the sixth, where the green runs right to the cliff edge. While beautiful, this hole is a little tricky. "It is not a good idea to try the left-hand side of the green—the cliff likes to eat the balls," the resort's website warns.

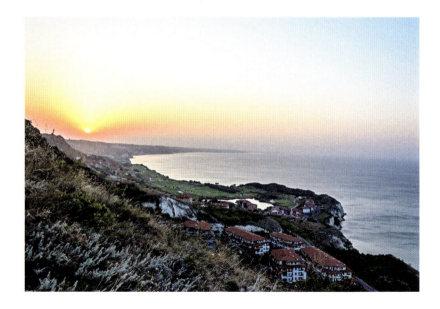

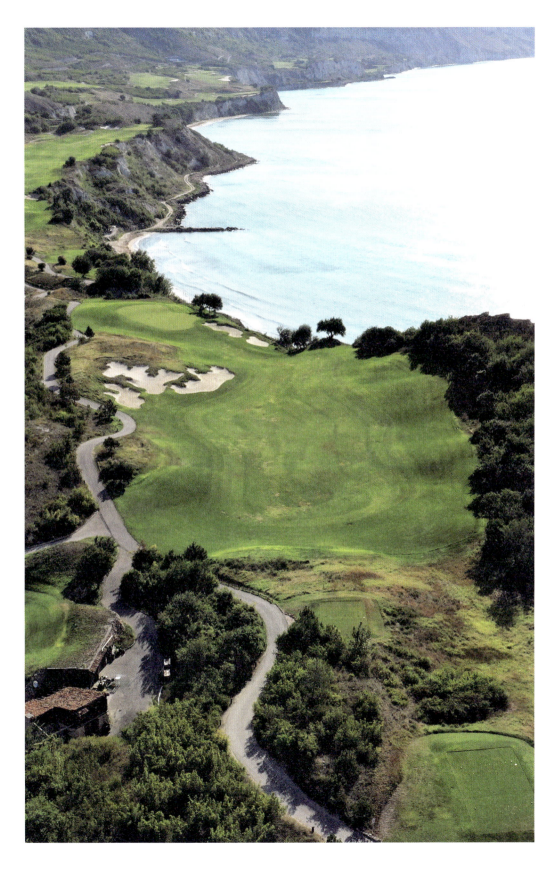

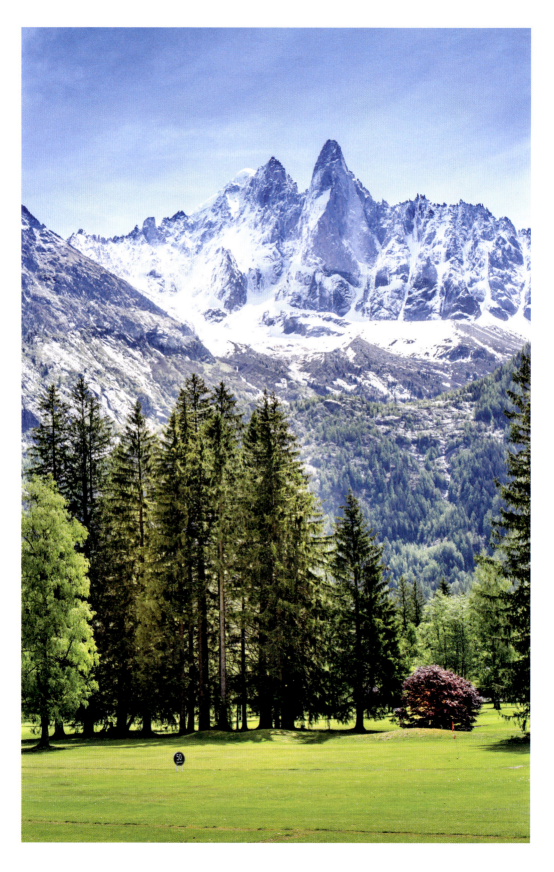

Europe — France

87 CHAMONIX GOLF CLUB

35 Route du Golf, 74400 Chamonix-Mont-Blanc, France

TO VISIT BEFORE YOU DIE BECAUSE

You golf beneath the overwhelming Mont Blanc and Aiguilles Rouges.

The dominant attraction in Chamonix is, without a doubt, the mountains. The hardiest of outdoorsy types might attempt to scale Mont Blanc or the Aiguille du Midi, while the more casually outdoorsy are satisfied with good old-fashioned skiing. But in the summer, there's also the opportunity to golf at the Golf Club de Chamonix. Though the course is largely flat, set into the valley beneath the peaks, it's not an easy layout; the opening hole has golfers carry two water hazards. Test your skills during the few months a year that the course is open (in the winter, the course is covered in snow and is used for skiing). To get a slightly different perspective of Mont Blanc, play a round at Courmayeur on the Italian side of the mountain.

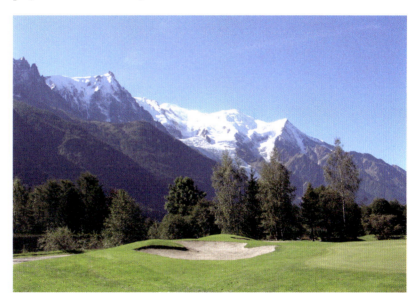

www.golfdechamonix.com/fr — 04 50 53 06 28

Europe · France

88 GOLF BLUEGREEN PLÉNEUF-VAL-ANDRÉ

Rue de la Plage des Vallées, 22370 Pléneuf-Val-André, France

TO VISIT BEFORE YOU DIE BECAUSE

The terrain in the Brittany region of France is delightfully picturesque.

With cliffs tumbling down to sandy beaches and the English Channel beyond, designer Alain Prat had plenty to work with when creating the attractive Pléneuf-Val-André course for golf company Bluegreen. But don't let the idyllic landscape fool you—strong winds carrying sea spray can throw a wrench into a golfer's best-laid plans, making playing here exceptionally challenging at times. That's especially true on the signature 11th hole, where the back tee is located on a cliff's rocky edge and golfers play parallel to the water.

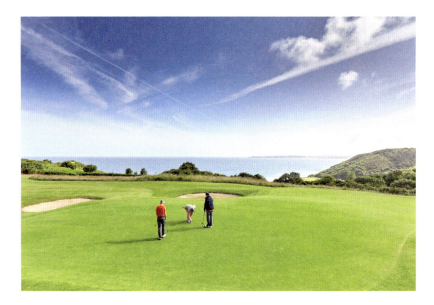

www.bluegreen.fr/pleneuf 0296630112

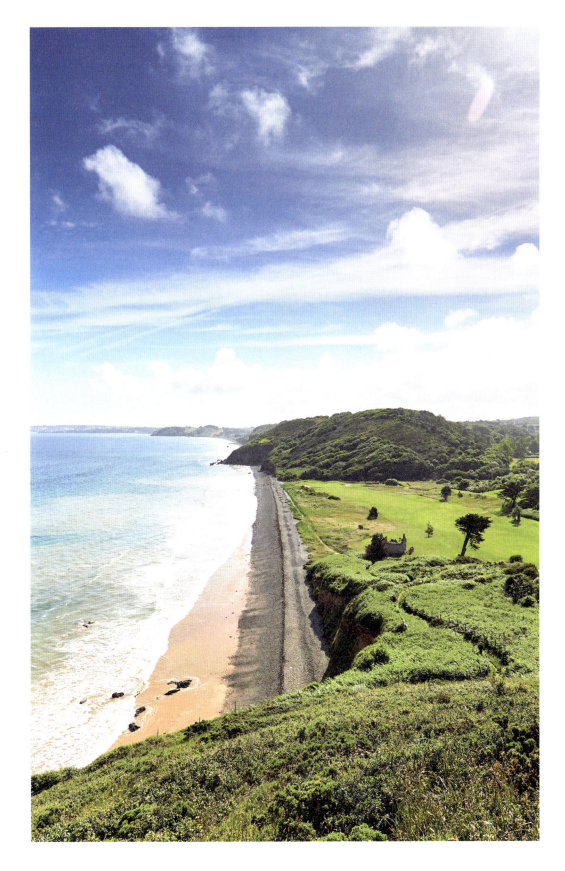

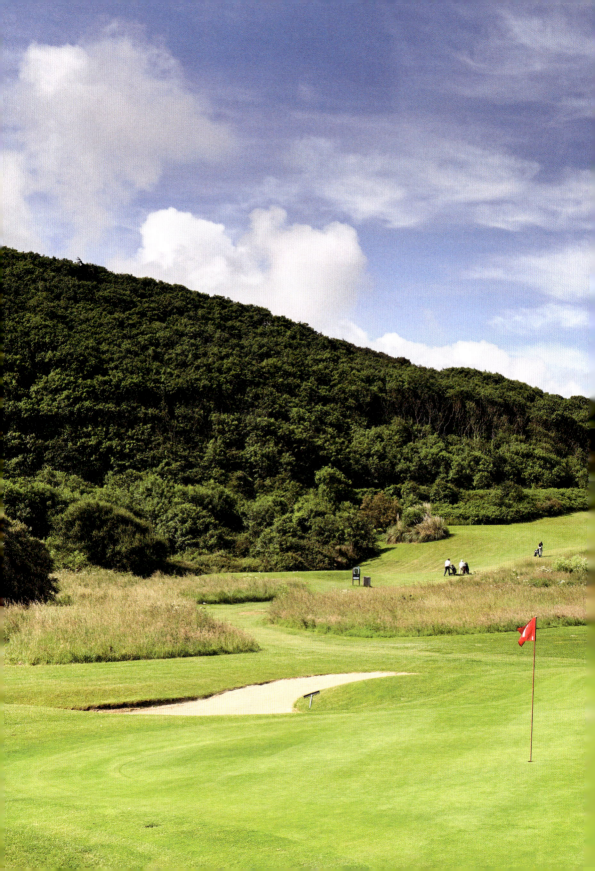

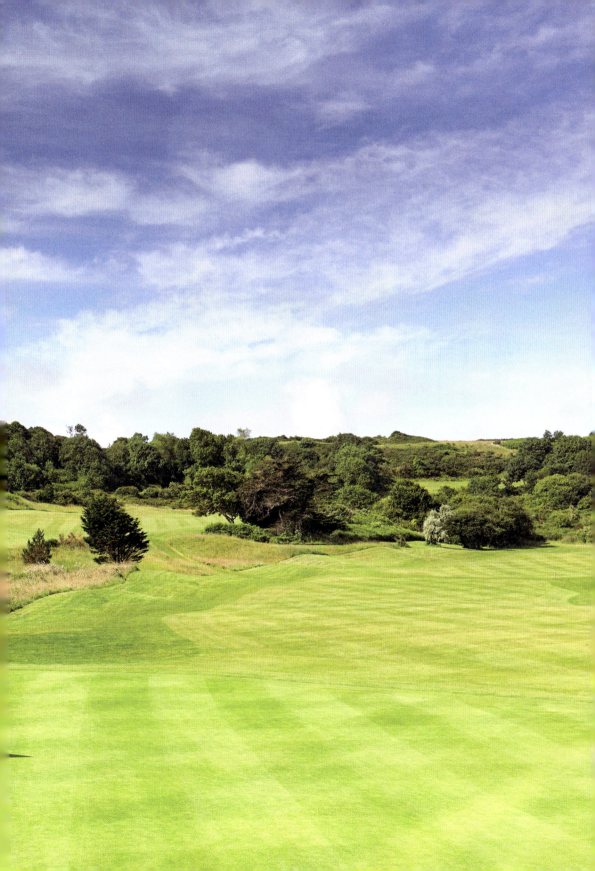

Europe · France

89 GOLF D'ÉTRETAT

Route du Havre, F-76790 Étretat, France

TO VISIT BEFORE YOU DIE BECAUSE

Many golf courses are built atop cliffs, but not cliffs like these.

At Golf d'Étretat in Normandy, the 10th hole is a stunner. The coastal town is known for its white chalk cliffs facing the English Channel, and the hole plays right up to them. The original course was designed in 1908 by Bernard Forbes, 8th Earl of Granard, and it featured just 13 holes, of which five were played twice. But the course was extended to its completion after World War I, though it suffered during World War II when its fairways and greens were filled with landmines. Golf d'Étretat reopened in 1949 and has since been entertaining French and international golfers alike.

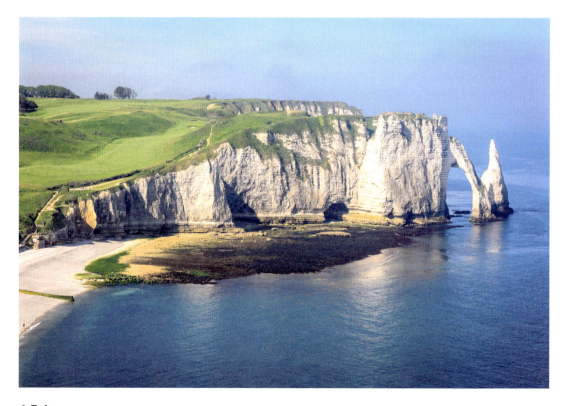

Europe France

90 LE GOLF NATIONAL: ALBATROS

2, avenue du golf CS40549, 78286 Guyancourt, France

TO VISIT BEFORE YOU DIE BECAUSE

This course has hosted the French Open every year but two since 1991.

Even if you're not a golf pro, you can still feel like one as you play Le Golf National's Albatros Course, the host of the venerable French Open since 1991 (save for two years). The stadium-style course just outside of Paris, near Versailles, can accommodate 80,000 spectators, and though there might not be quite that many as you play a round, you can still feel the grandeur. As the geography in this area of France is quite flat, architects Hubert Chesneau and Robert von Hagge had truckloads of earth moved to create the undulations of the course—they essentially had carte blanche to create the design of their dreams.

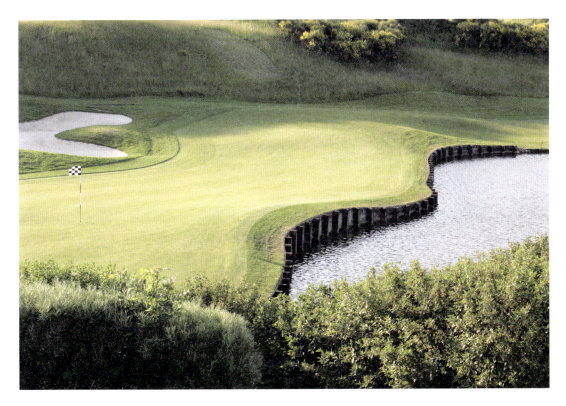

www.golf-national.com/en/albatros-course +33 1 30 43 36 00

Europe — France

91 GOLF DE SPÉRONE

Domaine de Spérone, 20169 Bonifacio, Corsica, France

TO VISIT BEFORE YOU DIE BECAUSE

This Corsican course has the best of Mediterranean beaches, limestone cliffs, and fragrant herbal scrubland.

While the landscape is a big part of any golf course, the natural surroundings on the island of Corsica truly awaken the senses. That's what makes Golf de Spérone, designed by the legendary Robert Trent Jones Sr., such an appealing place to play. Visually, you're gifted turquoise waters and white limestone cliffs, set to the backdrop of the sea's waves. Then the course is surrounded by maquis, or shrubland, packed with lavender, thyme, and rosemary, their fragrances blowing with the breeze across the fairways. The back nine are the more scenic of the holes, with the 16th hole, in particular, standing out as the signature—you must hit over the Mediterranean Sea twice on this par five.

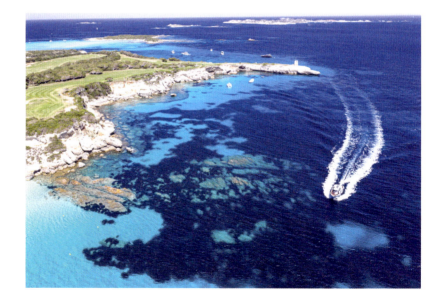

www.golfdesperone.com +33 (0) 4 95 73 17 13

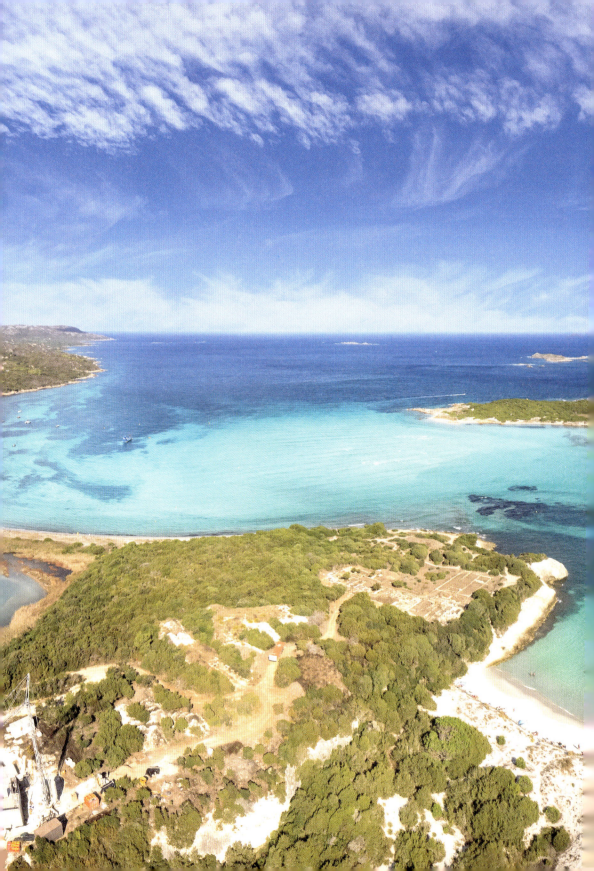

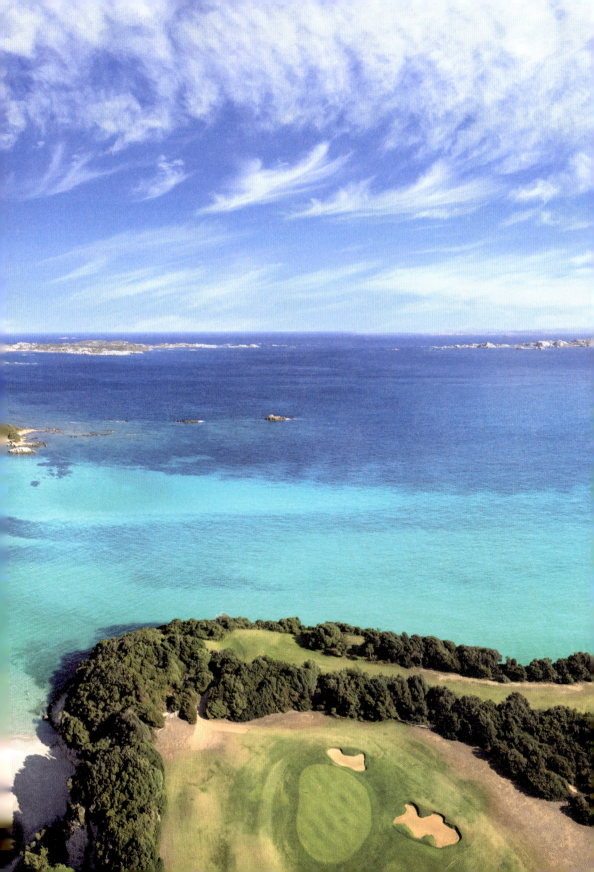

Europe Greece

92 COSTA NAVARINO: THE DUNES

Navarino Dunes, Messinia, Costa Navarino 24001, Greece

TO VISIT BEFORE YOU DIE BECAUSE

This course ushered in a new era of golf in Greece.

Unlike the countries on the western side of the Mediterranean, Greece is not a true golf destination. But the Costa Navarino resort, and more specifically the Dunes Course, has changed that. Opened in 2010, the Dunes became the country's first signature golf course, featuring a design by Bernhard Langer. (Its sister course, The Bay, was designed by Robert Trent Jones Jr.) There are some links-style elements throughout this course, namely a few artificial dunes and some gusty sea breezes at times, but the olive and citrus trees are a dead giveaway that you're in the Mediterranean and not the North Atlantic. Be forewarned: Both the fairways and the greens are deceptively large here. It's easy to lose a ball in the vegetation if you overshoot, and the putting surfaces are more dynamic than you might expect.

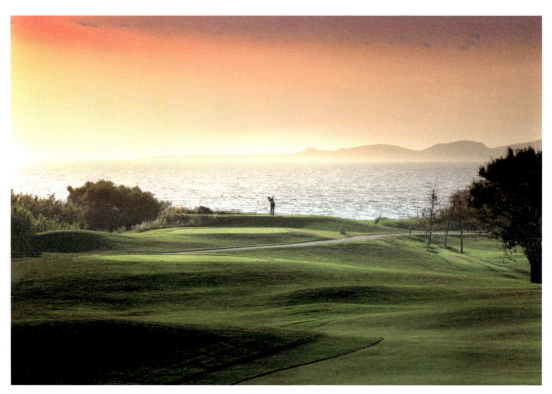

www.costanavarino.com/golf-resort/dunes-course

+30 27230 90200

Europe Iceland

93 BORGARNES GOLF COURSE

Golfklúbbur Borgarness, Hamar, 310 Borgarnes, Iceland

TO VISIT BEFORE YOU DIE BECAUSE

This is Iceland's only golf resort (among many golf courses).

For a relatively young golf course, the Borgarnes has seen quite a few iterations over the years. It was built in 1976 as a nine-hole course, expanding the three holes built in Borgarnes village by locals. It then grew to nine holes in 1987, before being entirely redesigned in 1998. The course as it now stands was completed in 2007, and it has accommodation and restaurants (the club bills itself as Iceland's only golf resort). But there's one thing that hasn't changed at all over the past few decades, namely its gorgeous natural setting. Located just shy of an hour outside of Reykjavík, the Bogarnes boasts dramatic mountain and water views.

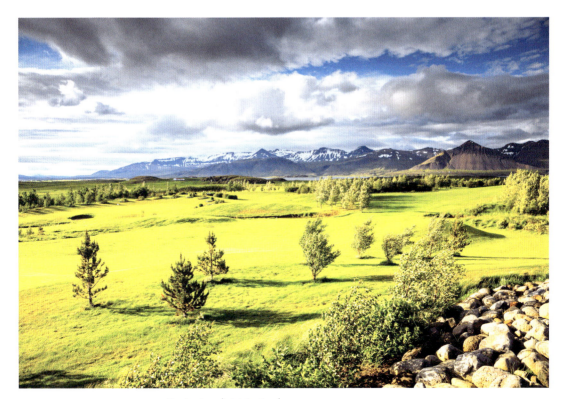

golficeland.org/introduction/borgarnes-golf-course 354-437-1663

Europe — Iceland

94 KEILIR GOLF CLUB

Steinholt 1, 220 Hafnarfjörður, Iceland

TO VISIT BEFORE YOU DIE BECAUSE

Glacier views are par for the course (pardon the pun).

Too often people misperceive Iceland as, well, an icy destination. And while there are snowy winters and plenty of glaciers, the climate is generally mild here, especially in the summer, when Icelanders love to play golf. There are more than 60 courses in the small island nation, some of which are open 24 hours a day (because the sun doesn't set in Iceland during the summer!). The top course is Keilir, a links course between the capital city of Reykjavík and the Keflavik airport, where the front nine traverse an old lava field, while the back nine lie on a peninsula abutting Hafnarfjordur harbor with views of the Snæfellsjökull glacier. The original nine-hole course was designed by local golfer Magnus Gudmundsson in 1967, with later extensions by Swedish designer Nils Skjöld and Icelandic designer Hannes Thorsteinsson and a renovation by English firm Mackenzie & Ebert.

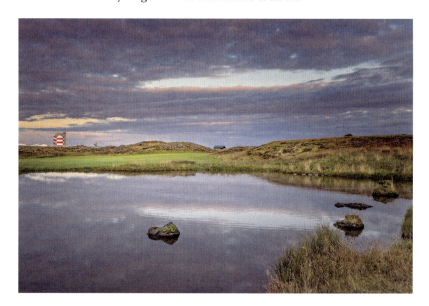

www.english.keilir.is +354 565 3360

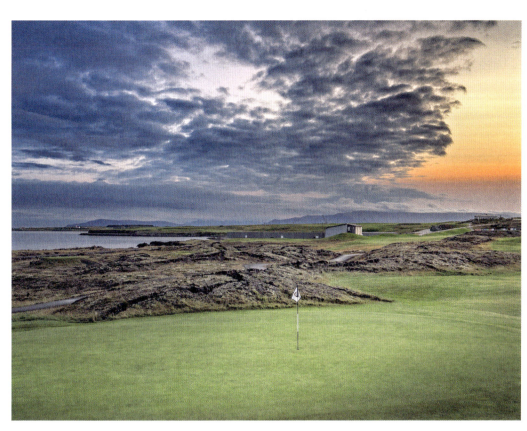
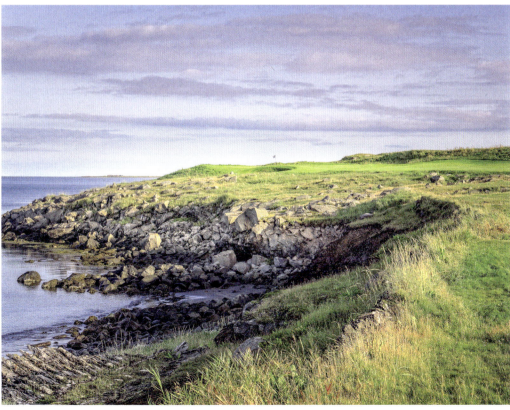

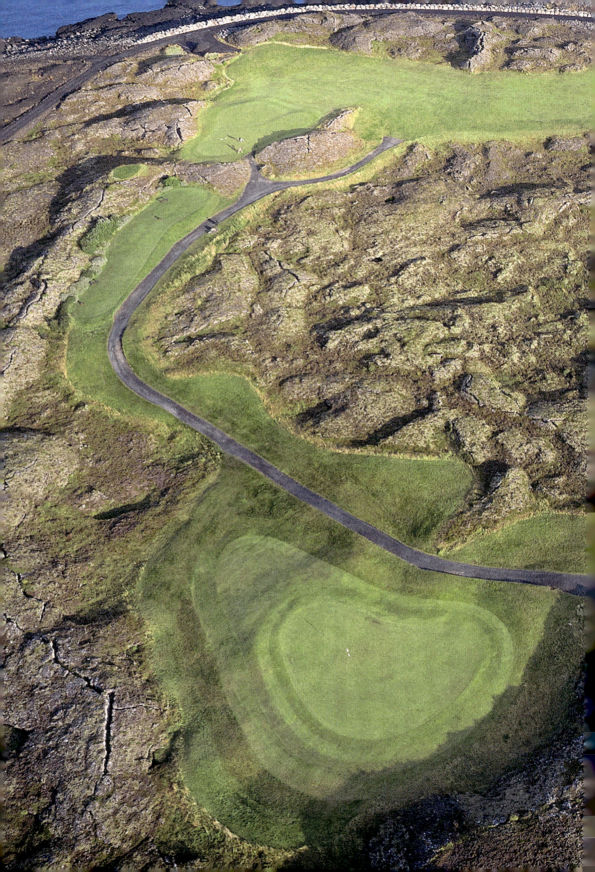

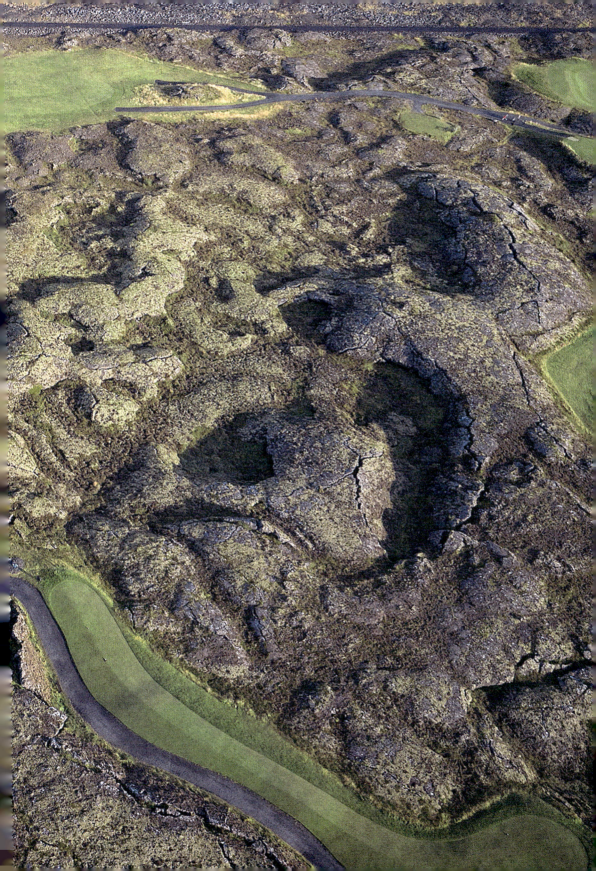

Europe Iceland

95 WESTMAN ISLANDS GOLF CLUB

Golfklúbbur Vestmannaeyja, Pósthólf 168, 902 Vestmannaeyjar, Iceland

TO VISIT BEFORE YOU DIE BECAUSE

You'll be golfing in an old volcano.

Iceland is the land of fire and ice, but when you're golfing at the Westman Islands (Vestmannaeyjar) Golf Club on Heimaey Island, it's definitely more fire than ice. Or at least it used to be—the course is built into an old volcano. But don't worry, it's extinct, so you probably don't have to worry about any lava hazards. (A neighboring volcano on the island did erupt in 1973.) Instead, you can enjoy the scenic surroundings and maybe even peep at one of the millions of puffins that nest here. That said, you'll have to focus—the winds can be unforgiving, and there are some steep cliffs to contend with. The Westman Islands Golf Club is one of the oldest in Iceland, founded in 1938, and it hosts the annual Volcano Open in early July, commemorating the end of the 1973 eruption.

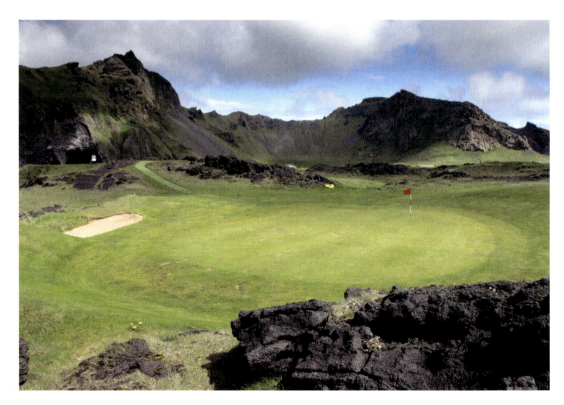

www.gvgolf.is +354 481 2363

Europe Ireland

96 BALLYBUNION GOLF CLUB: OLD

Sandhill Road, Ballybunion, County Kerry, Ireland

TO VISIT BEFORE YOU DIE BECAUSE

What was once an obscure links has become one of the most sought-after courses in the world.

When Ballybunion was founded in 1983 amid the dunes of County Kerry, Ireland, it was a treasure for locals, but enjoyed little international success. However, the Old Course did host the Irish Amateur Close Championship in 1937, following a renovation by English architect Tom Simpson and English golf champion Molly Gourlay, which still largely remains intact today. But by the 1960s, the secret was out, at least among the elite golf community. In 1982, golfer Tom Watson said "Nobody can call himself a golfer until he has played at Ballybunion; you would think the game originated there!" Ever since, golfers' thirst for the windy dunes of Ballybunion has been unquenchable.

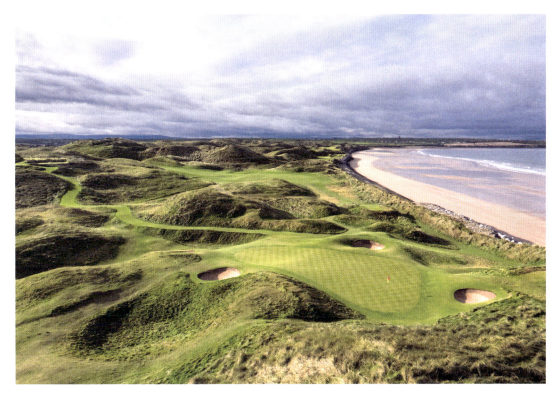

www.ballybuniongolfclub.com +353 (0) 68 27146

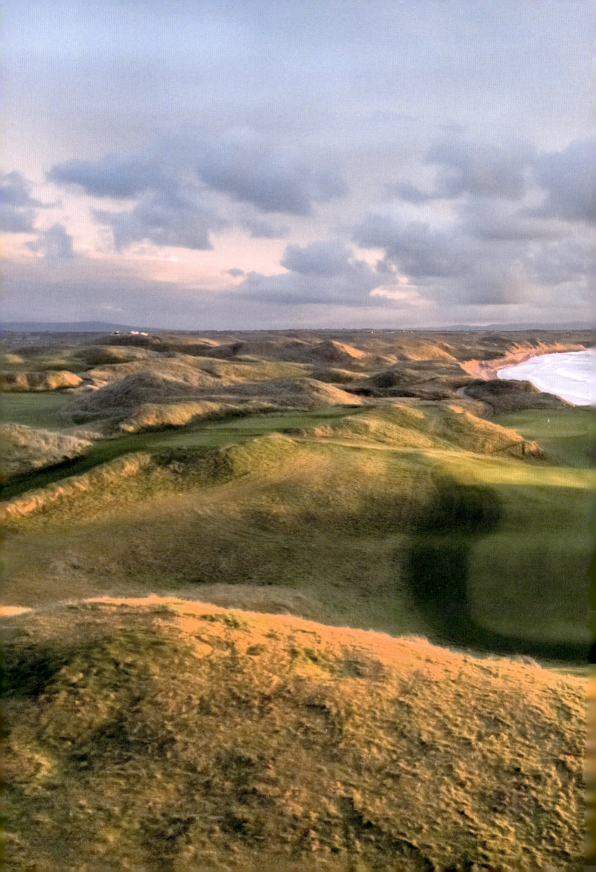

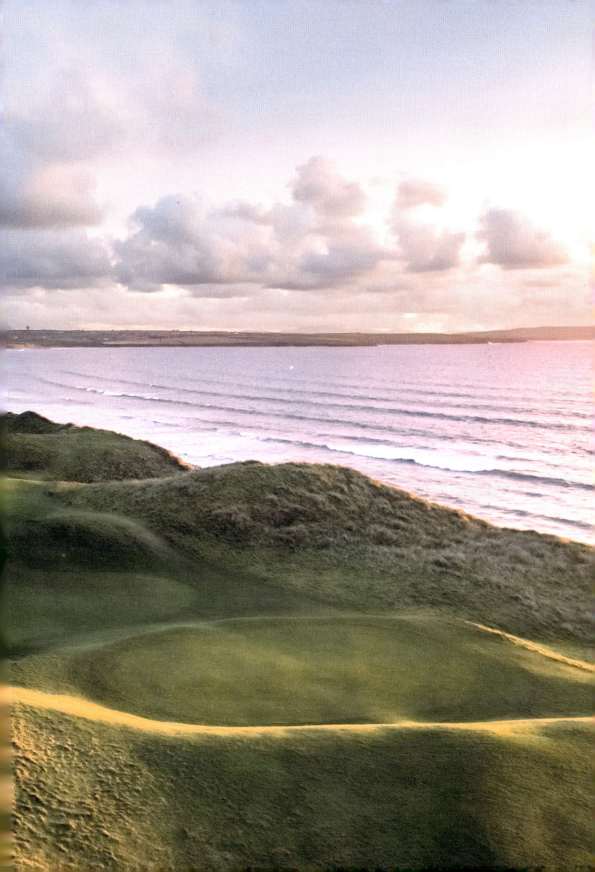

Europe Ireland

97 LAHINCH GOLF CLUB: OLD

Lahinch, County Clare, Ireland

TO VISIT BEFORE YOU DIE BECAUSE

Goats predict the weather at this historic Irish golf course.

Back in 1892, the Black Watch Regiment of the British Army was tasked with a crucial mission—to find the sand dunes in Ireland for a golf course. They came upon Lahinch, where they built 18 holes, which were later redesigned by Scottish golfer Old Tom Morris and Scottish architect Dr. Alister MacKenzie. Old Tom Morris called this "the finest natural course he had ever seen," a sentiment that holds true more than 125 years later. One of the most interesting quirks about Lahinch's Old Course is its herd of weather-predicting goats. According to Club lore, the goats helped golfers anticipate the weather conditions: If bad weather was brewing, the goats stayed close to the clubhouse, but on fair days they'd roam out to the course.

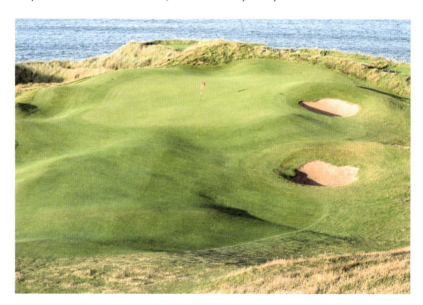

www.lahinchgolf.com +353 65 708 1003

Europe Ireland

98 OLD HEAD GOLF LINKS

Kinsale, County Cork, Ireland

TO VISIT BEFORE YOU DIE BECAUSE

Golf aside, the Old Head area is extraordinarily rich in history, wildlife, and plant life, all of which add to the experience of the game.

The diamond-shaped headland referred to in the name of this golf course is indeed old. Geologically, we're talking about hundreds of millions of years—but in human history? Well, let's just say that Greek polymath Ptolemy drew Old Head on one of his maps in 100 C.E. (and that's not to mention the 6,000-year-old artifacts found here). Interestingly, the course itself is relatively new: It opened in 1997. Designed by a team of golf A-listers, the course works its way through the spectacular clifftop landscape, some 300 feet above the Atlantic, right alongside the old castle and the picturesque lighthouse. Old Head is also a seabird breeding ground, with more than 60 species known to nest here, and a botanical playground, too, with more than 110 native plants.

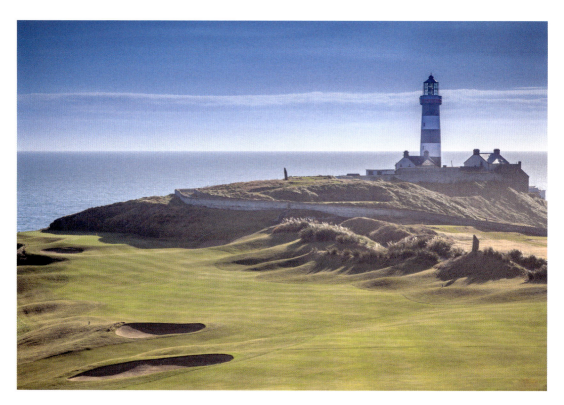

Europe Ireland

99 PORTMARNOCK GOLF CLUB: CHAMPIONSHIP

Golf Links Road, Portmarnock, Dublin, County Dublin, Ireland

TO VISIT BEFORE YOU DIE BECAUSE

The first Irish Open was held at this golf links, which has been played and loved by many of the greatest names in the sport.

In 1893, the grounds that are now the Portmarnock Golf Club were just a remote peninsula in the Irish Sea only accessible by boat. But William Chalmers Pickeman and George Ross recognized the site's potential as a golf course, and a year later the club opened with nine holes, whose design was overseen by golf champion Mungo Park. After further expansion, Portmarnock would go on to host the first Irish Open in 1927, then over the years draw in many of the best golfers in the world, many of whom enjoy the largely natural course's demands of playing in varied directions. In 2021, the club finally removed its men-only policy for membership, which had been in place since its founding.

Europe Italy

100 CERVINO GOLF CLUB

Via Circonvallazione 18, 11021 Breuil-Cervinia, Valtournenche, Valle d'Aosta, Italy

TO VISIT BEFORE YOU DIE BECAUSE

The iconic Matterhorn watches your every swing at this Alpine course.

If you're up for a high-altitude challenge while traveling Europe, head to Italy's Cervino Golf Club. The course is at an elevation of more than 6,700 feet, set in the shadow of the Matterhorn (known as Cervino in Italy). It was designed by Donald Herradine in the 1950s, and while the short course might not be the most difficult to play—it's just shy of 6,000 yards and the ball carries farther in the thin air—it has one of the best mountain views in Europe. Keep an eye out for marmots as you play, and try not to channel your inner Bill Murray à la Caddyshack.

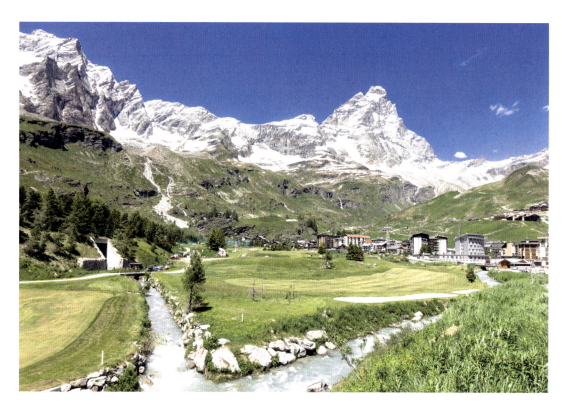

www.golfcervino.com +39 0166 949131

Europe　　　　　　　　　　　Italy

101　GOLF CLUB ALTA BADIA

Strada Planac 9, 39033 Corvara in Badia, Bolzano, Italy

TO VISIT
BEFORE YOU DIE
BECAUSE

The Dolomites provide perhaps the most dramatic backdrop in Italy, if not Europe.

The Dolomites might technically be a part of the Alps, but the look and feel in this more westerly region of Italy is slightly different from what you'll find out east, especially when it comes to the golf courses. At Golf Club Alta Badia, located just over 5,500 feet in elevation, near the town of Corvara (which the course is sometimes called), the landscape is a little more open, though it's still flanked by mountains, forests, and meadows. The course, which is just nine holes, becomes a ski run once the snow starts falling, so expect some slight hills.

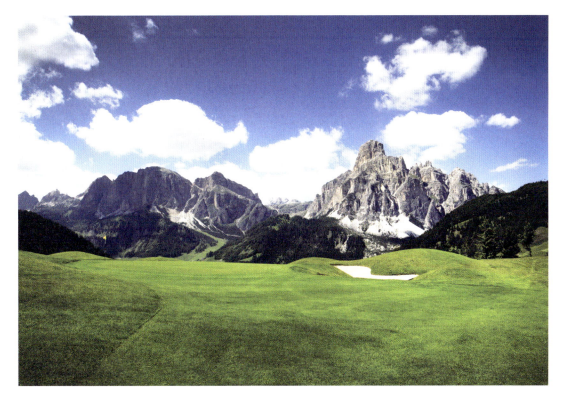

www.golfaltabadia.it/en　　　+39 0471 836655

Europe · Italy

102 GOLF CLUB CASTELFALFI: MOUNTAIN

Localita Castelfalfi, 50050 Montaione, Florence, Italy

TO VISIT BEFORE YOU DIE BECAUSE

Hilly vineyards and a medieval castle surround this postcard-perfect course.

Tuscany might be renowned for its wine, but you'll also find no shortage of golf courses between the vineyards and olive groves. One of the most exquisite is the Castelfalfi estate's Mountain Course, a championship-grade course with views of the medieval castle and surrounding vineyards. As its name implies, there's hilly terrain here, which makes the course a little tougher to play—within reason, of course. Castelfalfi was originally designed by architects Rainer Preissmann and Wilfried Moroder in 1991, but the duo redid the course entirely in 2011. There's a strong focus on the environmental impact of the course, which has earned the GEO eco-label for "green" greens. Among other eco-friendly maintenance techniques, the club uses recovered rainwater for irrigation.

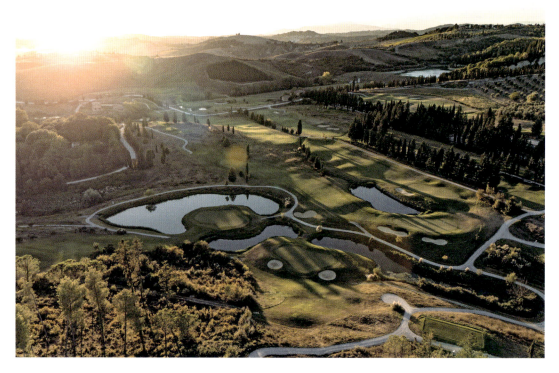

Europe Italy

103 GOLF CLUB COURMAYEUR ET GRANDES JORASSES

Località Le Pont, Val Ferret, 11013 Courmayeur, Italy

TO VISIT BEFORE YOU DIE BECAUSE

The Mont Blanc views are unparalleled on this side of the massif.

Located on the Italian side of Mont Blanc, Golf Club Courmayeur provides some summer fun in the Italian Val Ferret. The nine-hole course (which can be played twice for a full round) was founded by Englishman Peter Gannon in the 1930s and was renovated by Henry Cotton about a decade later. Back then, few ventured into the mountain villages in the summertime, choosing instead to visit in winter for skiing. But these days, plenty of visitors come to take in the mountain scenery. As you play beneath the Mont Blanc and Grandes Jorasses massifs, you'll cross the River Dora twice. To get a slightly different perspective of Mont Blanc, play a round at Chamonix on the French side of the mountain.

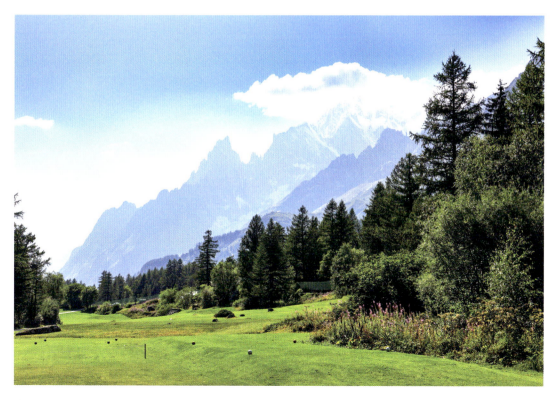

Europe — Italy

104 UNA POGGIO DEI MEDICI GOLF CLUB

Via di San Gavino 27, 50038 Scarperia e San Piero, Florence, Italy

TO VISIT BEFORE YOU DIE BECAUSE

The clubhouse once belonged to the Medici family.

It's not often that a clubhouse steals a course's thunder, but the one at UNA Poggio dei Medici Golf Club might break all the rules—it's set in a 16th-century hunting lodge, the Villa di Cignano, once owned by the eponymous Renaissance family. The golf course here followed much later, opening in 1992 with a parkland design by Alvise Rossi Fioravanti and Baldovino Dassù, and despite the fascinating history of the clubhouse, it truly does hold its own. The Tuscan landscape provides two ridges and three valleys for the course, which is within view of the medieval village of Scarperia.

www.golfpoggiodeimedici.com +39 055 8435562

Europe — The Netherlands

105 KONINKLIJKE HAAGSCHE GOLF & COUNTRY CLUB: ROYAL HAGUE

Groot Haesebroekseweg 22, 2243 EC Wassenaar, The Netherlands

TO VISIT BEFORE YOU DIE BECAUSE

If you didn't know better, this mainland Europe course looks as if it could be located in the British Isles.

The sandy dunes of Koninklijke Haagsche's Royal Hague Course are a dead ringer for the linksland found in the British Isles, save for the deciduous trees that pop up here and there. But you're in mainland Europe, near The Hague, the seat of government of the Netherlands. The course was originally designed by Harry Colt—his 10th in the country—though the project was largely overseen by his associate Charles Alison. It was completed in 1938, damaged in World War II, and later refurbished in the early 2000s by architect Frank Pont. The Royal Hague Course has earned the GEO eco-label for its sustainable practices, which include regular surveys of the flora and fauna around its fairways.

Europe — Norway

106 LOFOTEN LINKS

Tore Hjortsvei, 8314 Gimsøysand, Norway

TO VISIT BEFORE YOU DIE BECAUSE

The Midnight Sun and the Northern Lights are both visible here.

In 2015, the remote Norwegian archipelago of Lofoten opened its championship 18-hole golf course, Lofoten Links, on the island of Gimsøya. This is one of the northernmost golf courses in the world at 68 degrees north, meaning you can play for 24 hours in the summer and potentially see the Northern Lights in the fall—the course is open only from the end of May through mid- to late October, when the weather allows for outdoor activities. It's absolutely worth making the trip to Lofoten to play this course: The rugged landscape into which course architect Jeremy Turner worked the fairways is a sight to behold.

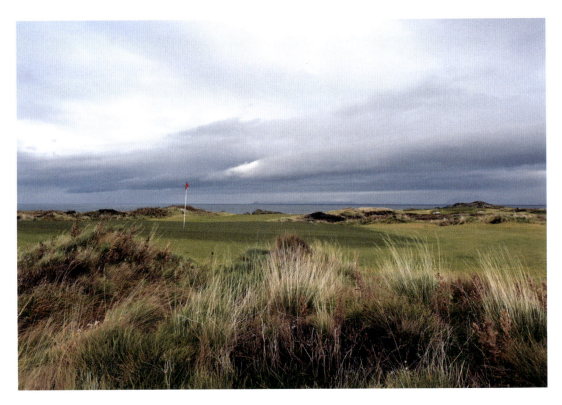

www.lofotenlinks.no/?lang=en +47 76 07 20 02

Europe Norway

107 TROMSØ GOLF CLUB

Slettmoveien 173, 9027 Ramfjordbotn, Norway

TO VISIT
BEFORE YOU DIE
BECAUSE

This is the northernmost 18-hole golf course in the world.

Golf isn't exactly considered an extreme sport, yet there are still some pretty epic courses that require golfers to have the heart of an adventurer. One of them is the Tromsø Golf Club, the world's northernmost 18-hole golf course at 69 degrees north. Despite this superlative, it's not actually that difficult to reach the course—it's located at the base of the Lyngen Alps, a 45-minute drive from Tromsø Airport. It's also a popular cruise stop for ships that are able to sail into more remote polar regions. Tromsø Golf Club's season is pretty short, just like Lofoten Links; it usually opens in late May and closes mid-October, allowing for 24-hour play in June and Northern Lights viewing in the fall.

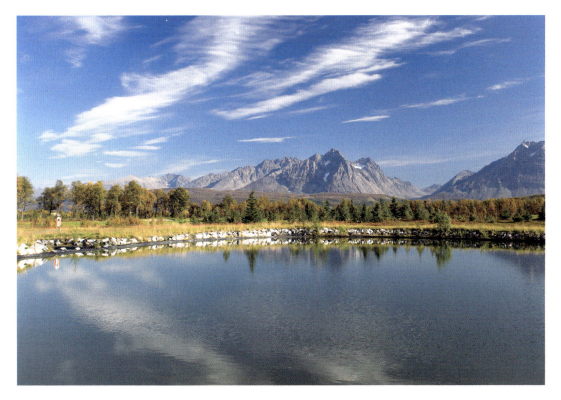

www.visittromso.no/tromso-golf-club +47 776 33 260

Europe Portugal

108 MONTE REI GOLF & COUNTRY CLUB: NORTH

Sesmarias, Apartado 118, 8901-907 Vila Nova de Cacela, Portugal

TO VISIT BEFORE YOU DIE BECAUSE

This is one of the best golf courses in Portugal, if not the best.

When the North Course at Monte Rei Golf & Country club opened in 2007, it became the very first Jack Nicklaus signature course in Portugal. While that's an impressive accolade in itself, what's even more remarkable is that it still ranks as one of the top golf courses in the country more than a decade later. While the Algarve region is known to be quite visually spectacular, particularly along the coastline, Monte Rei is set inland and has a slightly quieter setting, although it's still very picturesque. But the majority of the focus here is on the golf; with numerous water hazards, bunkers, and doglegs, this course certainly stretches the strategic mind.

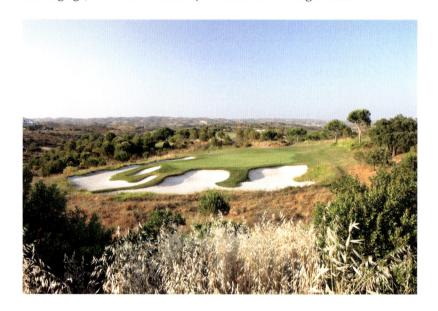

www.monte-rei.com +351 281 950 960

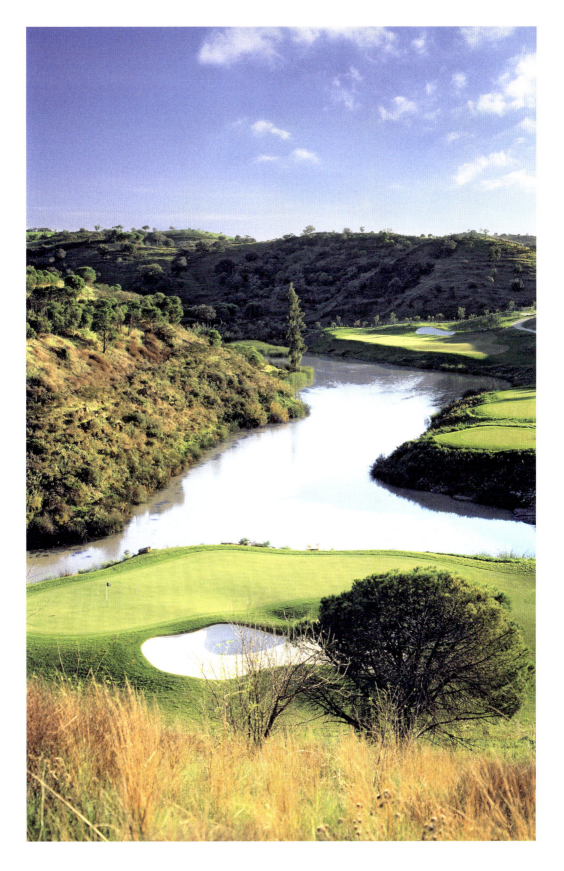

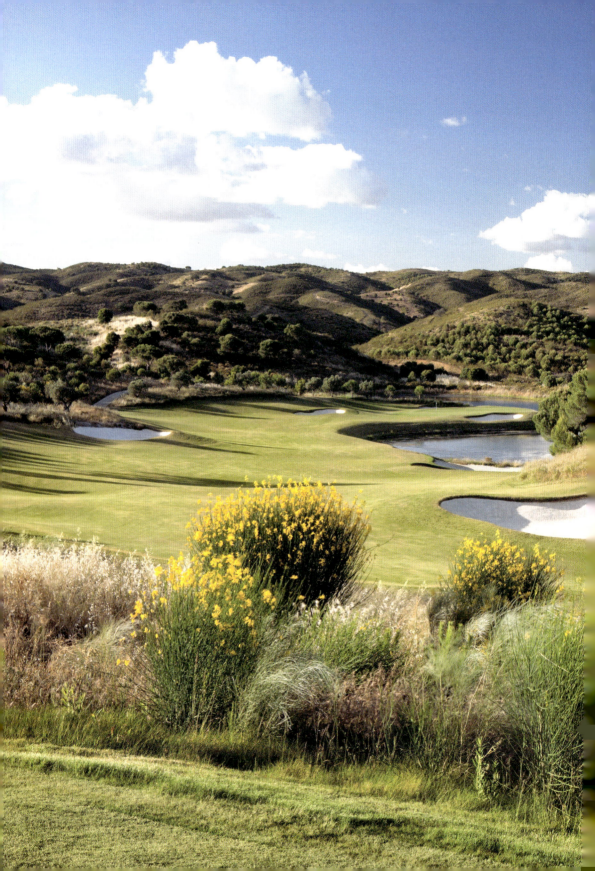

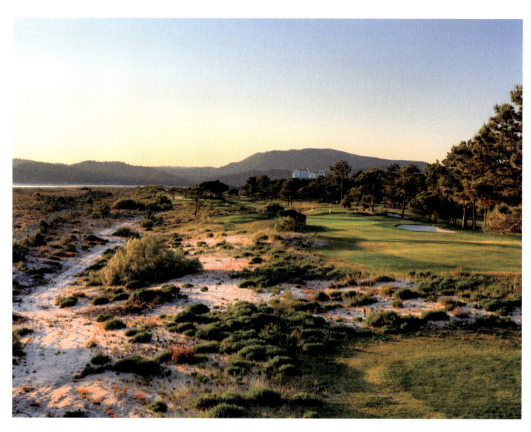
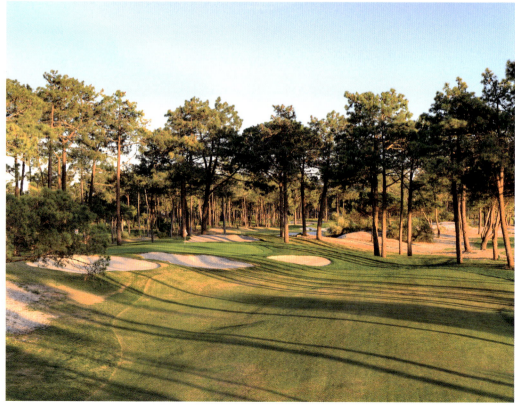

Europe · Portugal

109 TROIA GOLF

Tróia, 7570-789 GDL, Portugal

TO VISIT BEFORE YOU DIE BECAUSE

Robert Trent Jones Sr. named this course's third hole as one of his favorites of all time.

Set on a thin sliver of land just north of Portugal's Algarve coast and just south of Lisbon, Troia Golf's links-style course challenges golfers with numerous hazards and tricky winds. The course was designed by Robert Trent Jones Sr., who peppered the playing field with bunkers, many of which sit just in front of the greens (so don't come up short!). His favorite of the 18 holes is number three, a par four that takes players right out to the sea. The course is set right into the dunes, so sand and pine trees surround most of the fairways and you can spot the sea from many vantage points.

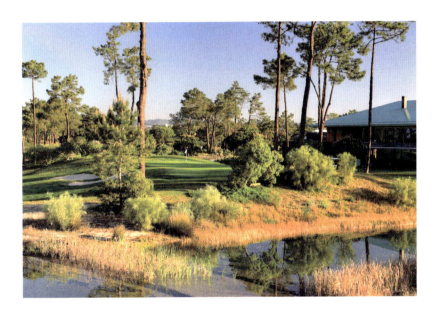

www.troiaresort.pt/en/troia-golf +351 265 499 400

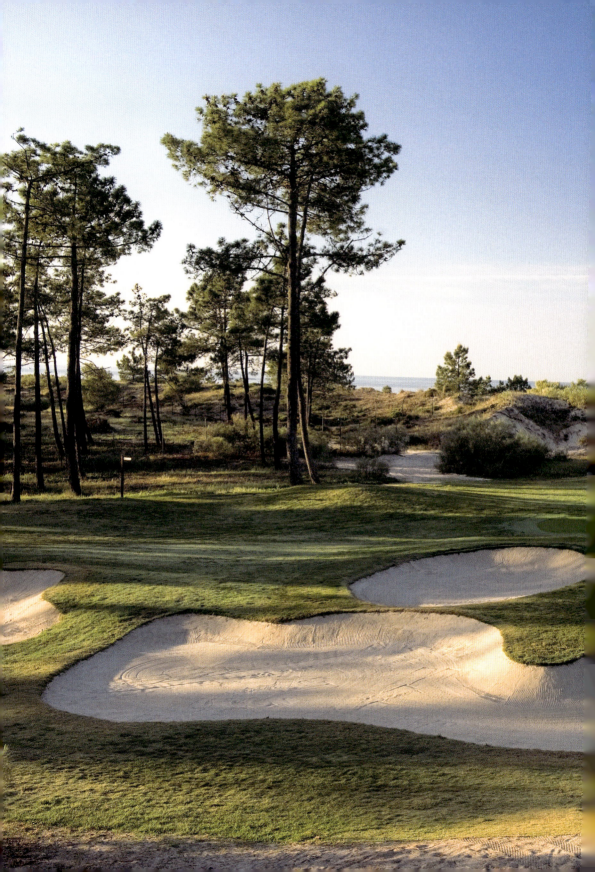

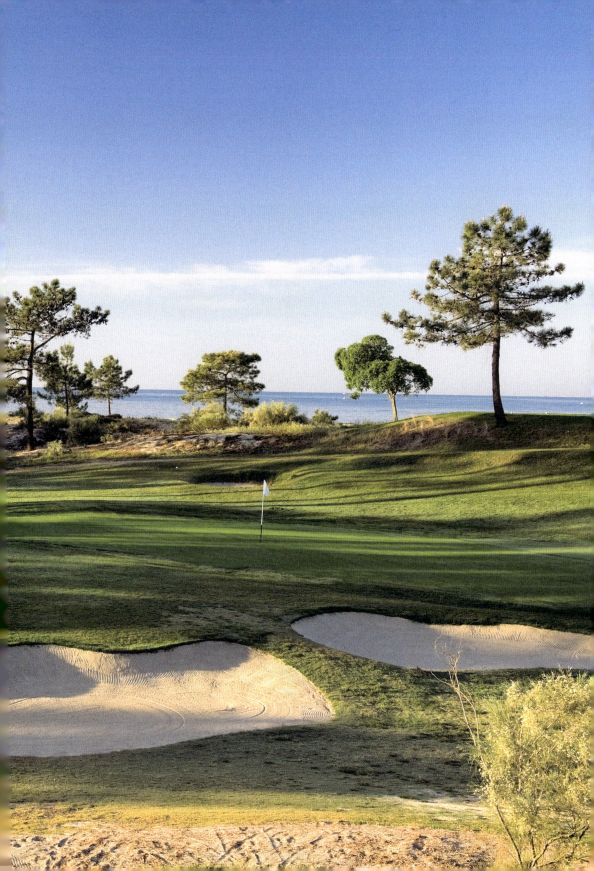

Europe · Russia

110 MOSCOW COUNTRY CLUB

Nakhabino-1, Krasnogorsky District, Moscow region, Russia

TO VISIT BEFORE YOU DIE BECAUSE

This is Russia's first golf course, opened in 1993.

Russia is many things, but a historic golf powerhouse is not one of them. The sport didn't gain a foothold in the country until somewhat recently. The Moscow Country Club was the first course in the country, opening its first nine holes in 1993. Russia tapped one of the best in the business, Robert Trent Jones Jr., to design the course, which weaves through a serene birch forest, around three lakes and a creek. The club hosted the inaugural Russian Open its first year in business and continued to do so for 15 years.

www.mccgolf.ru/en +7 495 626 59 10

Europe Spain

111 ABAMA GOLF

Carretera General, TF- 47 KM9, Guia de Isora, Tenerife, Spain

TO VISIT BEFORE YOU DIE BECAUSE

The view down the fairway to the Ritz-Carlton, Abama, and the Atlantic Ocean beyond is magnificent.

The volcanic archipelago of the Canary Islands has some pretty dramatic topography. Abama Golf—or more precisely, designer Dave Thomas—takes advantage of the hilly terrain of Tenerife to ensure that each hole on the course has an impressive view, whether of the Atlantic Ocean, the neighboring Moorish-style Ritz-Carlton or one of the 22 lakes (don't miss the waterfalls!). Since the slopes are so precipitous here, you'll absolutely need a buggy to get around. Fortunately, your wheels are included in the steep green fee. The undulating terrain also makes playing fairly demanding, so golfers should have quite a bit of experience before tackling Abama.

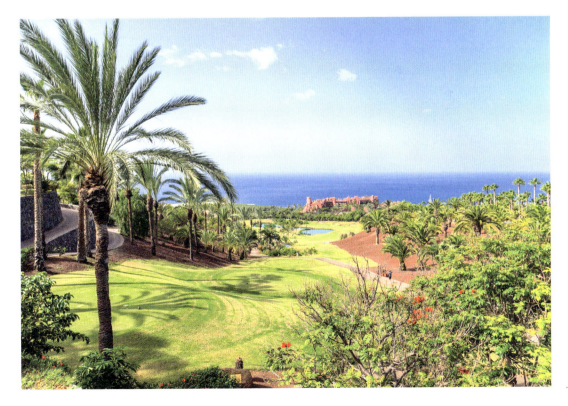

www.abamagolf.com/en +34 922 589 623

Europe Spain

112 ALCANADA GOLF CLUB

Carretera del Faro, 07400 Port d'Alcúdia, Balearic Islands, Spain

TO VISIT BEFORE YOU DIE BECAUSE

This course put northern Mallorca on the golf map.

The Mediterranean island of Mallorca is a popular holiday spot, and that means it has quite a few golf courses. But until 2003, most of those were located in its southern reaches. Alcanada Golf Club opened on the northern side of the island that year, and with its course designed by Robert Trent Jones Jr., and an oceanfront setting, it began to draw the crowds. Now it's regarded as one of the best courses on the island, even regularly ranking among the top in Spain as a whole. Enjoy the olive trees, pine trees, and oak trees that line the fairways, as well as the scenic Alcanada lighthouse off in the distance on a nearby island. (It actually offers rentable accommodation if you need a place to stay.)

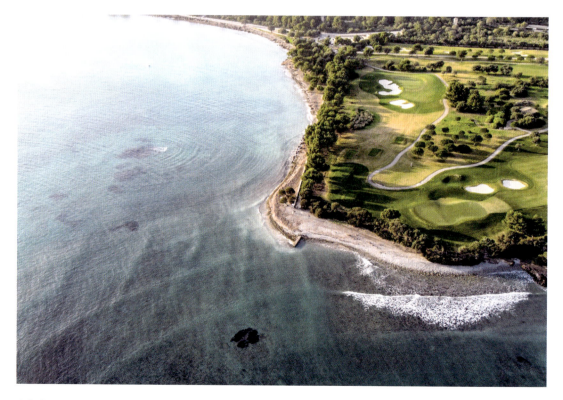

www.golf-alcanada.com/en +34 971 549 560

Europe — Spain

113 FINCA CORTESIN

Carretera de Casares, 29690 Casares-Málaga, Spain

TO VISIT BEFORE YOU DIE BECAUSE

It belongs to one of Spain's most highly sought-after luxury resorts, making this the ultimate vacation golf course.

If you're looking for a true golf vacation, turn your eye to Spain's Costa del Sol along the Mediterranean—there's a reason the region is also nicknamed the "Costa del Golf." There are many resorts here that have their own courses, but king among them is Finca Cortesin, a luxury property near the town of Casares. Although you can see the sea from the Cabell B. Robinson–designed course, it's routed through the rolling Andalusian hills, surrounded by groves of olive trees. Beautiful setting aside, the course is one of the most environmentally friendly in Spain, becoming the first to plant all its greens with MiniVerde Ultra Dwarf Bermudagrass, which requires less water and pesticides than other types of grass.

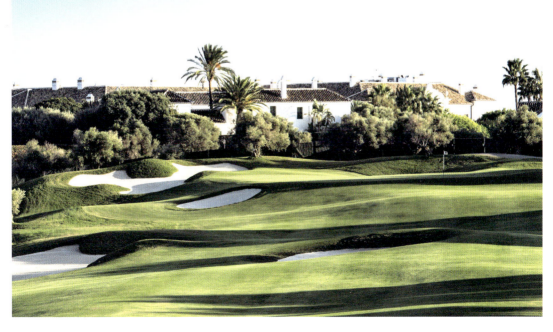

www.fincacortesin.com/golf +34 952 937 883

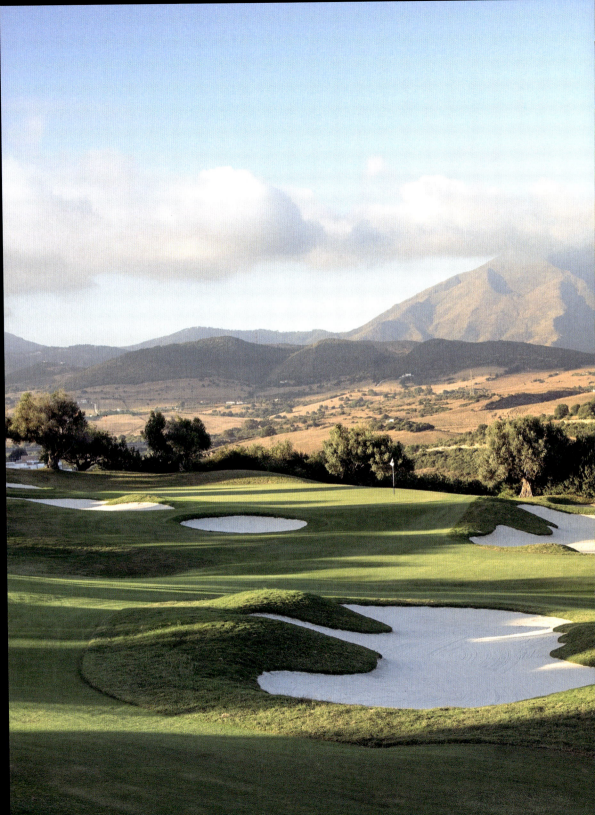

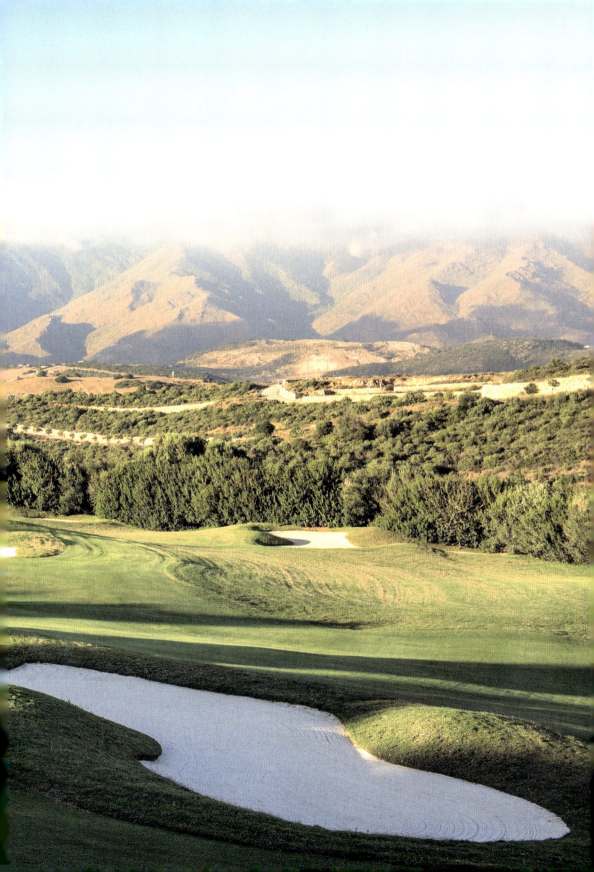

Europe Spain

114 REAL CLUB VALDERRAMA

Avenida Los Cortijos, 11310, Sotogrande, Cádiz, Spain

TO VISIT BEFORE YOU DIE BECAUSE

This is the crown jewel of European golf courses.

For more than 30 years, Real Club Valderrama in the hills of Andalusia has been rated the top golf course in Europe, but it didn't start out with such acclaim. It was founded in 1975 as "Las Alves," featuring a Robert Trent Jones Sr. design. Ten years later, the course's new owner asked the famous designer to refresh his original layout, and it's this iteration, renamed Valderrama, that has become such a European highlight, receiving royal status in 2014 by the Spanish monarchy. The course has hosted a number of tournaments, including the 1997 Ryder Cup, and club membership is highly exclusive, but Valderrama can still be played by visitors nonetheless.

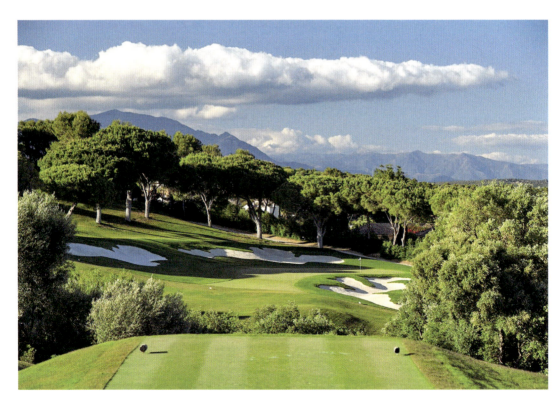

www.valderrama.com +34 956 791 200

Europe Spain

115 REAL GUADALHORCE CLUB DE GOLF

Avenida José Ortega y Gasset, 555 29196 Málaga, Spain

TO VISIT
BEFORE YOU DIE
BECAUSE

The course is split between classic English and classic American styles.

Playing a round at Real Guadalhorce Club de Golf is almost like taking a mini world tour to get a lesson in old-school golf design, even though you're playing in Spain's Costa del Sol. Finnish architect Kosti Kuronen designed the course to have two very distinct halves: The front nine holes are in typical English parkland style, with gentle undulations and no water hazards, while the back nine holes are more similar to American courses, with hillier terrain and more water. Beyond the course, the clubhouse is of particular note: it's an old mansion.

Europe Sweden

116 BRO HOF SLOTT GOLF CLUB: STADIUM

Bro Hof Slott Golf Club, 197 91 Bro (Bro Gård), Sweden

TO VISIT
BEFORE YOU DIE
BECAUSE

The long lakeside course is one of the best in Sweden.

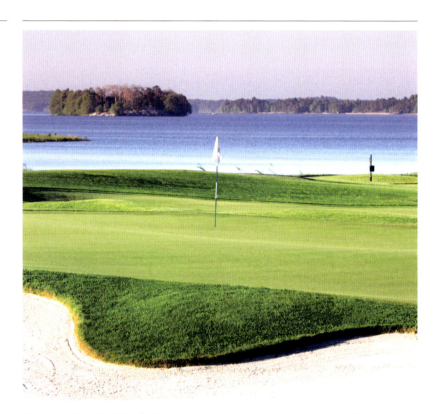

The year Bro Hof Slott's Stadium Course opened it was named the best golf course in Sweden by the country's edition of *Golf Digest* in a highly impressive debut. That was in 2007, and Bro Hof Slott remains at or near the top of best-of-Sweden lists of many publications. It received international fame in 2012, when it hosted the Nordea Masters, won by Lee Westwood. The Stadium Course was designed by Robert Trent Jones Jr., who also designed the club's second course, The Castle, which runs along the shores of Lake Mälaren, just a 30-minute drive north of Stockholm. (You can also reach the course via boat from the capital city.) Given its waterfront location, there are plenty of water hazards here, not to mention some challenging hills. And if you play from the black tees (which is limited to professionals and tournaments), the course measures some 8,000 yards.

www.brohofslott.com +46 (0) 8 545 279 90

Europe · Switzerland

117 ANDERMATT SWISS ALPS GOLF COURSE

Reussen, 6490 Andermatt, Switzerland

TO VISIT BEFORE YOU DIE BECAUSE

The pastoral setting cuts you off from the chaos of the modern world, if only for the duration of a round of golf.

The village of Andermatt is primarily known for skiing, but when the weather warms up for a few months a year, you can also come here to golf. The Andermatt Swiss Alps Golf Course opened in 2016, and golfers flock to it because of its ability to transport you to another time and place. As you make your way outward, you may pass some cows grazing on the hillside, with snowcapped peaks in the background. A babbling brook provides some soothing white noise. The air is fresh, the grass green. Although the majority of the holes are flat at Andermatt, there are a few at the end of the valley that are on an incline, and require some extra focus.

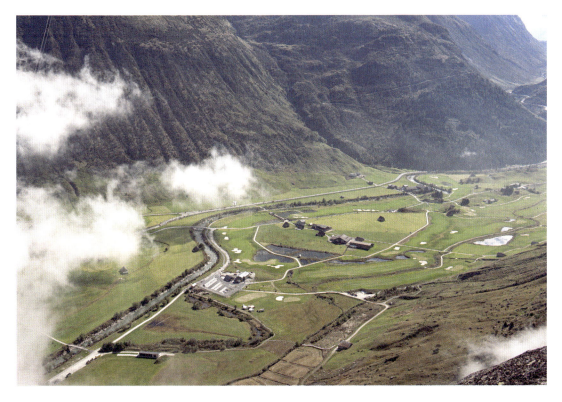

www.andermatt-golf.ch/en +41 41 888 74 47

Europe / Switzerland

118 GOLF CLUB BAD RAGAZ: CHAMPIONSHIP

7310 Bad Ragaz, Switzerland

TO VISIT BEFORE YOU DIE BECAUSE

For more than a hundred years golfers have been enjoying this scenic course in the Rhine Valley.

The Grand Resort Bad Ragaz has everything you'd expect from a grand resort—luxury hotels, fine dining, a thermal spring, a casino, and, yes, an excellent golf course. The original nine-hole course was built here in 1904 and hosted a number of early championship events, including the 1908 Ladies Challenge Cup. The current 18-hole course, now known as the Championship Course, was designed by Don Harradine and completed in 1959. It's highly regarded for its picturesque setting between two mountains in the Rhine Valley, though the holes are fairly flat and very "playable"—its difficulty level is ideal for seasoned leisure golfers. But this is still a championship-level course which has hosted the Swiss Seniors Open since 1997.

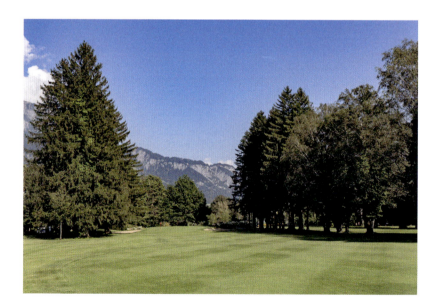

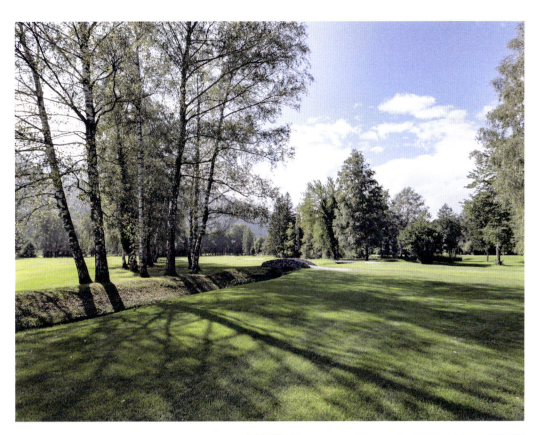
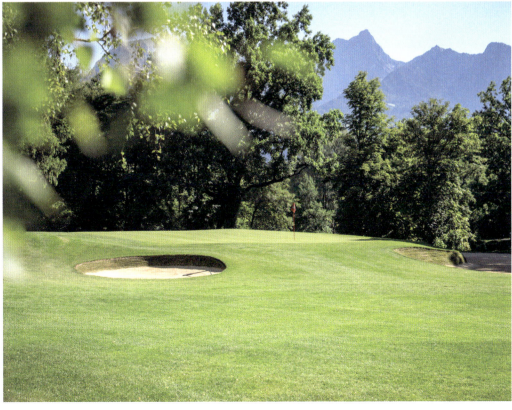

Europe　　　　　　　　　　　　Switzerland

119　GOLFCLUB ENGELBERG-TITLIS

Wasserfallstrasse 114, CH-6390 Engelberg, Switzerland

TO VISIT
BEFORE YOU DIE
BECAUSE

You can enjoy the mountains from a comfortably flat golf course.

Playing mountain courses isn't always the easiest on the body, particularly if you're going about it on foot. But at Golfclub Engelberg-Titlis, founded in the 1920s, you get to take in all the mountain scenery without any of the physical strain, because the course is delightfully flat. That doesn't mean it's boring, though. You play through streams and lakes in this lovely Alpine valley near Lucerne, which sits at a comfortable 3,300 feet above sea level. That means your ball will travel a bit farther, but you won't feel out of breath after a swing. At just over 6,000 yards, this is also a relatively quick game, meaning you can really take your time and enjoy the views.

www.golfclub-engelberg.ch　　　+41 41 638 08 08

Europe · Turkey

120 LYKIA LINKS

Denizyaka Mah. 1, Kamışlıgöl Küme Evleri No. 1 Manavgat / Antalya, Turkey

TO VISIT BEFORE YOU DIE BECAUSE

This is the first links course in Turkey.

The Belek area of Antalya has many golf courses, but when the Lykia Links opened in 2007, it became Turkey's very first links course, set on the Gulf of Antalya in the Mediterranean. Because the dunes aren't entirely natural here, they've been engineered perfectly to complement the course. Designer Perry Dye did a masterful job creating complex holes that challenge both casual and advanced players alike. From one part of the course you'll have views of the beaches and the sea, and from another you'll look upon the mountains in the distance. While Lykia does have links-like qualities, the warm weather is a nice change of pace from what you'd experience in the British Isles.

www.lykialinks.com +90 242 744 26 10

Europe — United Kingdom

121 ARDGLASS GOLF CLUB

Castle Place, Ardglass, County Down, Northern Ireland BT30 7TP, UK

TO VISIT BEFORE YOU DIE BECAUSE

Royal County Down Golf Club might get all the fame in Northern Ireland, but Ardglass gives it a run for its money.

Ardglass might've set a record for the longest amount of time to expand to a full 18-hole course. The club was founded in 1896 with seven holes, and while two more were added shortly thereafter, holes ten through 18 weren't born until the late 1960s. Since then, the course has been remodeled a bit to contemporary taste, but its historic nature still remains—especially when it comes to the clubhouse. According to the club, the building is the oldest one used as a clubhouse in the world—it can be definitively dated to the 15th century, but it's possible parts of it existed even earlier. While the clubhouse's history is intriguing, you're here to play the course, which has some of the best views in the game; the Irish Sea is visible throughout the course, and you can even see the Isle of Man and the Mountains of Mourne.

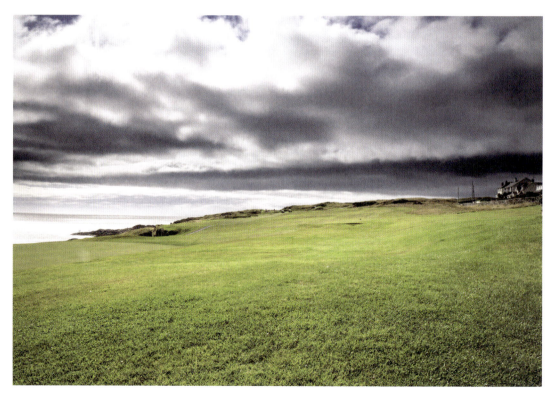

www.ardglassgolfclub.com — +44 (0) 28 44 841 219

Europe United Kingdom

122 GLENEAGLES: KING'S

Auchterarder, Perthshire, Scotland PH3 1NF, UK

TO VISIT BEFORE YOU DIE BECAUSE

Lee Trevino once said of this course, "If Heaven is as good as this, I sure hope they have some tee times left."

Scotland's historic Gleneagles resort is known as "The Glorious Playground," so it should be little surprise that it's a wonderland for outdoor enthusiasts, including golfers. It has three championship courses, the most famous of which is the King's Course, designed by James Braid and opened in 1919—five years before the hotel. In 1921, it hosted the first match between American and British golfers, laying the groundwork for the Ryder Cup, which it would officially host for the first time in 2014. It has also hosted the Scottish Open, the European Golf Team Championships, and the Solheim Cup, among other tournaments. While Scotland is best known for its links courses, Gleneagles' King's Course is one of the best inland courses in the UK.

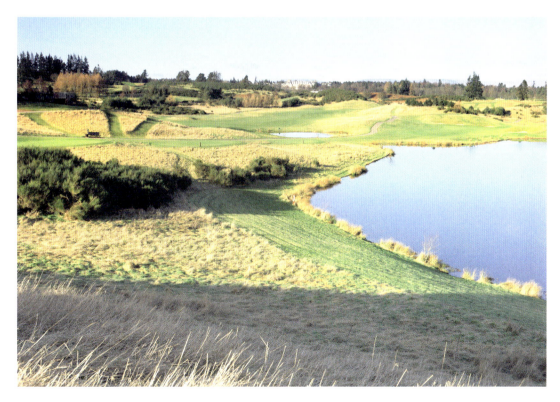

Europe United Kingdom

123 ROYAL DORNOCH: CHAMPIONSHIP

Golf Road, Dornoch, Scotland IV25 3LW, UK

TO VISIT BEFORE YOU DIE BECAUSE

Golf has been played here for more than 400 years.

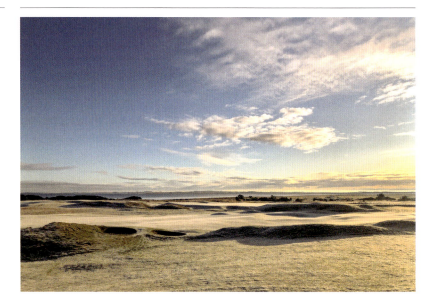

Playing the Championship Course at Royal Dornoch requires golfers to make something of a pilgrimage, but it's one many have on their bucket lists. It's located a four-hour drive north of both Edinburgh and Glasgow, set on the bay of Dornoch Firth, and this remote location gives the natural links an extra touch of raw beauty. Though Royal Dornoch was founded in 1877 (and given its royal title by King Edward VII in 1906), records show that golf has been played here since at least 1616, making this one of the oldest golf towns in the world. As such, it's one of the biggest names in golf history. The original course had just nine holes, but Old Tom Morris was hired to double that number in 1886, with subsequent alterations by John H. Taylor, George Duncan, and Tom Mackenzie. Dornach also has an added attraction as the hometown of Donald Ross who was born here in 1872 and grew up playing the course. Despite all this high-class golf pedigree, Royal Dornoch pushes a relaxed, informal atmosphere with generous hospitality.

Europe — United Kingdom

124 MUIRFIELD

Duncur Road, Muirfield, Gullane, East Lothian, Scotland EH31 2EG, UK

TO VISIT BEFORE YOU DIE BECAUSE

Muirfield's looping front and back nines are not your usual out-and-back links.

The home of one of the world's oldest golf clubs, the delightfully named The Honourable Company of Edinburgh Golfers (HCEG), Muirfield is one of Scotland's iconic golf courses. The club itself originally played at Leith Links and Musselburgh before building its own course, Muirfield, in 1891 and tapping Old Tom Morris to create the layout—an unusual links design that features two looping nines instead of the classic out-and-back orientation. As such, golfers must adjust to new wind directions throughout a round, which increases the difficulty level here. Though HCEG is a private club, visitors are welcome to play here on certain days of the week. The course has hosted the Open Tournament 16 times, most recently in 2013.

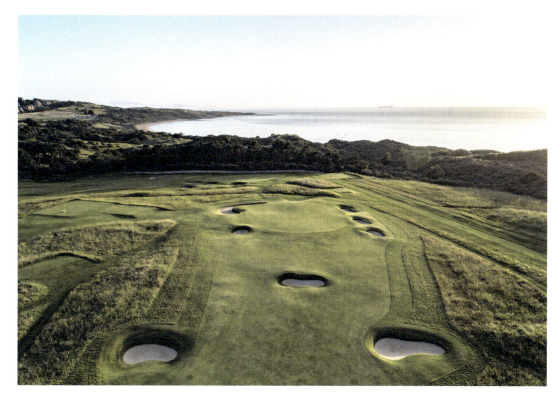

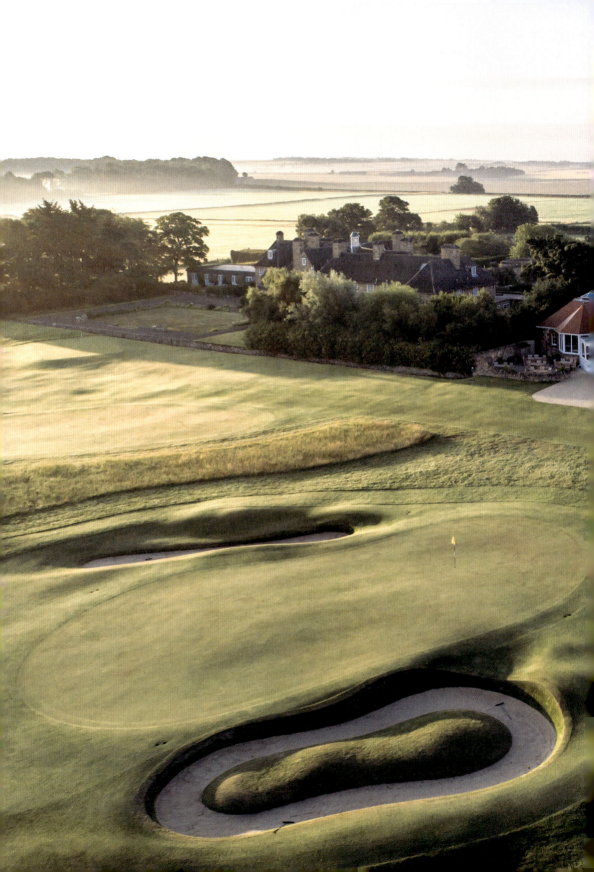

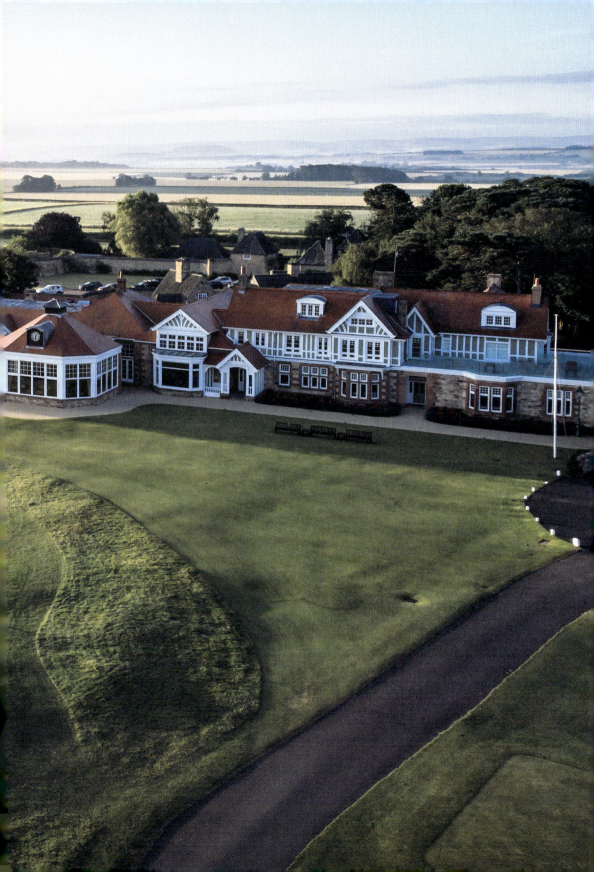

Europe — United Kingdom

125 ROYAL LYTHAM & ST. ANNES GOLF CLUB

Links Gate, Lytham St. Annes, Lancashire, Scotland FY8 3LQ, UK

TO VISIT BEFORE YOU DIE BECAUSE

Unlike most links, the Royal Lytham & St. Annes is inland and surrounded by houses and a railway line—an unusual setting for such a prestigious, historic course.

When it was built in 1897, Royal Lytham & St. Annes Golf Club, with its wild dunes along the sea, was the epitome of a perfect links. But over the past century the world has closed in on the course, quite literally! Though it's still considered a true links course, Lytham is unusually surrounded by a red-roofed housing development with an active train line running up one of its sides. And forget the sea—you can no longer see it! Yet somehow none of this really matters, because Lytham is still one of the best courses in England, hosting no fewer than 11 Open Championships and two Ryder Cups. When you're playing, you won't notice any of the distractions, since all your focus will be on avoiding the 174 bunkers peppered throughout the course.

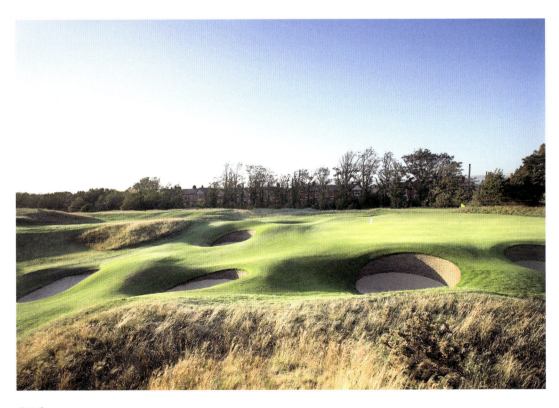

www.royallytham.org +44 (0)1253 724206

Europe United Kingdom

126 ST. ANDREWS LINKS: OLD COURSE

West Sands Road, St Andrews, Scotland KY16 9XL, UK

TO VISIT BEFORE YOU DIE BECAUSE

This is the birthplace of golf.

Golf has been played in the Scottish town of St. Andrews for more than 600 years—the Old Course is recognized by the *Guinness Book of World Records* as the world's oldest course. Although casual play began as early as the 14th century (or perhaps even earlier), it was in 1552 that Archbishop John Hamilton issued a charter recognizing the right of the public to play golf at St. Andrews links. And it remains a public course to this day! Some 45,000 rounds are played on the Old Course every year, drawing an international crowd looking to get a taste of golf history. Fun fact: The Old Course set the standard for the 18-hole round in 1764, but at that time the course had just 10 holes—eight of them were played twice in a round. It should also be noted that this was the home course of Old Tom Morris, born in St. Andrews in 1821.

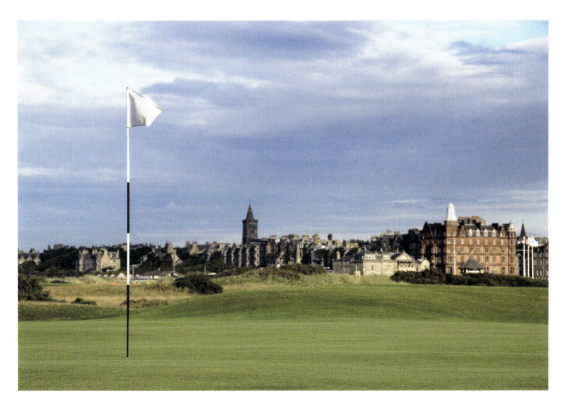

Europe United Kingdom

127 SUNNINGDALE: OLD

Ridgemount Road, Sunningdale, Berkshire, England SL5 9RR, UK

TO VISIT BEFORE YOU DIE BECAUSE

It championed inland courses in the UK back in the early 20th century.

At the turn of the 19th century, golf was largely played along the seashore in the British Isles, but Sunningdale's very early success contributed to golf's inland expansion. It was built in the undeveloped English countryside 30 miles outside of London—then considered quite far from the city—and it was very difficult to reach. But after the club offered the London and South Western Railway's general manager an honorary membership, a stop was added nearby. Over the past century, numerous championships have been held here, with members and visitors alike lauding not only the beauty of the wooded landscape, but also the true joy of playing every single hole. Golfer Bobby Jones was extremely fond of Sunningdale's Old Course. "I wish I could take this course home with me," he once said. The magnificent oak tree near the 18th hole is the emblem of the club.

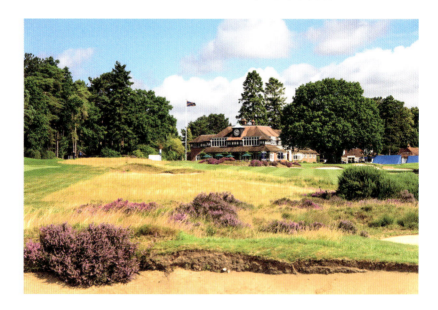

www.sunningdalegolfclub.co.uk/old_course +44 (0)1344 621681

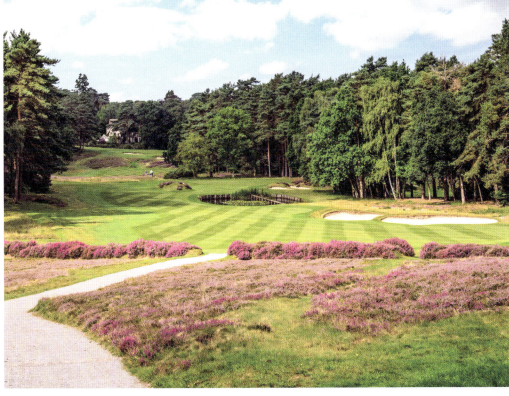

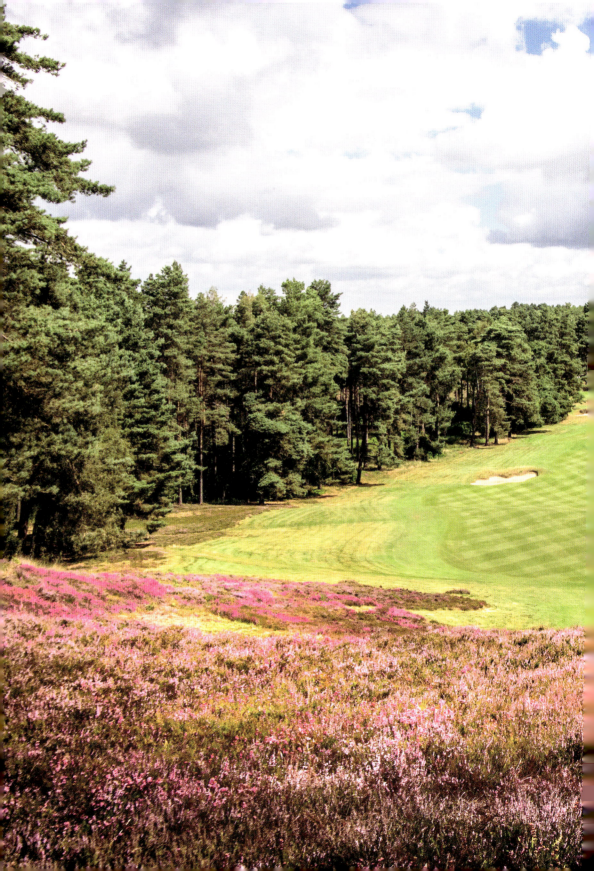

Europe — United Kingdom

128 TRUMP INTERNATIONAL GOLF LINKS SCOTLAND

Balmedie, Aberdeen, Scotland AB23 8YE, UK

TO VISIT BEFORE YOU DIE BECAUSE

In 2012, this newcomer shook up the history-rich Scottish golf scene.

Many of the best golf courses in the world are tried-and-true masterpieces built at least a few decades, if not a century, ago. But Trump International Golf Links Scotland made international waves when it debuted in 2012. The course is set into a landscape that is nothing short of breathtaking, the Martin Hawtree design weaving through 100-foot-tall grassy dunes along three miles of Aberdeenshire coast. Of course, building a golf course in the Great Dunes of Scotland posed some ecological issues in maintaining the natural integrity of the site, but Hawtree rose to the challenge: "Working closely with the environmental scientists the vision pivots on sensitive integration into this landscape," he said.

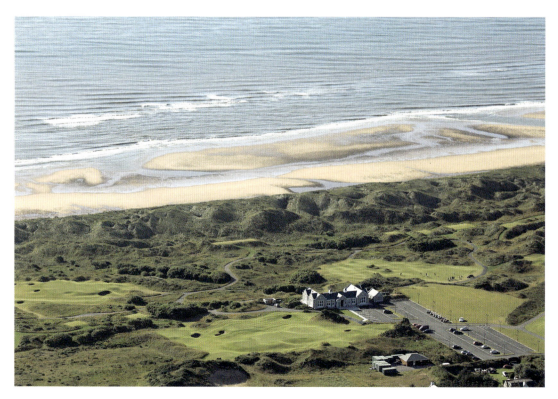

www.trumpgolfscotland.com/golf +44 (0)1358 743 300

Europe United Kingdom

129 TRUMP TURNBERRY RESORT: AILSA

Maidens Road, Turnberry, Ayrshire, Scotland KA26 9LT, UK

TO VISIT BEFORE YOU DIE BECAUSE

Despite being one of the most famous and highly rated golf courses in the world, the Ailsa is very playable for golfers of all abilities.

Scotland has one or two golf courses you might have heard of. Or maybe three or four... Okay, there are dozens of excellent courses in the country, many of which are considered some of the best in the world. Prior to 2016, the Ailsa Course at the Trump Turnberry Resort was a highly rated one—it hosted the Open four times in its Mackenzie Ross–designed iteration—but it wasn't necessarily a bucket-list item for many golfers. That all changed after a Martin Ebert–led renovation bumped it to the top (or close to the top) of many rankings. Now, golfers the world over come to play here, most of whom state that it's a pure joy to play this course.

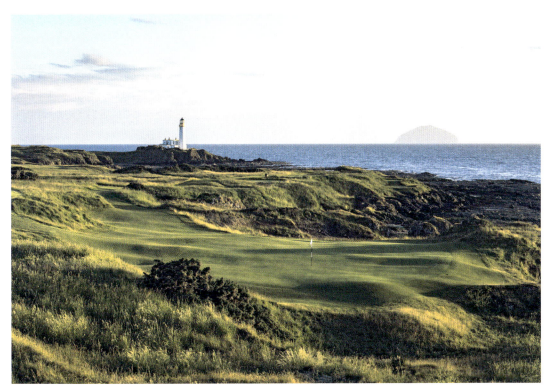

www.turnberry.co.uk/ailsa-golf-course-scotland +44.1655.331.000

Europe — United Kingdom

130 WHALSAY GOLF CLUB

Skaw, Shetland, Scotland ZE2 9AW, UK

TO VISIT BEFORE YOU DIE BECAUSE

The club itself acknowledges its course's "treacherous golfing challenges."

The remote island of Whalsay in Scotland's Shetland Islands has long been a fishing island, and it probably always will be. And thanks to its enthusiastic residents, it's also a golf destination, home to Britain's northernmost golf course. The community-run Whalsay Golf Club, of which some 15 percent of the island's thousand or so residents are members, was founded in 1976, establishing a true links course after spending a few years playing atop peat. Given its clifftop location on a headland exposed to North Atlantic winds, conditions are tricky, even for the most experienced golfer. But playing here is exciting, to say the least, and many die-hard golf fans make the trek for a round or two.

www.whalsaygolfclub.co.uk +44 1806 566705

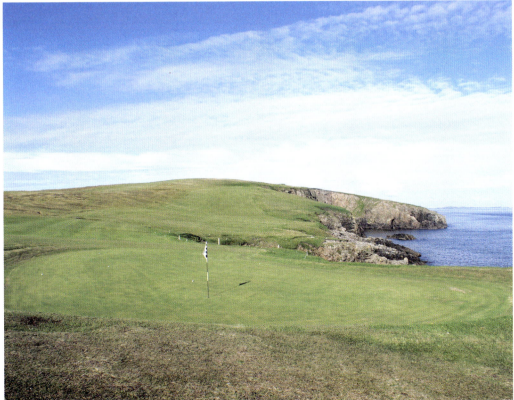

Oceania Australia

131 BARNBOUGLE: DUNES

425 Waterhouse Road, Bridport, Tasmania 7262, Australia

TO VISIT BEFORE YOU DIE BECAUSE

With Mike Keiser, Tom Doak, and Mike Clayton at the helm of this links course, you know you're in for a treat.

Golf impresario Mike Keiser struck gold when he spotted the dunes of northeast Tasmania lining what was once a potato farm. Barnbougle is home to not one, but two of Australia's best golf courses—and true links courses at that. While you should certainly make time for a round at both the Dunes Course and the Lost Farm Course (which, despite being neighbors, have entirely different feels and experiences), if you were pressed to pick just one, choose the former. The Dunes course was the first at Barnbougle, designed by Tom Doak and Mike Clayton in 2004, and the natural landscape here is strikingly reminiscent of the coasts of the British Isles—if not even more dramatic, creating steep undulations that make for a challenging game.

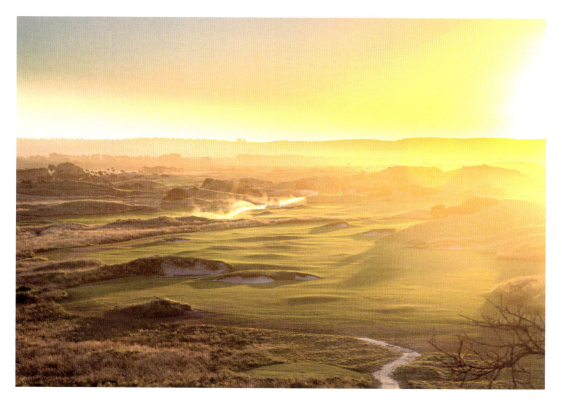

www.barnbougle.com.au (03) 6356 0094

Oceania · Australia

132 CAPE WICKHAM GOLF LINKS

Cape Wickham Road, King Island, Tasmania 7256, Australia

TO VISIT BEFORE YOU DIE BECAUSE

This is one golf course whose views are anything but overrated.

Australia is not short of beautiful landscapes, but King Island has some pretty exceptional ones, even by Aussie standards. The island is set halfway between Victoria on the mainland and the island-state of Tasmania in the Bass Strait and has a population of less than 2,000 people. It's primarily known for its produce, meat, cheese, and seafood. Cape Wickham Golf Links is arguably the most popular attraction on the island, being one of the most lauded golf courses in Australia. However, given its secluded location, it's still relatively untouristed. All the better for the golfers who make the trek! They're rewarded with windswept landscapes and fantastic architecture by Mike DeVries and Darius Oliver.

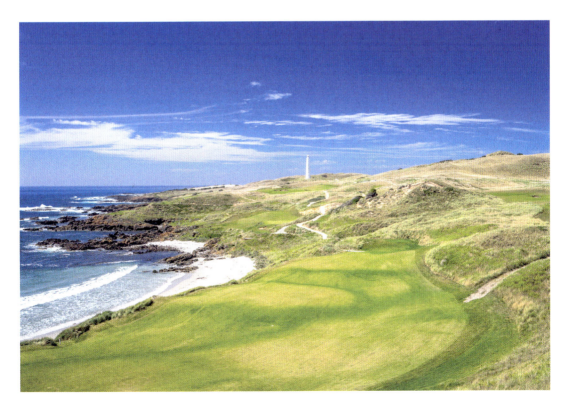

www.capewickham.com.au +61 3 6463 1200

Oceania Australia

133 CHRISTMAS ISLAND GOLF COURSE

HPF2+GG7, Christmas Island 6798, Australia

TO VISIT BEFORE YOU DIE BECAUSE

This remote course has an official rule for what to do if a crab steals your ball.

Australia is already a pretty remote country, but its territory of Christmas Island is a whopping 1,616 miles away from the mainland, located in the Indian Ocean near Indonesia. As such, its solitary golf course is Australia's northernmost. It has some pretty unique features, not least among them special rules regarding crabs. You see, Christmas Island is known for its massive red crab migration, when 60 million crustaceans cross the island, including the golf course. But that's not all—Christmas Island is also home to the robber crab, otherwise known as the coconut crab, which is the world's largest land crustacean, topping out with a three-plus-foot wingspan. As their name implies, robber crabs are known to steal golf balls.

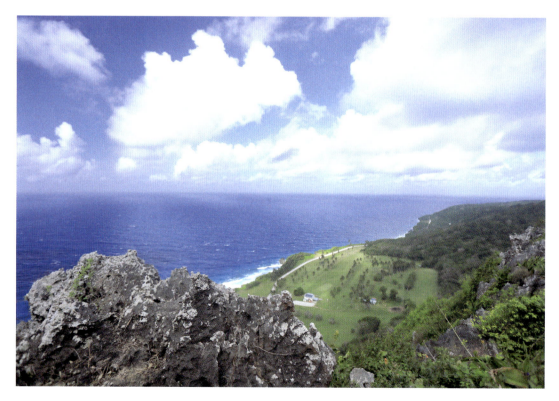

www.christmasislandgolfclub.com

Oceania Australia

134 COOBER PEDY OPAL FIELDS GOLF CLUB

1509 Rowe Drive, Coober Pedy, South Australia 5723, Australia

TO VISIT BEFORE YOU DIE BECAUSE

There's no grass at this unusual course, which is the only one in the world to have reciprocal rights for its members to play at the Old Course at St. Andrews.

The remote town of Coober Pedy in South Australia is known for three things: its opal mines, its underground dwellings, and its golf course. Because temperatures in this arid region regularly soar above 100°F, greenery is scarce, which makes Coober Pedy a rather unusual place for a golf course. But the local residents—many of whom live underground to escape the heat—have built their own grass-free golf course, played during the cooler winters or on summer evenings. Instead of fairways, it has white sandstone, and instead of greens, it has scrapes made from a mixture of quarry dust and waste oil, which, according to the club makes a very good putting surface when properly mixed. For teeing off, golfers carry around little squares of artificial grass. Fun fact: On this completely grassless course, the occasional "Keep off Grass" sign keeps players amused.

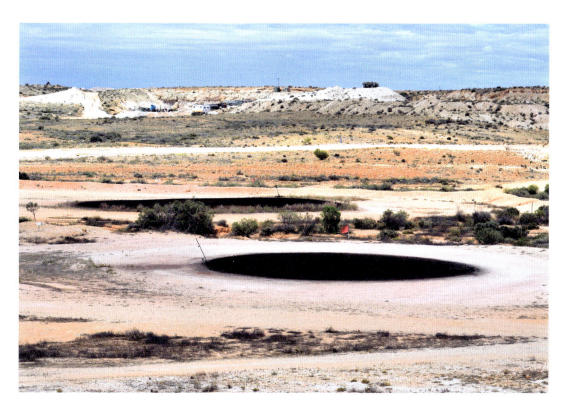

www.cooberpedygolfclub.com.au +61 417 217 904

Oceania　　　　　　　Australia

135　GRANGE GOLF CLUB: WEST

White Sands Drive, Grange, South Australia 5022, Australia

TO VISIT BEFORE YOU DIE BECAUSE

What was once swampland is now a world-class parkland golf course.

Golf has been played in the area since 1910, but the Grange Golf Club wasn't formally established until 1926, located on what was once swampland but is now a well-developed suburb of Adelaide. There was originally just one course here, but in 1967, a second one—the West Course—debuted with a design by Vern Morcom. But the course changed again in 2008 with some pretty extensive renovation work by Mike Clayton. (Greg Norman reworked the East Course in 2012.) In 2016 and 2019, the West Course hosted the Women's Australian Open.

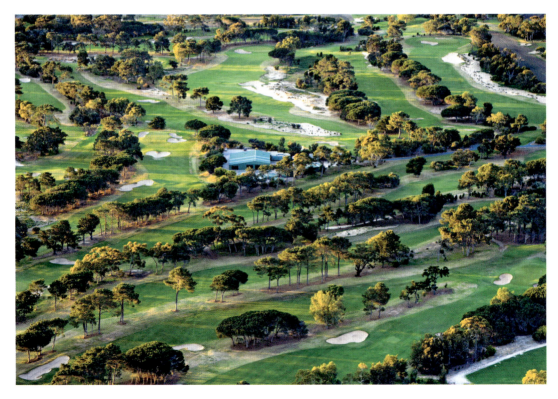

www.grangegolf.com.au/cms　　　+353 (0) 1 493 2889

Oceania • Australia

136 KINGSTON HEATH

Kingston Road, Cheltenham, Victoria 3192, Australia

TO VISIT BEFORE YOU DIE BECAUSE

Many believe this to be Australia's finest golf course.

When it comes to the Sandbelt region of Melbourne you really can't go wrong in picking a golf course. The sandy soil is a delight for designers, who can easily mold the earth into their ideal form with relatively minimal effort. That said, Kingston Heath is one of the best, potentially edging out its main competitor, the Royal Melbourne Golf Club, simply because it's more welcoming of visitors. In any case, you're in for a spectacular game here; the Dan Soutar-designed course (with bunker input from Alister MacKenzie) opened in 1925, and it's hosted all manner of tournaments, from the Australian Open to the Australian Masters.

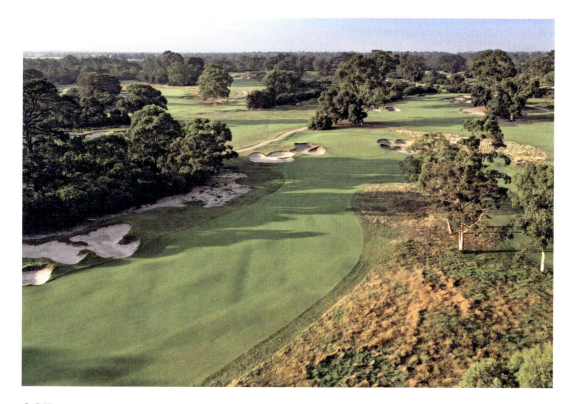

www.kingstonheath.melbourne (03) 8558 2700

Oceania Australia

137 LORD HOWE ISLAND GOLF CLUB

Lagoon Road, Lord Howe Island, New South Wales 2898, Australia

TO VISIT BEFORE YOU DIE BECAUSE

Only 400 visitors are allowed on the entire island at a time, so it's never crowded on this stunning course.

Lord Howe Island in the Tasman Sea is a remote paradise for vacationers looking to take advantage of the incredible marine environment via snorkeling, diving, or other watersports. On dry ground, there are two forested mountains to hike, plenty of beaches to explore, and, yes, even a nine-hole golf course to play. Named a UNESCO World Heritage Site for its scenic landscapes and robust biodiversity, Lord Howe Island can be visited only by 400 visitors (excluding the few hundred residents) at a time to protect the ecosystem, so you'll almost never run into crowds on the golf course.

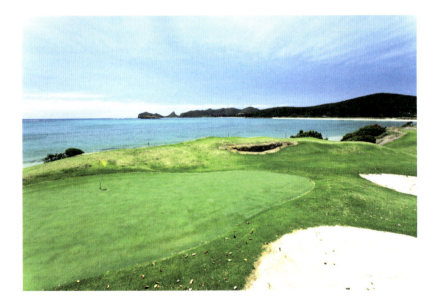

www.lhi.golf 24 696 038 489

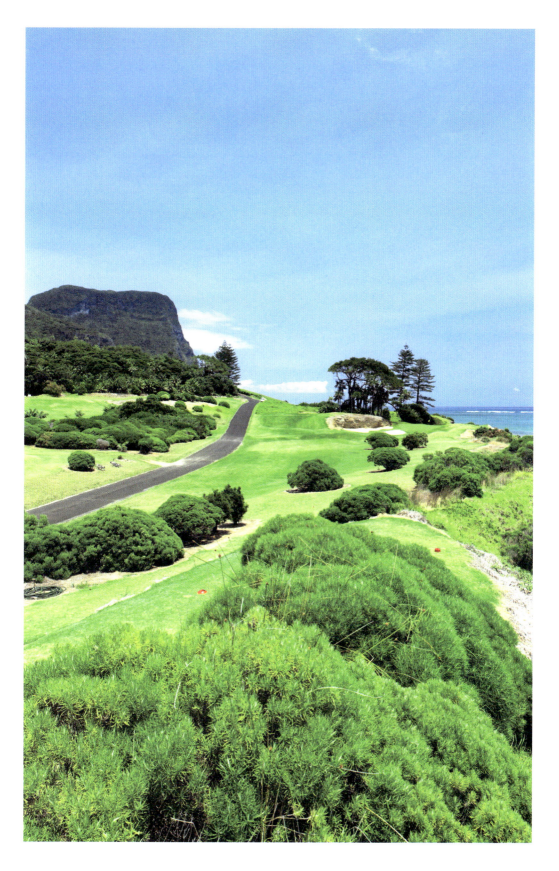

Oceania Australia

138 NEW SOUTH WALES GOLF CLUB

Botany Bay National Park, 101 Henry Head Lane, La Perouse, New South Wales 2036, Australia

TO VISIT BEFORE YOU DIE BECAUSE

The winds on this Alister MacKenzie–designed course make it a real challenge, but a thoroughly satisfying one.

In 1770, British explorer Captain James Cook made landfall in Australia for the first time, gathering drinking water from a natural spring on the north side of Botany Bay. Some 150 years later, that same spot is known for an entirely different reason—it's the 17th tee of the New South Wales Golf Club, an Alister MacKenzie masterpiece that opened in 1928. MacKenzie himself praised the waterfront location, once telling *Golf Illustrated* that it had "more spectacular views than any other place I know with the possible exception of the new Cypress Point golf course I am doing..." He's not wrong—the vistas along the rocky shoreline are beautiful. But despite the pretty setting, this is a difficult course to play, with strong winds a regular presence.

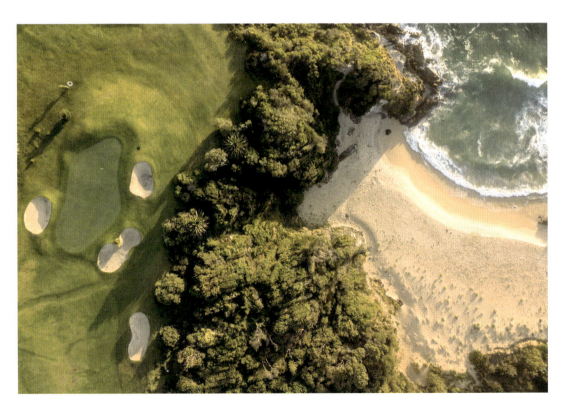

www.nswgolfclub.com.au/cms + 61 2 9661 4455

Oceania Australia

139 NULLARBOR LINKS

58 Poynton Street, Ceduna, South Australia 5690, Australia

TO VISIT
BEFORE YOU DIE
BECAUSE

At nearly 850 miles long, this is the longest golf course in the world.

You thought an 8,000-yard golf course was long? Try 848.17 miles. Welcome to Nullarbor Links, the longest golf course in the world. It's technically an 18-hole par-72 course, and the holes themselves are of normal length. It's the distance between them that's extraordinary. Fortunately, you don't need to walk it. The course was developed as a time-passing activity for truckers making the long haul down the Eyre Highway in Australia between Kalgoorlie in Western Australia and Ceduna in South Australia; each hole is in a different spot along the route. Some are actually played in actual golf clubs, while others are located at sheep stations or roadhouses. Depending on whether or not you decide to do a little sightseeing along the way, your round might take anywhere from a few days to over a week.

www.nullarborlinks.com +61 407 990 049

Oceania · Australia

140 ROTTNEST ISLAND GOLF CLUB

Koora Nortji Wangkiny Court, Rottnest Island, Western Australia 6161, Australia

TO VISIT BEFORE YOU DIE BECAUSE

There are adorable quokkas here.

Rottnest Island off the coast of Perth is an extremely popular day-trip destination for its beaches, snorkeling, scenic hikes, and bike rides. But it's also home to a nine-hole golf course, one of the island's best-kept secrets. (Fun fact: The club established equal playing rights for women way back in the 1960s—long before many of the top clubs in the world, some of which remain men-only to this day.) And this golf course comes with a bonus. Rottnest Island is one of the few places in the world with a native population of quokkas, perhaps the cutest little marsupials around, and which always look like they're smiling. It's incredibly likely you'll see a few of the cutie-pies run out onto the course during your round.

www.rottnestgolf.org · 0438 493 325

Oceania · Australia

141 THE ROYAL ADELAIDE GOLF CLUB

328 Tapleys Hill Road, Seaton SA 5023, Australia

TO VISIT BEFORE YOU DIE BECAUSE

The Australian Open has been held nine times at this inland links course.

Despite being more than a mile from the sea, Royal Adelaide Golf Club has a links aura to it. But since the course was founded in 1870 (well, 1892 on its current site), the earth has actually been worked and reworked again by architects, including Alister MacKenzie in 1926. But it's a testament to their skill how natural the course looks! As one of the top courses in Australia, it's hosted the Australian Open no fewer than nine times throughout its history, as well as 16 editions of Amateur Championships of Australia. It's technically only open to members, but there are limited tee times for visitors—you'll need some luck to secure one.

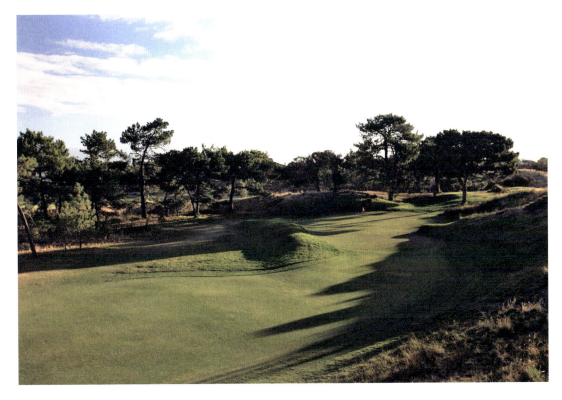

www.royaladelaidegolf.com.au/cms 61 8 8356 5511

142 13TH BEACH: BEACH

1732 Barwon Heads Road,
Barwon Heads, Victoria 3227, Australia

TO VISIT BEFORE YOU DIE BECAUSE

It's home to the Victoria Open.

Australia's state of Victoria is not lacking in golf courses, especially in the Sandbelt region on the Mornington Peninsula. But just across the Port Phillip Bay is the Bellarine Peninsula, where you'll also find world-class golf, mainly on younger courses. One of the best is the Beach Course at 13th Beach, designed by Tony Cashmore and opened in 2001, which has a classic links-style feel to it, weaving between dunes. The course has hosted the Victorian Open, or Vic Open, since 2013, the year the tournament changed its format to have men and women playing on the same course at the same time—and for equal prize money.

Oceania Australia

143 JOONDALUP RESORT COUNTRY CLUB

Country Club Boulevard, Connolly, Western Australia 6027, Australia

TO VISIT BEFORE YOU DIE BECAUSE

This challenging resort course has three scenic nines that you can mix-and-match for a full round.

When Robert Trent Jones Jr. designed the Joondalup Resort Country Club just north of Perth, Australia, in 1985, he decided to carve three picturesque nines out of the Western Australian bush. The king among them is the Quarry Course, not only for its challenging layout but also its striking scenery in—you guessed it—a former limestone quarry. Of particular note are the "moon crater" bunkers on the second hole that create an otherworldly landscape, though the greenery here firmly plants you on Earth. There are also the Dune and Lake nines: The former traverses hilly bushland, while Lake is a more links-like course along gentle lakeside dunes. Most golfers choose to pair up Quarry and Dune to create a full round, but the best option is to play all three.

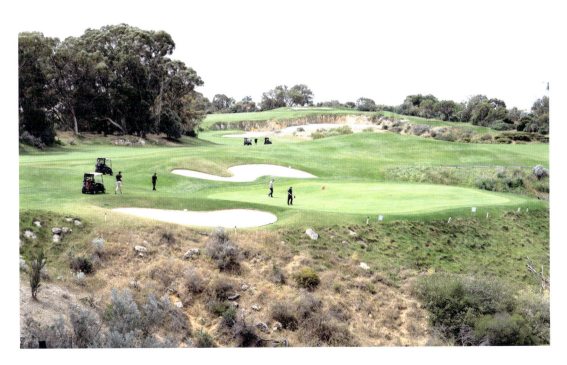

https://www.joondalupresort.com.au/golf +61 8 9400 8811

Oceania — New Zealand

144 CAPE KIDNAPPERS

446 Clifton Road, Te Awanga, Hawke's Bay 4180, New Zealand

TO VISIT BEFORE YOU DIE BECAUSE

The back nine are built on top of precipitous "fingers" of land that stretch out some 460 feet above the sea.

Despite being a geographically small country with a relatively small population, New Zealand has an impressive number of highly ranked golf courses, not least among them Cape Kidnappers, a daring course that challenges those with a fear of heights. Designer Tom Doak set the back nine holes atop narrow slivers of land—"fingers" if you will—between which are steep cliffs that drop 460 feet into Hawke's Bay. This course is not for the faint of heart, although admittedly it appears far more intimidating from the air than it does from the fairways or greens. Still, the views from the back nine are pretty stupendous.

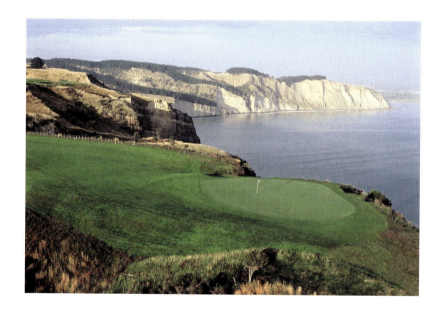

www.robertsonlodges.com/the-lodges/cape-kidnappers/golf

+64 6 873 1018

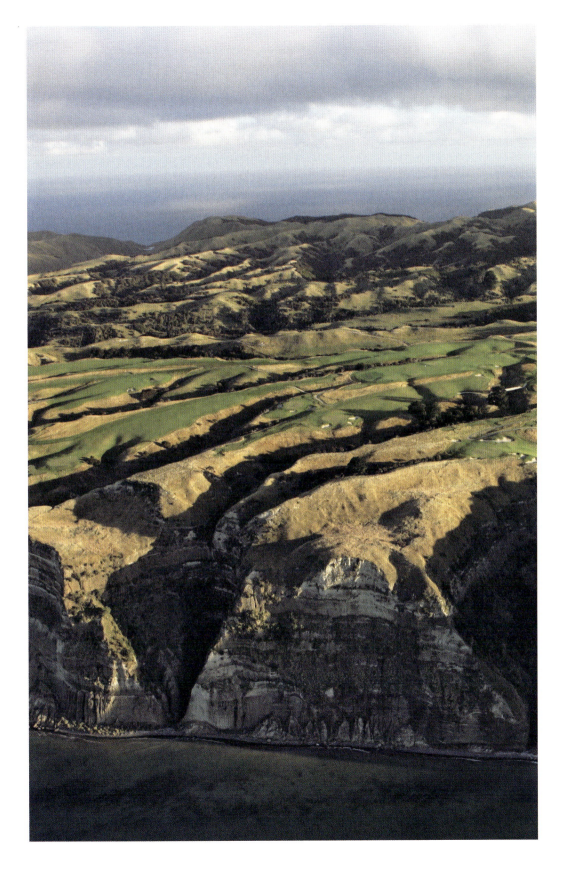

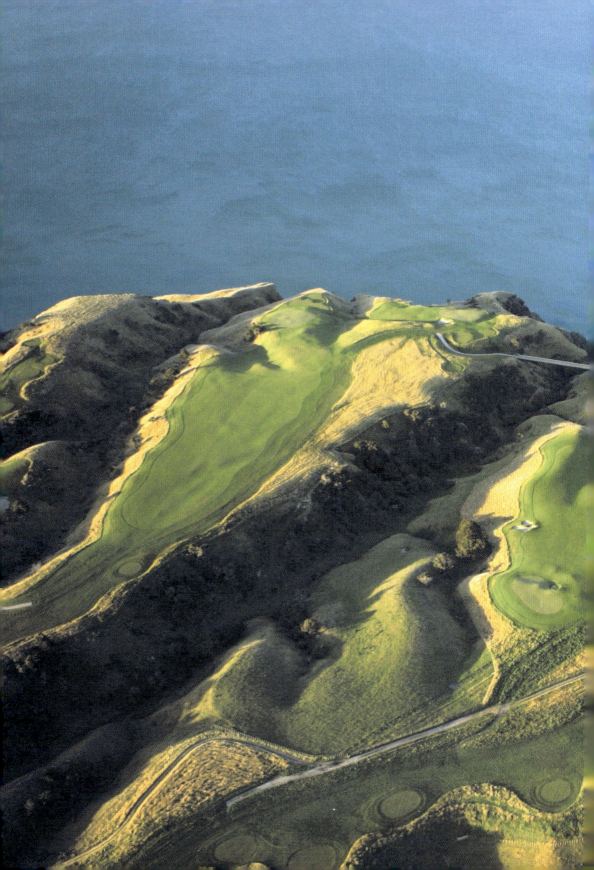

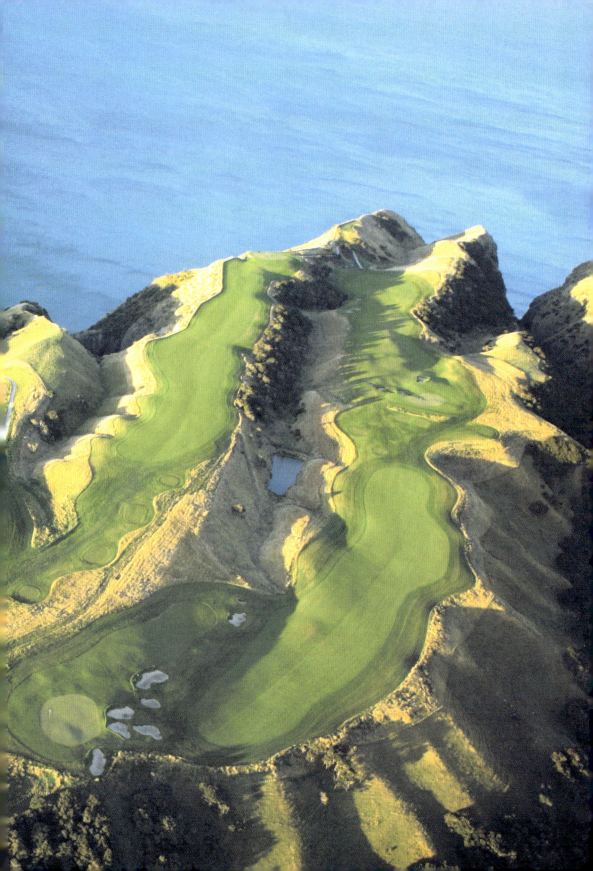

Oceania — New Zealand

145 THE HILLS

164 McDonnell Road, Arrowtown 9351, New Zealand

TO VISIT BEFORE YOU DIE BECAUSE

What was originally just a par-three hole is now one of New Zealand's most exclusive clubs.

New Zealand's golf courses are largely inclusive, but when The Hills opened as a members-only club in 2007, it set a precedent for exclusivity. But don't worry, the club does allow visitors to play here on a limited basis, and it's definitely worth inquiring about a booking. The course was originally just a single par-three hole on the grounds of businessman Sir Michael Hill's Arrowtown home, set in a scenic glacial valley. But The Hills grew outward from there; Darby Partners, which worked on the first hole for Hill, expanded it to a full 18-hole course, which would go on to host the New Zealand Open. It's known for its series of sculptures that decorate the course, including a herd of metal Clydesdale horses.

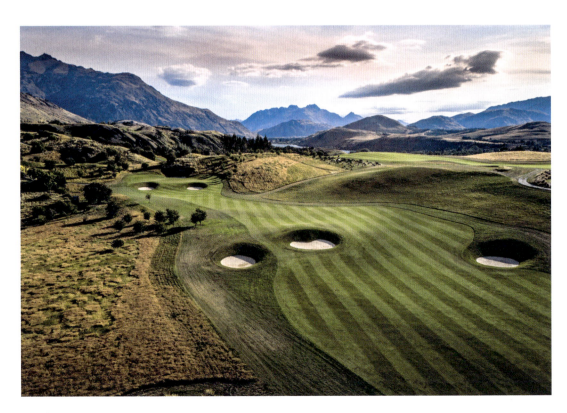

www.thehills.co.nz +643 409 8290

Oceania New Zealand

146 JACK'S POINT

McAdam Drive, Jack's Point, Queenstown 9371, New Zealand

TO VISIT
BEFORE YOU DIE
BECAUSE

The backdrop of The Remarkables mountain range is simply remarkable.

It's always enjoyable when something is named so perfectly; you can't help but smile. That's undoubtedly true of The Remarkables, which serves as the backdrop to Jack's Point. The Darby Partners–designed golf course sits far below the 7,500-foot peaks, right along the shores of Lake Wakatipu, surrounded by grasslands, outcrops, and bluffs. Best of all, despite its seemingly remote location, Jack's Point is just a 20-minute drive from downtown Queenstown. It's really no surprise at all that this elegant course often cracks the top 100 lists—the setting is genuinely breathtaking.

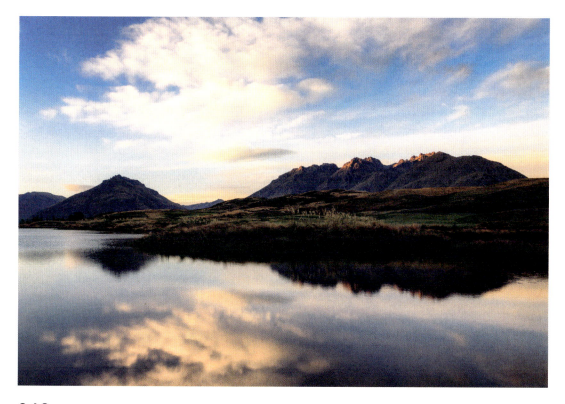

www.jackspoint.com +64 (3) 450 2050 ext 1

Oceania — New Zealand

147 KAURI CLIFFS

139 Tepene Tablelands Road, Matauri Bay, Northland 0478, New Zealand

TO VISIT BEFORE YOU DIE BECAUSE

With some of New Zealand's most temperate weather and an impressive view, Kauri Cliffs is a delight to play.

There is no shortage of clifftop golf courses in New Zealand, but Kauri Cliffs is certainly among the best of them. As the David Harman–designed course is located in the northern reaches of the North Island, the weather is balmier here than at more southern courses, though it can be a little wet at times. But when the skies are clear, the views are breathtaking; 15 holes have ocean views, and six are played right along the edge of the cliffs. If you're journeying out to this spot for a round, add in an overnight or two at the attached Lodge at Kauri Cliffs, a luxurious Relais & Châteaux property.

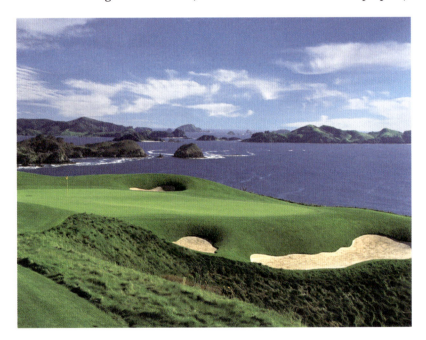

www.robertsonlodges.com/the-lodges/kauri-cliffs/golf

+64 9 407 0060

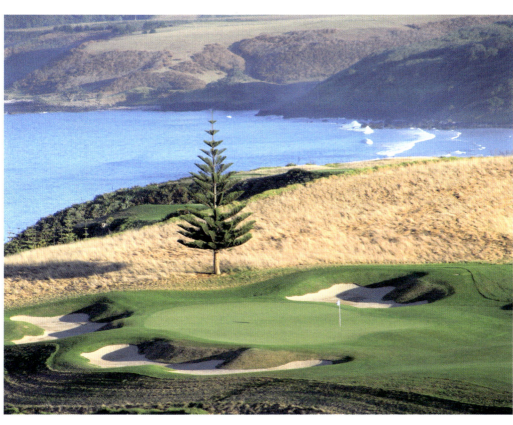
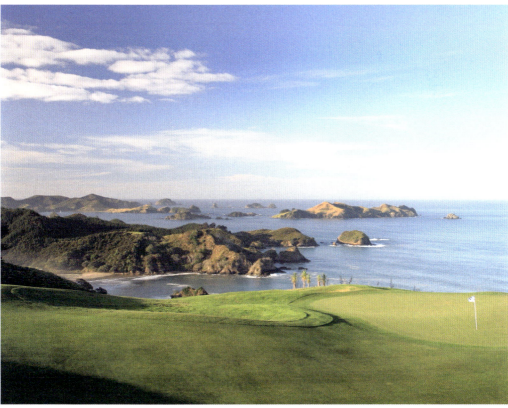

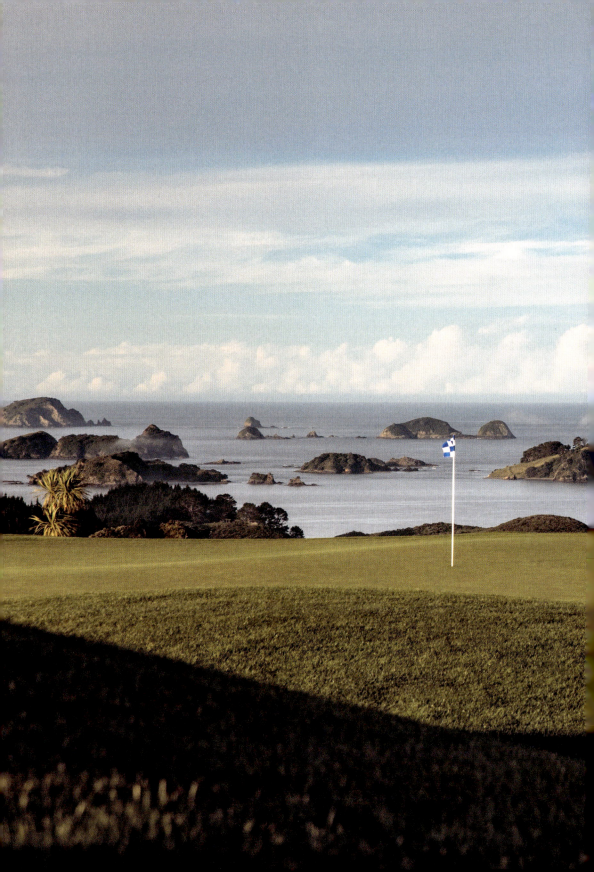

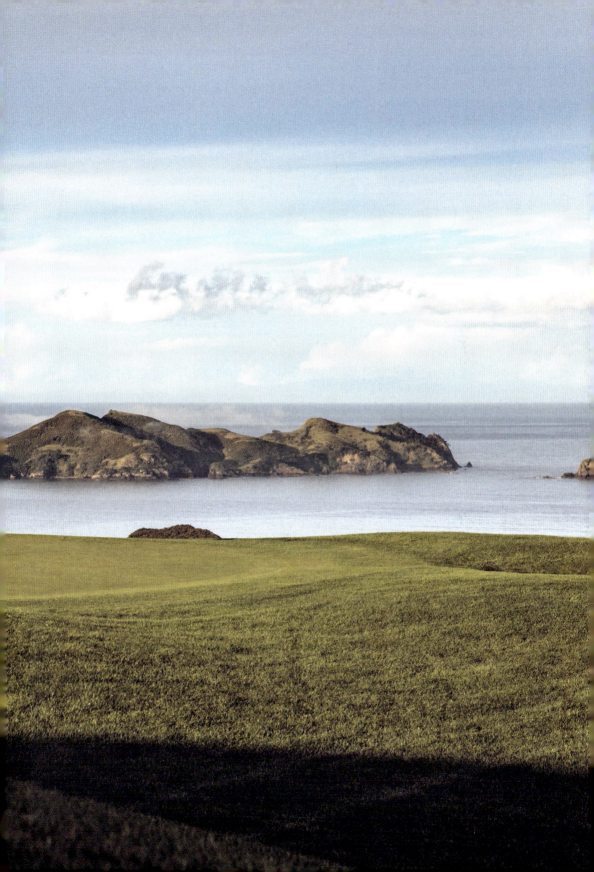

Oceania — New Zealand

148 MILLBROOK RESORT

1124 Malaghans Road, Arrowtown 9371, New Zealand

TO VISIT BEFORE YOU DIE BECAUSE

The New Zealand Open is played at this dramatic course.

Since it opened for play in 1992, Millbrook Resort between Queenstown and Arrowhead has been constantly evolving. The original 18-hole course was designed by John Darby and Bob Charles, but Greg Turner and Scott Macpherson were asked to split the course into two nine-hole courses, then add a brand-new nine-hole course. For some time, golfers could mix-and-match which two of the three courses they wanted to play for a full round. But now, Millbrook has added another nine holes, and the original 18 are now played as a single course (The Remarkables), while the two new nine-hole courses have been grouped together into a second 18-hole course (the Coronet). Millbrook Resort has already hosted the New Zealand Open three times, with future tournaments to come.

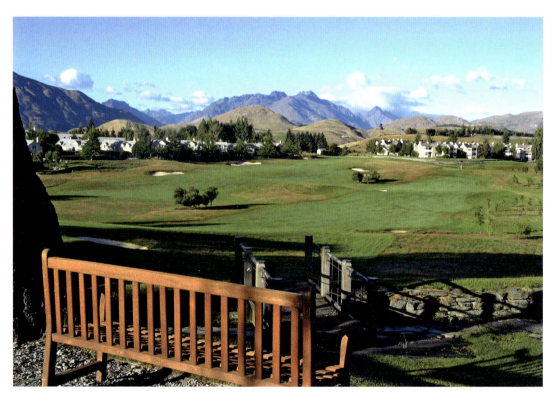

www.millbrook.co.nz/golf — 0800 645 527

149 PARAPARAUMU BEACH GOLF CLUB

376 Kapiti Road, Paraparaumu Beach, Paraparaumu 5032, New Zealand

TO VISIT BEFORE YOU DIE BECAUSE

A true links course, Paraparaumu has been called the "spiritual home of New Zealand golf."

Despite being on the opposite side of the planet from the British Isles, New Zealand has more in common with the motherland than simply being a part of the Commonwealth. It has similar geography, allowing the Kiwis to develop true links courses. Perhaps the best of them all is at Paraparaumu Beach Golf Club, set in the dunes of Kapiti Coast. Founded in 1949 and designed by Australian Alex Russell, Paraparaumu has hosted 12 New Zealand Opens throughout its history. The course is considered by many the "spiritual home of New Zealand golf."

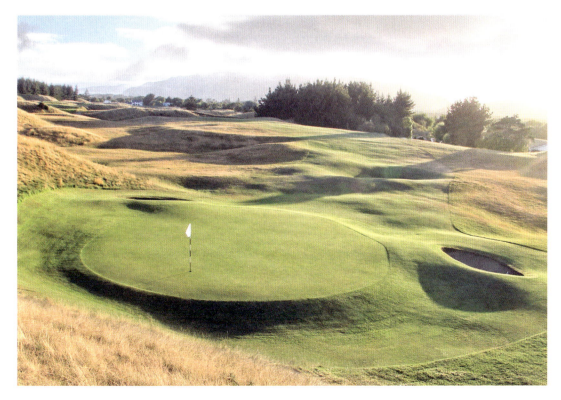

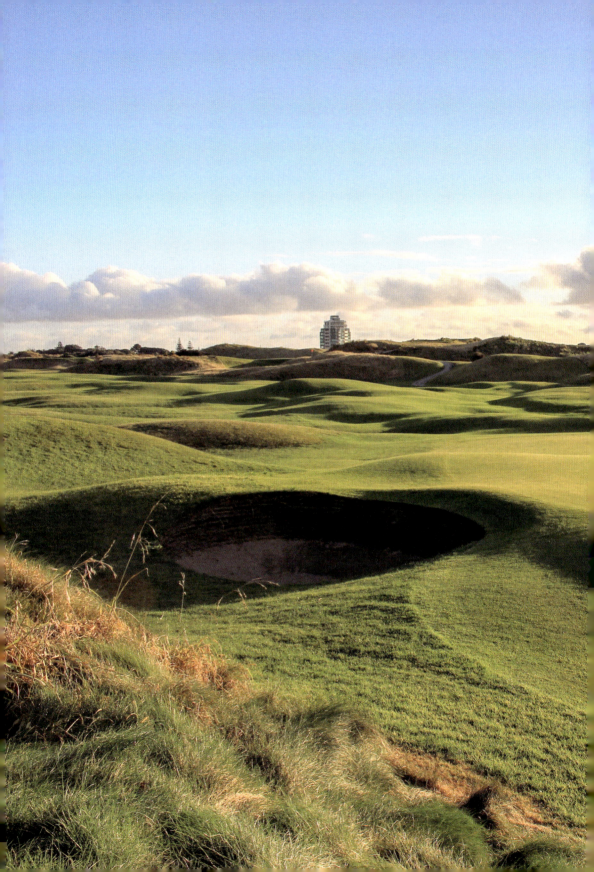

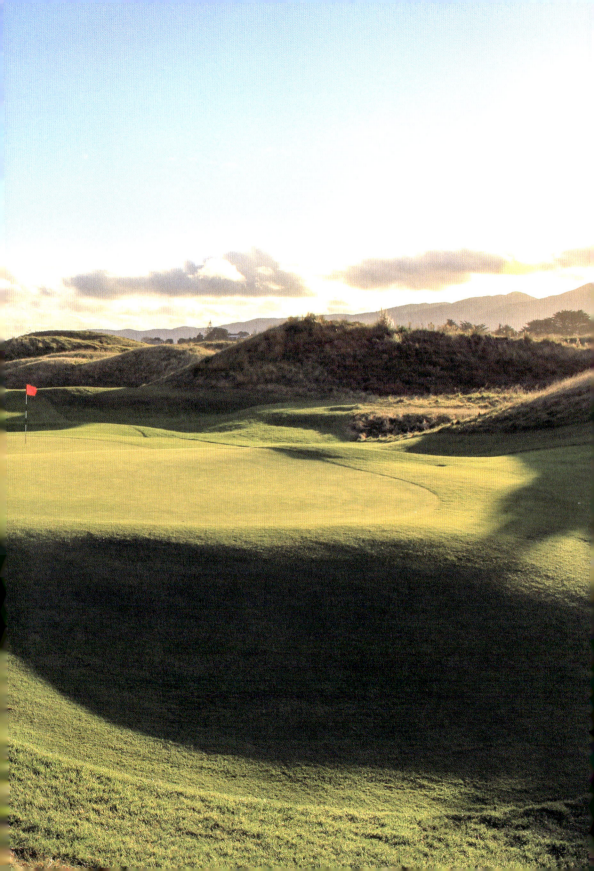

Oceania — Northern Mariana Islands

150 LAO LAO BAY GOLF & RESORT: EAST COURSE

Kagman, Saipan 96950, Northern Mariana Islands

TO VISIT BEFORE YOU DIE BECAUSE

Among all of Greg Norman's golf courses in the world, this one might be the most far-flung.

The island of Saipan in the Northern Mariana Islands has a population of less than 50,000 people, but it has six golf courses—not too shabby a ratio. Though they're all impressive for various reasons, Lao Lao Bay Golf and Resort's East Course stands out for two. First, it's set on top of a cliff, so it has amazing views. You even have to hit over the ocean at the signature sixth. Second, it's a Greg Norman–designed course, first opened in the 1990s. If you ever find yourself in the Northern Mariana Islands, be sure to book a tee time here.

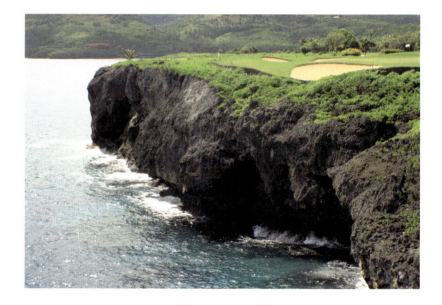

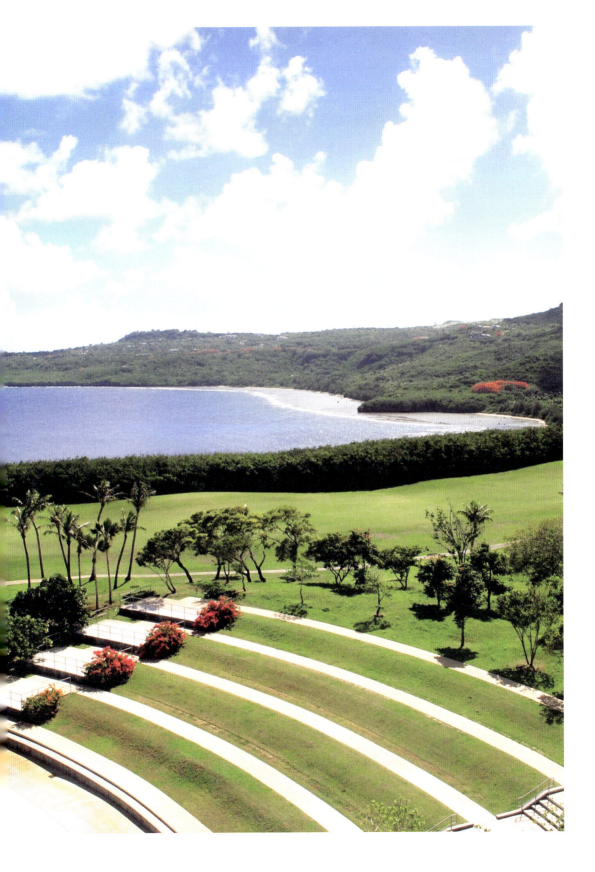

Index 150 Golf Courses

13th Beach . 236
Abama Golf191
Alcanada Golf Club 92
Andermatt Swiss Alps Golf Course 199
Arabella Golf Club 82
Ardglass Golf Club 206
Arrowhead Golf Course29
Ayodhya Links 128
Ba Na Hills Golf Club 137
Bali National Golf Club111
Ballybunion Golf Club 167
Bandon Dunes Golf Resort32
Barnbougle 222
Black Jack's Crossing33
Black Mountain Golf Club132
Borgarnes Golf Course161
Bro Hof Slott Golf Club 198
Broadmoor Golf Club34
Cape Kidnappers 238
Cape Wickham Golf Links 223
Cervino Golf Club174
Chamonix Golf Club149
Chapelco Golf & Resort10
Christmas Island Golf Course 224
Coeur D'Alene Resort35
Constance Lemuria Golf Course81
Coober Pedy Opal Fields Golf Club 225
Costa Navarino 160
Dai Lai Starf Golf & Country Club .138
Diamante Cabo San Lucas23
Dubai Creek Golf & Yacht Club134
Education City Golf Club123
Emirates Golf Club136
Fairmont Banff Springs Golf Course 18
Fairmont Grand Del Mar36
Finca Cortesin 193
Four Seasons Resort Hualalai44
Four Seasons Resort Lanai40
Furnace Creek Golf Course45
Furry Creek Golf & Country Club . . .19
Gary Player Country Club 83
Gávea Golf and Country Club16
Gleneagles .122
Gold Mountain 46
Golf Bluegreen Pléneuf-Val-André .150
Golf Club Alta Badia175
Golf Club Bad Ragaz 200
Golf Club Castelfalfi176
Golf Club Courmayeur
et Grandes Jorasses177
Golf Club Wilder Kaiser144
Golf de Spérone 156
Golf D'Etretat 154

Golfclub Engelberg-Titlis 204
Grange Golf Club 226
Gulmarg Golf Club 109
Handara Golf & Resort114
Ile Aux Cerfs Golf Club75
Indian Wells Golf Resort50
Jack's Point 243
Jockey Club Kau Sai Chau107
Joondalup Resort Country Club . . .237
Jungmun Golf Club 126
Kananaskis Country Golf course20
Kapalua Plantation Course51
Kauri Cliffs 244
Keilir Golf Course 162
Kiawah Island52
Kingston Heath227
KN Golf Links Cam Ranh139
Koninklijke Haagsche Golf
and Country Club179
Laguna Golf Lăng Cô142
Lahinch Golf Club70
Lake Victoria Serena
Golf Resort & Spa97
Lalit Golf & Spa Resort110
Lao Lao Bay Golf Resort14
Le golf National 155
Leopard Creek Country Club85
Lima Golf Club 28
Llao Llao Resort, Golf & Spa 252
Lofoten Links 180
Lord Howe Island Golf Club 230
Los Alamos County Golf Club53
Lydia Links 205
Marina Bay Golf Course124
Marriott Mena Golf Course73
Mauna Kea Golf Course54
Merapi Golf Yogyakarta115
Millbrook Resort 248
Montei Rei Golf & Country Club . . 182
Moscow Country Club 190
Mount Kinabalu Golf Club119
Muirfield . 209
New South Wales Golf Club 232
Nullarbor Links 233
Ojai Valley Inn 60
Old Head Golf Links172
Omeya Golf Club 80
Paraparaumu Beach Golf Club . . . 249
Payne's Valley Golf Course57
Pearl Valley .87
Peble Beach Golf Links 62
Pezula Championship Course 86
PGA West .56

Phokeethra Country Club103
Pinehurst No. 2 64
Pinnacle Point Golf Club 90
Portmarnock Golf Club173
Primland Resort 68
Punta Espada Golf Club21
Quivira Golf Club24
Real Club Vaderrama 196
Real Guadalhorce Club de Golf197
Rottnest Island Golf Club 234
Royal Dornoch 208
Royal Harare Golf Club 98
Royal Limburg Golf Club145
Royal Lytham & St. Annes Golf Club 212
Royal Selangor Golf Club120
Royal Thimphu Golf Club102
Sea Cliff Resort & Spa 96
Sedona Golf Resort 69
Sentosa Golf Club125
Shanqin Bay Golf Club104
Siam Country Club133
Silvies Valley Ranch71
Skukuza Golf Club 94
St. Andrews Links213
Sunningdale214
Tamarina Golf Club76
Templer Park Country Club121
Terravista Golf Course 17
The Clearwater Bay Golf
& Country Club 106
The Els Club Teluk Datai118
The Hills . 242
The Royal Adelaide Golf Club 235
Torrey Pines72
TPC Kuala Lumpur122
Thracian Cliffs Golf
& Beach Resort146
Troia Golf .187
Tromsø Golf Club181
Trump international
Golf Links Scotland 218
Trump Turnberry Resort219
Una Poggio Dei Medici Golf Club . .178
Ushuaia Golf Club15
Victoria Golf and Country Resort . .127
Vinpearl Golf Nha Trang143
Westman Island Golf Club 166
Whalsay Golf Club 220
Windsor Golf Hotel &
Country Club74
Yalong Bay Golf Club105

© Photos

p.10-13 Courtesy of Chapelco Golf & Resort / p.14 Buenaventuramariano – iStock / p.15 Goddard_Photography – iStock / p.16 Luoman – iStock / p.17 JohannesCompaan – iStock / p.18 Craig Zerbe – iStock / p.19 Chris Babcock – iStock / p.20 PickStock – iStock / p.21 BCWH – iStock / p.22-23 Missing35mm – iStock / p.24-25 Courtesy of Quivira Golf Club / p.26-27 Hornsteincreative.com / p.28 Antori – iStock / p.29 SCIsquared – iStock / p.30-31 RhinoJoe iStock / p.32 Matt De Sautel – iStock / p.33 Randy Martinez – shutterstock / p.34 ivanastar – iStock / p.35 ImagineGolf – iStock / p.36-40 Courtesy of Fairmont Grand Del Mar: Grand Golf Club / p.41-43 Courtesy of Four Seasons Resort Lanai / p.44 Courtesy of Four Seasons Resort Hualalai / p.45 LizzieMaher – iStock / p.46-49 Courtesy of Gold Mountain Golf Club / p.50 StephenBridger – iStock / p.51 ejs9 – iStock / p.52 Miranda Osborn-Sutphen – iStock / p.53 MonaMakela – iStock / p.54-55 Courtesy of Mauna Kea Beach Hotel / p.56 iShootPhotosLLC – iStock / p.57-59 Chris Murphy / p. 60-61 Courtesy of Ojai Valley Inn / p.62 Johnrandallalves – iStock / p.63 (top) JennaWagner – iStock / p.63 (bottom) Todamo – iStock / p. 64-67 Courtesy of Pinehurst Resort & Country Club / p.68 Courtesy of Primland Resort / p.69 ImagineGolf – iStock / p.70-71 Courtesy of Silvies Valley Ranch / p.72 Jerry Ballard – iStock / p.73 sanchesnet1 – iStock / p. 74 Courtesy of Windsor Golf Hotel & Country Club / p.75 Quality Master – shutterstock / p.76-79 Courtesy of Tamarina Golf Club / p.80 Grant Laversha / p.81 yykkaa – iStock / p.82 Arnold Petersen – iStock / p.83 intsys – iStock / p.84-85 Grant Laversha / p.86 Courtesy of Pezula Golf / p.87-89 Daniel Saaiman / p.90-93 Courtesy of Pinnacle Point Golf Club / p.94-95 Jean Rossouw / p.96 Courtesy of Sea Cliff Resort & Spa / p.97 Courtesy of Lake Victoria Serena Golf Resort & Spa / p.98 Christopher Scott / p.99 Louise Ward / p.100-101 Christopher Scott / p.102 Christian Kober – Shutterstock / p.103 Jacob Sjoman / p.104 DreamArchitect – Shutterstock / p.105 wonry – iStock / p.106 Chunyip Wong – iStock / p.107 Daniel Fung – Shutterstock / p.108 (top) Ramnath B. Bhat – Shutterstock / p.108 (bottom) Ka27 – Shutterstock / p.110 Anurag R Modak – Shutterstock / p.111-113 Courtesy of Bali National Golf Club / p.114 Mikhail Yuryev – Shutterstock / p.115 Bambang Wijaya – Shutterstock / p.116-117 supriyanto97 – Shutterstock / p.118 Yarygin – Shutterstock / p.119 Lano Lan – Shutterstock / p.120 Mike Casper – Shutterstock / p.121 Ravindran John Smith – iStock / p.122 Amrul Isham Ismail – Shutterstock / p.123 Shakeel Sha – iStock / p.124 Courtesy of Marina Bay Golf Course / p.125 Courtesy of Sentosa Golf Club Singapore / p.126 searagen – iStock / p.127 Son of the Morning Light – Shutterstock / p.128-131 Joe Vorachat / p.132 Nils Arne Johnsen Norway – Shutterstock / p.133 tool2530 – Shutterstock / p.134 deveritt – Shutterstock / p.135 (top) clearandtransparent - Shutterstock / p.135 (bottom) typhoonski – Shutterstock / p.136 ChandraDhas – iStock / p.137 Khoa Nguyen Dang – Shutterstock / p.138 quangpraha – iStock / p.139-141 Mai Trang Nguyen / p.142 Courtesy of Laguna golf Lang Cô / p.143 Vietnam Stock Images – Shutterstock / p.144 Hiphunter – iStock / p.145 Courtesy of Royal Limburg Golf Club / p.146 ncristian – iStock / p.147 Aum Studio – iStock / p.148 Greens and Blues – Shutterstock / p.149 boussac – iStock / p.150-153 A. Lamoureux / p.154 olrat – Shutterstock / p.155 isogood_patrick – Shutterstock / p.156 Courtesy of Golf de Spérone / p.157 Pawel Kazmierczak – Shutterstock / p.158-159 Balate Dorin – Shutterstock p.160 Costanavarino – flickr / p.161 Creative Travel Projects – Shutterstock / p.162-165 Dave Sansom / p.166 Milan Tesar – Shutterstock / p.167-169 Evan Schiller / p.170 mikedabell – iStock / p.171 levers2007 – iStock / p.172 Fingerszz – iStock / p.173 infrontphoto – iStock / p.174 Francesco Bonino – Shutterstock / p.175 Michal Zak – Shutterstock / p.176 Courtesy of Golf Club Castelfalfi / p.177 ArtMassa / p.178 Smilzo – Adobe Stock / p.179 Knpje – Wikimedia Commons / p.180 Alexander Jung – iStock / p.181 Courtesy of Tromso Golf Club / p.182-185 Courtesy of Monte Rei Golf & Country Club / p.186-189 Courtesy of Troia Golf / p.190 Adobe Stock / p.191 Pawel Kazmierczak – Shutterstock / p.192 pbsm – iStock / p.193-195 Courtesy of Finca Cortesin / p.196 Courtesy of Real Club Valderrama / p.197 alphotographic – iStock / p.198 sjoeman – iStock / p.199 Adobe Stock / p.200-203 Courtesy of Golf Club Bad Ragaz / p.204 fotoember – iStock / p.205 Wertu Studio – Shutterstock / p.206 Adobe Stock / p.207 DouglasMcGilviray – iStock / p.208 Catherine Philip – iStock / p.209-211 Gary Eunson / p.212 Mark Alexander Photography / p.213 jvoisey – iStock / p.214-217 Kevin Diss photography www.kevindiss.com / p.218 Cabro Aviation/CC BY-SA 4.0. / p.219 Dale Kelly – Shutterstock / p.220-221 Joe Huntly / p.222 Bell-Davey Photography - Shutterstock/ p.223 Alex Cimbal – Shutterstock / p.224 TravellingFatman – Shutterstock / p. 225 fotofritz16 – iStock / p.226 Mike Annese – iStock / p.227-229 Gary Lisbon / p.230-231 Image Supply – Shutterstock / p.232 apartment – Shutterstock / p.233 Courtesy of Nullarbor Links / p.234 Osprey Creative – Shutterstock / p.235 Courtesy of the Royal Adelaide Golf Club / p.236 Kye G – Shutterstock / p.237 Courtesy of Joondalup Resort / p.238-241 Courtesy of Cape Kidnappers / p.242 Airswing Media / p.243 Lukas Bischoff – iStock / p.244-247 Courtesy of Kauri Cliffs & Jacob Sjoman / p.248 SouthernLight – iStock / p.249-251 Courtesy of Paraparaumu Beach Golf Club / p.252 raksybH – iStock / p.253 RaksyBH – Shutterstock

In the same series

150 Restaurants
You Need to Visit
Before You Die
ISBN 9789401454421

150 Gardens
You Need to Visit
Before You Die
ISBN 9789401479295

150 Houses
You Need to Visit
Before You Die
ISBN 9789401462044

150 Hotels
You Need to Visit
Before You Die
ISBN 9789401458061

150 Vineyards
You Need to Visit
Before You Die
ISBN 9789401485463

150 Bars
You Need to Visit
Before You Die
ISBN 9789401486194

150 Wine bars
You Need to Visit
Before You Die
ISBN 9789401486224

150 Bookstores
You Need to Visit
Before You Die
ISBN 9789401489355

Colophon

Texts
Stefanie Waldek

Copy-editing
Bracha de Man

Book Design
ASB (Atelier Sven Beirnaert)

Sign up for our newsletter with news about new and forthcoming publications on art, interior design, food & travel, photography and fashion as well as exclusive offers and events. If you have any questions or comments about the material in this book, please do not hesitate to contact our editorial team: art@lannoo.com

© Lannoo Publishers, Belgium, 2022
D/2022/45/15 - NUR 450/500
ISBN 978 94 014 8195 3
6th print run

www.lannoo.com

All rights reserved. No part of this publication may be reproduced or transmitted in any form or by any means, electronic or mechanical, including photocopy, recording or any other information storage and retrieval system, without prior permission in writing from the publisher.

Every effort bas been made to trace copyright bolders. If, however, you feel that you have inadvertently been overlooked, please contact the publishers.